SPECLAB

Digital Aesthetics and Projects in Speculative Computing

JOHANNA DRUCKER

University of Chicago Press | Chicago and London

Johanna Drucker is the Martin and Bernard Breslauer Professor in the Graduate
School of Education and Information Studies at the University of California,
Los Angeles.

The University of Chicago Press, Chicago 60637
The University of Chicago Press, Ltd., London
© 2009 by The University of Chicago
All rights reserved. Published 2009
Printed in the United States of America

18 17 16 15 14 13 12 11 10 09 1 2 3 4 5

ISBN-13: 978-0-226-16507-3 (cloth)
ISBN-13: 978-0-226-16508-0 (paper)
ISBN-10: 0-226-16507-8 (cloth)
ISBN-10: 0-226-16508-6 (paper)

Library of Congress Cataloging-in-Publication Data

Drucker, Johanna, 1952–
 SpecLab : digital aesthetics and projects in speculative computing /
Johanna Drucker.
 p. cm.
 Includes bibliographical references and index.
 ISBN-13: 978-0-226-16507-3 (cloth : alk. paper)
 ISBN-13: 978-0-226-16508-0 (pbk. : alk. paper)
 ISBN-10: 0-226-16507-8 (cloth : alk. paper)
 ISBN-10: 0-226-16508-6 (pbk. : alk. paper)
 1. Humanities—Research—Data processing. 2. Humanities—Digital
libraries. 3. Image processing—Digital techniques. 4. Information storage
and retrieval systems—Humanities. 5. Metadata. I. Title.
AZ105.D785 2009
025.06′0013—dc22

 2008041462

♾ The paper used in this publication meets the minimum requirements of the
American National Standard for Information Sciences—Permanence of Paper for
Printed Library Materials, ANSI Z39.48-1992.

For Bethany and Jerry,
with affection and appreciation

CONTENTS

ILLUSTRATIONS

The Background to SpecLab

At the core of this book are convictions derived from both theoretical investigations into problems of knowledge production and experimental projects conceived under the general rubric of speculative computing. Speculative computing arose from a productive tension with work in what has come to be known as digital humanities. That field, constituted by work at the intersection of traditional humanities and computational technology, uses digital tools to extend humanistic inquiry. Computational methods rooted in formal logic tend to be granted more authority in this dialogue than methods grounded in subjective judgment. But speculative computing inverts this power relation, stressing the need for humanities tools in digital environments. The goal of SpecLab, then, was to challenge the conceptual foundations of digital humanities through aesthetic provocation. The relevance of the arguments I make here—for the importance of aesthetics, subjectivity, and speculative work—is not restricted to projects undertaken in electronic environments. But these insights arose in the process of working out problems in knowledge representation and interpretation that were central to digital humanities in the late 1990s and early 2000s.[1]

Digital humanities has taken on an important task: addressing the methods and implications of the migration of our cultural legacy into digital form and the creation of new, born-digital materials and tools. Nowhere was digital humanities more highly developed in the 1990s than at the University of Virginia.[2] I was a latecomer to that dynamic arena but one with an established interest in aesthetics and the use of new media in fine arts, poetry, graphic arts, and information design.[3] With Jerome McGann and Bethany Nowviskie, I created several projects, beginning in 2000, that became the core of SpecLab.

Under that rubric (short for Speculative Computing Laboratory) we undertook collaborations with uncertain outcomes, intent on contesting the emerging conventions of the digital humanities community. The happy circumstance of having, within a community where practices and methods were not yet fully consolidated, a small cohort intent on introducing experimental projects created a fertile institutional context within which the undertakings on which this book reports were conceived and executed.

I now believe that the lessons of SpecLab are as vital to the future of the humanities as digital humanities is to the continuation of scholarship and research across the humanistic disciplines. We learned many lessons about knowledge and subjectivity, about information design and representation, about creating conditions of use, and about designing instruments to show the complex activity of interpretation. These have recast my understanding of traditional print materials as radically as my encounter with critical theory, deconstruction, and poststructuralism did twenty-five years ago. In many ways, SpecLab allowed those theoretical constructs to be applied to practice, even as they were combined with insights from quantum physics, 'pataphysics, systems theory, and cognitive studies.

This book is thus addressed to several communities. Among digital humanists, reflection on our specific experience may yield lessons for future research. To the wider field of humanist scholars, it offers an introduction to the theoretical implications of the practical changes being wrought by digital activity in the way we do our daily business. The field of digital humanities is not simply concerned with creating new electronic environments for access to traditional or born-digital materials. It is the study of ways of thinking differently about how we know what we know and how the interpretative task of the humanist is redefined in these changed conditions. SpecLab's projects were attempts at designing ways to model and demonstrate new conceptions of that work and

its fundamental assumptions. For me, the questions guiding this activity have always been the same: What is the relation between aesthetic expression and knowledge? And how do we take such relations into account in modeling our interpretative approaches so that they expose the ideological as well as epistemological workings of complex cultural activities? From my very first encounters with digital media, I have been convinced that the powerful cultural authority exerted by computational media, grounded in claims to objectivity premised on formal logic, can be counterbalanced through aesthetic means in which subjectivity is central to the concept of knowledge as interpretation.

Aesthesis, as will become clear in the pages ahead, is the term by which I refer to a theory of partial, situated, and subjective knowledge—a theory whose aims are ideological as well as epistemological. Digital media, through a curious combination of capabilities, can be the site of demonstrating simultaneously the exclusion of subjects (persons constituted in their relation to social, cultural, historical circumstances) *and* their presence, inscription, and participation in the production of knowledge. I think this is what brought home so strongly the realizations that form my argument.

These are large claims. The concept of aesthesis engages basic questions about knowledge and its representation, and interpretative acts and the values assigned to them within a cultural frame. Insofar as form allows sense to appear to sentience, to paraphrase Aristotle, the role of aesthetics is to illuminate the ways in which the forms of knowledge provoke interpretation.[4] Insofar as the formal logic of computational environments validates instrumental applications regarding the management and creation of digital artifacts, imaginative play is crucial to keeping that logic from asserting a totalizing authority on knowledge and its forms. Aesthesis, I suggest, allows us to insist on the value of subjectivity that is central to aesthetic artifacts—works of art in the traditional sense—and to place that subjectivity at the core of knowledge production.[5]

Formal logic, with its grounding in *mathesis* and claims to objectivity, can be challenged only by an equally authoritative tradition of aesthetic works and their basis in subjective forms of knowledge production. Conceived in such a framework, neither "works" nor "forms" are self-evident entities. They are emergent phenomena constituted by shifting forces and fields through productive acts of interpretation. Thus "forms" (texts, images, complex expressions of any kind) are coded artifacts, constrained and specific, that provoke a reading or interpretative event.

This "interpretative event" is an intervention in a probabilistic or discursive field linked to a sphere of cultural production that has historical and temporal, as well as bibliographical, cultural, and other, dimensions. An individual reader, however, often accesses the field only through an encounter with the artifact. (Scholarly work, research, and criticism, by contrast, deliberately expand beyond the "artifact" into the broader discourse of production, reception, and so on.)

Conceived in this way, knowledge forms are never stable or self-identical but always situated within conditions of use. Knowledge, then, is necessarily partial, subjective, and situated. Objectivity, we have long recognized, is the wish dream of an early rational age, one that was mechanistic in its approaches. The persistence and success of that rational tradition is realized in the extent to which our contemporary administered culture builds its own authority upon the formal procedures computational logic enables and makes instrumental.

Aesthesis challenges the authority of this systematic rationality by questioning its founding assumptions, particularly its totalizing concepts of knowledge. In a curious historical coincidence, the very era that witnessed the dismantling of truth claims by poststructuralist practice and deconstructive theory witnessed the rise of the cultural authority of computational media. Digital technology has insinuated itself into the infrastructure and rituals that form the basis of daily life to such an extent that, despite the availability of a philosophical base for undoing its authority, there is a pervasive tendency to bracket any critiques in the interest of getting on with business. Nowhere was this contradiction more evident than in the struggles to keep humanistic theory central to the digital humanities. Time after time, we saw theoretical understandings subordinated to the practical "requirements of computational protocols." As one of my digital humanities colleagues used to remark, we would go into the technical discussions as deconstructed relativists and come out as empirically oriented pragmatists.

Thus the single most important challenge we gave ourselves in SpecLab was to design representations that modeled subjectivity within knowledge production. Making visible these subjective acts of interpretation, and the role of imaginative play, served to challenge the authority claims of formal logical systems. The event of interpretation in a digital environment includes many steps: creating a model of knowledge, encoding it for representation, embodying it in a material expression, and finally encountering it in a scene of interpretation. Each is part of a performative system governed by basic principles of second-generation

systems theory, in particular, codependence and emergence.[6] These can be used to describe an aesthetic experience grounded in subjective judgment just as surely as they can be used to describe formal systems.

When I arrived at the University of Virginia, I found that a culture of design and visual knowledge was conspicuously missing.[7] What interest there was in visual or graphic design was grounded in information design and its ideals of transparency in the representation of data.[8] Critical editing, corpus linguistics, translation, and archive building had been central to early digital projects, but attention to subjectivity and the rhetorical properties of graphical aesthetics was not part of the design process at UVa (or anywhere in the humanities at that time). Graphic design and interface design were often regarded as window dressing, a skin to be grafted, at the last minute, onto an already formed information structure.[9] The understanding that *design is information* was not part of the approach.

My background combined historical and practical approaches to graphical forms of knowledge production, as well as a theoretical disposition to produce a critical metalanguage for describing these approaches. I had everything to learn about digital humanities when I arrived at UVa. I didn't know the basics of HyperText Markup Language (HTML, the code used to specify the graphic characteristics of information in an on-screen/browser environment). I was far from initiated into the mysteries of the Text Encoding Iniative (TEI, a set of conventions for standardizing tags across projects) or Extensible Markup Language (XML, a generic form of tagging and structuring data).[10] But my training as an artist-practitioner and art historian had given me a deep conviction about the ways graphical forms of knowledge embody subjective inflection. The specificity and variety of graphical expressions, and their relatively unstable, informal codes, combined with the rhetorical force of presentation—constitute an argument in any information display.[11]

I joined the digital humanities community at UVa at a fertile moment. Under the visionary leadership of John Unsworth, the Institute for Advanced Technology in the Humanities (IATH), had established itself at the forefront of the field. Its international reputation, justly deserved, had fostered an atmosphere of heady engagement with questions of metadata, display features and functionalities, and such now-quaint but still persistent topics as overlapping hierarchies. In the early 1990s, when a gift from IBM was used to establish the research center, Unsworth had the insight that the future of digital humanities was on the Web. IATH created pioneering projects with a core group that combined the tal-

ents of computational humanists, philosophers of information science, and some senior scholars who were early and eager adopters. The Rossetti Archive, established by Jerome McGann as a demonstration of the capacity of computational technology to provide an environment for scholarly editing and archival research, and The Valley of the Shadow, Ed Ayers's showpiece of historical interpretation, in which all primary materials would be made available as part of the scholarly work, were two of the initial undertakings.[12] Along with other major projects at UVa and elsewhere (the Blake Archive, Project Muse, the Crystal Palace, Voice of the Shuttle, and the Perseus Project, among others), these became the testing ground on which first-generation digital humanities scholarship came of age.

In 1999 the Web was only a few years old, though the Internet backbone on which it was built had been in existence for decades. Palm Pilots, iPods, CD burners, and DVDs were still future technology or just on the horizon. Critical studies in digital media were beginning to appear, with a handful of serious works on the cultural impact of new technology, particularly in the arts.[13] Real-time interactions in virtual space using text-only display had, already in the 1980s, demonstrated the addictive quality of social networking and online environments in multiplayer games. MUDs (Multi-User Dungeons) and MOOS (MUDs Object-Oriented) had proved so seductive that undergraduates would go without sleep, food, sex, and face-to-face social interaction in order to keep playing.[14] Then in the 1990s, the graphical interface that had made desktop computing so user-friendly began to be translated into vivid new displays. Text-only screens, blinking green or amber against dull black, were replaced by full-color monitors. Search engines sprang up and competed: AltaVista, Jeeves, Google, and others now vanished from the scene. Amazon and eBay were already well-established brands, but online news and day trading were still primitive. So much of what is now established habit was then barely in view.

As an early adopter, the University of Virginia had invested in creating an infrastructure to encourage the delivery of services in electronic form and in laying the foundation for a digital library. Most importantly, it had fostered the development of models of electronic scholarship. These projects were using new technology to ask research questions that were not viable using traditional print-based materials. Many of these questions had a meta aspect to them, encouraging reflection on models of knowledge, rather than simply focusing on objects, artifacts, or scholarly inquiry. Staying up nights discussing classification systems and

thinking of ways to structure data may sound drab—and tame alongside the debates then raging about the right to self-determination of intelligent machines and the possibilities of silicon-based life replacing carbon forms—but for those of us engaged in the dizzying tasks of "disambiguation" and "content modeling" required by digital methods, these activities were engrossing and stimulating.[15]

Not since my days in the poetry world of the Bay Area in the 1970s, or the film theory circles at Berkeley in the 1980s, had I experienced such intellectual camaraderie and exuberance. The generosity of colleagues, their willingness to engage in serious conversation about information structures, computational language, and the cultural and ideological implications of technological transformation, and the common commitment to figuring out what digital humanities had to teach us about our traditional approaches and unexamined assumptions as scholars was striking. We shared readings and projects without reserve, in an atmosphere of generative collegial contention. Within SpecLab in particular, we had the rare opportunity to develop a specialized insight and understanding that has yet to be fully documented and described. This book aims to communicate the spirit and substance of that activity as I experienced it.

This book is neither a history of digital humanities nor an introduction to its tenets or practices.[16] Nor is it a history of IATH and related ventures at the University of Virginia. That story is not mine to tell. Anyone interested in the intellectual frameworks of that community and its development would do well to read *Radiant Textuality* by Jerome McGann, who participated from the outset. A fascinating journalistic account could be written documenting the curious history of digital humanities at UVa. But at this moment, it seems more pressing to communicate the intellectual substance of what we learned and use it to envision the next phase of work.

From the very beginning of my engagement with digital humanities I have benefited from a community of colleagues of exceptional generosity and vision. The aforementioned John Unsworth, Matt Kirschenbaum, Kim Tryka, Mike Furlough, Bethany Nowviskie, Daniel Pitti, Thorny Staples, Worthy Martin, Geoff Rockwell, and Andrea Laue made substantive contributions to our work and thought. More recently, Bess Sadler, Bradley Daigle, Nick Laicona, and Eric Rettberg provided their unique skills. Others who passed through our orbit—Nathan Piazza, Steve Ramsay, Annie Schutte, John Maeda, and John David Miller, among others—had their own impact.

In the last decade, I have had the good fortune to enjoy an ongoing dialogue with Jerome McGann. He is the other of the "we" that appears frequently throughout this text. Rare indeed to have so kindred a spirit for so unusual an undertaking. Our talents are complementary rather than overlapping, though our shared interests and sensibilities, and common frames of reference, make our exchanges highly fruitful. The spirit of play and invention in the service of imagination is crucial to our vision, and I cannot imagine that this work would exist as it does were it not for his engagement in the conception and execution of many of its ideas and arguments.

The conviction that led me to write the essay "Can Graphesis Challenge Mathesis?" in the late 1990s, however, had been forming for a decade before I met Jerry. I came to subjectivity from a studio practice and the critical study of graphical objects, an approach that brought an emphasis on visuality and design into our UVa conversations and projects as a crucial component of aesthetic insight. The issues that were formulated in a rudimentary way in that essay, and later expanded from graphical issues in knowledge representation to the larger question of subjectivity and the design of conditions of use and interpretation, are of quite a different kind and sensibility than those that come from textual scholarship. They overlap in the fundamental and crucial interest in designing electronic instruments to engage and demonstrate the subjective character of knowledge as interpretation. My contribution was to take what I had learned about subjectivity through visuality and aesthetics into our collective labors in speculative computing.

This book has evolved considerably. Originally conceived as a collection of essays, on which it still draws heavily, it was simply going to replay the development of our thinking and projects at SpecLab. Under the influence of my judicious readers and with the support of Susan Bielstein at University of Chicago Press, it has become a more synthetic book. My central argument is that subjectivity and aesthetics are essential features in the design of digital knowledge representation as that terrifying but very real prospect comes to fruition—the migration of our cultural legacy into electronic environments and the instrumental processing of nearly all aspects of daily life through digital media. The lessons of this book are not confined to insights into how to make things in a digital environment. They spring from that source, but I hope they provide insights into how to think within the broader culture. Where, how, and through what means can we model our understanding of knowledge as a humanistic endeavor within the structures and strictures of our increasingly administered and digitally instrumentalized world?

The first section of the book, "Speculative Computing," provides an introduction to digital humanities in order to contrast with it the distinctive character of speculative computing. The second section, "Projects at SpecLab," describes the development of our work and traces the way hands-on design and production are integrated with theory as a working process in order to imagine environments for subjective knowledge production. In the third section, "From Aesthetics to Aesthesis," various aspects of the materiality, specificity, and implications of the study of digital media are discussed. The section begins with a discussion of my initial impulse to examine graphical codes and the challenge posed by analog images to the logical premises and assumptions that underlie much digital work. This discussion extends into the examination of texts and codes, insights that shifted from mechanistic to probabilistic approaches to materiality and led to investigations of higher-order intellectual structures in metadata and modeling. A discussion of the aesthetic properties of digital media from historical and contemporary perspectives is followed by a discussion of ideology and virtuality. A concluding note sketches a few thoughts on lessons of SpecLab for digital media studies, current and future design practices, and humanistic inquiry.

The spirit of play with which we imagined these projects is an essential aspect of generative insight. Around conference tables or in public presentations, our projects often provoked the query "Are they serious?" The discussion and design of Temporal Modeling, Ivanhoe, and our sketches for the 'Patacritical Demon or my Subjective Meteorology all generated this response. The discomfort caused by our challenges to the cultural authority of computational methods registered the significance of subjective approaches and the threatening aspect of playfulness as a generative engine of imagination. That was crucially important. That moment of questioning disbelief showed that we were creating a gap between familiar ways of imagining what we know and unfamiliar possibilities for reimagining them. In that gap we created the projects of SpecLab.

1.0

Speculative Computing

1.1 From Digital Humanities to Speculative Computing

Our activities in speculative computing were built on the foundation of digital humanities. The community at the University of Virginia in which these activities flourished was largely, though not exclusively, concerned with what could be done with texts in electronic form. Early on, it became clear that aggregation of information, access to surrogates of primary materials, and the manipulation of texts and images in virtual space all provided breakthrough research tools. Projects in visualization were sometimes part of first-generation digital humanities, but the textual inclination of digital humanities was nurtured in part by links to computational linguistics whose analyses were well served by statistical methods. (Sheer practicality played a part as well. Keyboarded entry of texts may raise all kinds of not so obvious issues, but no equivalent for "entering" images exists—a point, as it turns out, that bears on my arguments about materiality.) Some literary or historical scholars involved in critical editing and bibliographical studies found the flexibility of digital instruments advantageous.[1] But these environments also gave rise to theoretical and critical questions that prompted innovative reflections on traditional scholarship.

The early character of digital humanities was formed by concessions to the exigencies of computational disciplines.[2] Humanists played by the rules of computer science and its formal logic, at least at the outset. Part of the excitement was learning new languages through which to rethink our habits of work. The impulse to challenge the cultural authority of computational methods in their received form came later, after a period of infatuation with the power of digital technology and the mythic ideal of *mathesis* it seemed to embody. That period of infatuation (a replay of a long tradition) promoted the idea that formal logic might be able to represent human thought as a set of primitives and principles, and that digital representation might be the key to unlocking its mysteries. Naïve as this may appear in some circles, the utopian ideal of a world fully governed by logical procedures is an ongoing dream for many who believe rationality provides an absolute basis for knowledge, judgment, and action.[3] The linguistic turn in philosophy in the early decades of the twentieth century was fostered in part by the development of formalist approaches that aspired to the reconciliation of natural and mathematical languages. The intellectual premises of British analytic philosophy and those of the Vienna Circle, for instance, were not anomalies but mainstream contributions to a tradition of mathesis that continued to find champions in structural linguistics and its legacy throughout the twentieth century.[4] The popular-culture image of the brain as a type of computer turns these analogies between thought and processing into familiar clichés.[5] Casual reference to nerve synapses as logic gates or behaviors as programs promotes an unexamined but readily consumed idea whose ideal is a total analysis of human thought processes, as if they could be ordered according to formal logic.[6] Science fiction writers have exploited these ideas endlessly, as have futurologists and pundits given to hyperbole, but widespread receptiveness to their ideas shows how deeply rooted the mythology of mathesis is in the culture at large.[7]

Digital humanists, however, were interested, not in analogies between organic bodies and logical systems, but in the intellectual power of information structures and processes. The task of designing content models or conceptual frameworks within which to order and organize information, as well as the requirements of data types and formats at the level of code or file management, forged a pragmatic connection between humanities research and information processing. The power of metalanguages expressed as classification systems and nomenclature was attractive, especially when combined with the intellectual discipline

imposed by the parameters and stringencies of working in a digital environment. A magical allure attached to the idea that imaginative artifacts might yield their mysteries to the traction of formal analyses, or that the character of artistic expressions might be revealed by their place within logical systems. The distinction between managing or ordering texts and images with metadata or classification schemes and the interpretation of their essence as creative works was always clear. But still, certain assumptions linked the formal logic of computational processes to the representation of human expressions (in visual as well as textual form), and the playful idea that one might have a "reveal codes" function that would expose the compositional protocols of an aesthetic work had a compelling appeal. At first glance, the ability of formal processing to manage complex expressions either by modeling or manipulation appeared to be mere expediency. But computational methods are not simply a means to an end. They are a powerful change agent setting the terms of a cultural shift.

By contrast, speculative computing is not just a game played to create projects with uncertain outcomes, but a set of principles through which to push back on the cultural authority by which computational methods instrumentalize their effects across many disciplines. The villain, if such a simplistic character must be brought on stage, is not formal logic or computational protocols, but the way the terms of such operations are used to justify decisions about administration and management of cultural and imaginative life based on the presumption of objectivity.[8] The terms on which digital humanities had been established, while essential for the realization of projects and goals, needed to be scrutinized with an eye to the discipline's alignment with such managerial methods. As in any ideological formation, unexamined assumptions are able to pass as natural. We defined speculative computing to push subjective and probabilistic concepts of knowledge as experience (partial, situated, and subjective) against objective and mechanistic claims for knowledge as information (total, managed, and externalized).

: : :

If digital humanities activity were reduced to a single precept, it would be the requirement to disambiguate knowledge representation so that it operates within the codes of computational processing. This requirement has the benefit of causing humanist scholars to become acutely self-conscious about the assumptions under which we work, but also to concede many aspects of ambiguity for the sake of workable solutions. Basic

decisions about the information or substantive value of any document rendered in a digital surrogate—whether a text will be keyboarded into ASCII, stripping away the formatting of the original, or how a file will be categorized—are fraught with theoretical implications. Is *The Confessions* of Jean Jacques Rousseau a novel? The document of an era? A biographical portrait? A memoir and first-person narrative? Or a historical fiction? Should the small, glyphic figures in William Blake's handwriting that appear within his lines of poetry be considered part of the text, or simply disregarded because they cannot be rendered as ASCII symbols?[9] At every stage of development, digital instruments require such decisions. And through these decisions, and the interpretive acts they entail, our digital cultural legacy is shaped.

Because of this intense engagement with interpretation and epistemological questions, the field of digital humanities extends the theoretical questions that came into focus in deconstruction, postmodern theory, critical and cultural studies, and other theoretical inquiries of recent decades. Basic concerns about the ways processes of interpretation constitute their objects within cultural and historical fields of inquiry are raised again, and with another level of historical baggage and cultural charge attached. What does it mean to create ordering systems, models of knowledge and use, or environments for aggregation or consensus? Who will determine how knowledge is classified in digital representations? The next phase of cultural power struggles will be embodied in digital instruments that model what we think we know and what we can imagine.

Digital humanities is an applied field as well as a theoretical one, and the task of applying these metaconsiderations puts humanists' assumptions to a different set of tests. It also raises the stakes with regard to outcomes.[10] Theoretical insight is constituted in this field in large part through encounters with application. The statistical analysis of texts, creation of structured data, and design of information architecture are the basic elements of digital humanities. Representation and display are integral aspects of these activities, but they are often premised on an approach influenced by engineering, grounded in a conviction that transparency or accuracy in the presentation of data is the best solution. Blindness to the rhetorical effects of design *as a form of mediation* (not of transmission or delivery) is an aspect of the cultural authority of mathesis that plagues the digital humanities community. Expediency is the name under which this authority exercises its control, and in its shadow grow the convictions that resolution and disambiguation are virtues, and that

"well-formed" data behaves in ways that eliminate the contradictions tolerated by (traditionally self-indulgent) humanists. The attitude that objectivity—defined in many cases as anything that can be accommodated to formal logical processes—is a virtue, and the supposedly fuzzy quality of subjectivity implicitly a vice, pervades the computation community. As a result, I frequently saw the triumph of computer culture over humanistic values.[11]

Humanists are skilled at complexity and ambiguity. Computers, as is well known, are not. The distinction amounts to a clash of value systems, in which fundamental epistemological and ideological differences arise. Digital projects are usually defined in highly pragmatic terms: creating a searchable corpus, making primary materials for historical work available, or linking such materials to an interactive map and timeline capable of displaying data selectively. Theoretical issues that arise are, therefore, intimately bound to practical tasks, and all the lessons of deconstruction and poststructuralism—the extensive critiques of reason and grand narratives, the recognition that presumptions of objectivity are merely cultural assertions of a particular, historical formation—threaten to disappear under the normalizing pressures of digital protocols. This realization drove SpecLab's thought experiments and design projects, pushing us to envision and realize alternative possibilities.

Digital Humanities and Electronic Texts

Digital humanities is not defined entirely by textual projects, though insofar as the community in which I was involved focused largely on text-based issues, its practices mirrored the logocentric habits endemic to the academic establishment.[12] Even so, many of my own convictions regarding visual knowledge production were formulated in dialogue with that community. Understanding the premises on which work in the arena of digital humanities was conceived is important as background for our design work at SpecLab—and to heading off the facile binarisms that arise so easily, pitting visual works against texts or analog modes against digital ones, thus posing obstacles to more complex thought.

Textual studies met computational methods on several different fields of engagement. Some of these were methods of manipulation, such as word processing, hypertext, or codework (a term usually reserved for creative productions made by setting algorithmic procedures in play).[13] Others were tools for bibliographical studies, critical editing and collation, stylometrics, or linguistic analysis. Another, mentioned

briefly above, was the confluence of philosophical and mathematical approaches to the study of language that shared an enthusiasm for formal methods. The history of programming languages and their relation to modes of thought, as well as their contrast with natural languages, is yet another. All of these have a bearing on digital humanities, either directly (as tools taken up by the field) or indirectly (as elements of the larger cultural condition within which digital instruments operate effectively and gain their authority).

Twenty years ago a giddy excitement about what Michael Heim termed "electric language" turned the heads of humanists and writers. Literary scholars influenced by deconstruction saw in digital texts a condition of mutability that seemed to put the idea of differential "play" into practice.[14] The linking, browsing, combinatoric possibilities of hypertext provided a rush to authorial imagination. Suddenly it seemed that conventions of "linearity" were being exploded. New media offered new manipulative possibilities. Rhizomatic networks undercut the apparent stasis of the printed page. Text seemed fluid, mobile, dynamically charged. Since then, habits of use have reduced the once dizzying concept of links and the magic of being able to rework texts on the screen to the business of everyday life. But as the "wow" factor of those early encounters has evaporated, a deeper potential for interrogating what a text is and how it works has come into view within the specialized practices of electronic scholarship and criticism. In particular, a new order of metatexts has come into being that encodes (and thus exposes) attitudes toward textuality.

Early digital humanities is generally traced to the work of Father Roberto Busa, whose *Index Thomisticus* was begun in 1949. Busa's scholarship involved statistical processing (the creation of concordances, word lists, and studies of frequency), repetitive tasks that were dramatically speeded by the automation enabled by computers. Other developments followed in stylometrics (quantitative analysis of characteristics of style for attribution and other purposes), string searches (matching specific sequences of alphanumeric characters), and processing of the semantic content of texts (context sensitive analysis, the semantic web, etc.).[15] More recently, scholars involved in the creation of electronic archives and collections have established conventions for metadata (the Dublin Core Metadata Initiative), markup (the Text Encoding Initiative), and other elements of digital text processing and presentation.[16] This process continues to evolve as the scope of online projects expands from creation of digital repositories to peer-reviewed publishing, the design

of interpretative tools, and other humanities-specific activities. The encounter of texts and digital media has reinforced theoretical realizations that printed materials are not static, self-identical artifacts and that the act of reading and interpretation is a performative intervention in a textual field that is charged with potentiality.[17] One of the challenges we set ourselves was to envision ways to *show* this dramatically rather than simply to assert it as a critical insight.

The processes involved in these activities are not simply mechanical manipulations of texts. So-called technical operations always involve interpretation, often structured into the shape of the metadata, markup, search design, or presentation and expressed in graphic display. The gridlike structures and frames in Web browsers express an interpretive organization of elements and their relations, though not in anything like an isomorphic mirroring of data structures. Features such as sidebars, hot links, menus, and tabs have become so rapidly conventionalized that their character as representations has become invisible. Under scrutiny, the structural hierarchy of information coded into buttons, bars, windows, and other elements of the interface reveals the rhetoric of display. Viewing the source code—the electronic equivalent of looking under the hood—shows an additional level of information structure. But this still doesn't provide access to or reading knowledge of the metadata, database structures, programming protocols, markup tags, or style sheets that underlie the display. Because these various metatexts actively structure a domain of knowledge production in digital projects, they are crucial instruments in the creation of the next generation of our cultural legacy. Arguably, few other textual forms will have greater impact on the way we read, receive, search, access, use, and engage with the primary materials of humanities studies than the metadata structures that organize and present that knowledge in digital form.[18]

Digital humanities can be described in terms of its basic elements: statistical processing, structured data, metadata, and information structures. Migrating traditional texts into electronic form allows certain things to be done with them that are difficult, if not impossible, with print texts. Automating the act of string searching allows the creation of concordances and other statistical information about a text, which in turn supports stylometrics. The capacity to search large quantities of text also facilitates discourse analysis, particularly the sort based on reading a word, term, or name in all its many contexts across a corpus of texts.

Many of the questions that can be asked using these methods are well served by automation. Finding every instance of a word or name in a

large body of work is tedious and repetitive; without computers, the basic grunt work—like that performed by Father Busa—takes so long that analysis may be deferred for years. Automating narrowly defined tasks creates enormous amounts of statistical data quickly. The data then suggest other approaches to the study at hand. The use of pronouns versus proper names, the use of first person plural versus singular, the reduction or expansion of vocabulary, the use of Latinate versus Germanic forms—these are basic elements of linguistic analysis in textual studies that give rise to interesting speculation and scholarly projects.[19] Seeing patterns across data is a powerful effect of aggregation. Such basic automated searching and analysis can be performed on any text that has been put into electronic form.

In the last decade the processes for statistical analysis have grown dramatically more sophisticated. String searches on ASCII (keyboarded) text have been superceded by folksonomies and tag clouds generated automatically by tracking patterns of use. Search engines and analytic tools no longer rely exclusively on the tedious work of human agents as part of the computational procedure. And data mining allows context-dependent and context-independent variables to be put into play in ways that would have required elaborate coding in an earlier era of digital work.[20] The value of any computational analysis hangs, however, on deciding what can be expressed in terms of quantitative or otherwise standard parameters. The terms of the metric according to which any search or analytic process is carried out are framed with particular assumptions about the nature of data. What is considered data—that is, what is available for analysis—is as substantive a consideration as what is revealed by its analysis. I am not making a simple distinction between what is discrete and can be measured easily (such as counting the number of *e*'s in a document) and what cannot (quantifying the white space that surrounds them). Far more important is the difference between what we think can be measured and what is *outside that conception* entirely (e.g., the history of the design of any particular *e* as expressed or repressed in its form). The critique that poststructuralism posed to structuralist formalisms exposed assumptions based in cultural value systems but expressed as epistemological categories. The very notion of a standard metric is ideological. (The history of any *e* is a complicated story indeed.) The distinction between what can be parameterized and what cannot is not the same as the difference between analog and digital systems, but that between complex, culturally situated approaches to knowledge and totalized, systematic ones.[21]

Metalanguages and Metatexts

The automated processing of textual information is fundamental to digital humanities, but so is the creation and use of metatexts, which describe and enhance information but also serve as performative instruments. As readers and writers we are habituated to language and, to some extent, to the "idea of the text" or "textuality." Insights into the new functions of digital metatexts build on arguments that have been in play for twenty years or more in bibliographic, textual, and critical studies.[22] Metalanguages have a fascinating power, carrying a suggestion of higher-order capabilities.[23] As texts that describes a language, naming and articulating its structures, forms, and functions, they seem to trump languages that are used merely for composition or expression. A metatext is a subset of metalanguage, one that is applied to a specific task, domain, or situation. Digital metatexts are not merely commentaries on a set of texts. In many cases they contain protocols that enable dynamic procedures of analysis, search, and selection, as well as display. Even more importantly, metatexts express models of the field of knowledge in which they operate. The structure and grouping of elements (what elements are included in the metadata for a title, publication information, or physical description of an artifact?) and the terms a metadata scheme contains (are graphical forms reproduced, and if so in what media and format, or just described?) have a powerful effect. Indeed, metadata schemes must be read as models of knowledge, as discursive instruments that bring the object of their inquiry into being, shaping the fields in which they operate by defining quite explicitly what can and cannot be said about the objects in a particular collection or online environment. Analysis of metadata and content models, then, is an essential part of the critical apparatus of digital humanities.

One tenet of faith in the field of digital humanities is that engaging with the constraints of electronic texts provides insight into traditional text formats.[24] Making explicit much that might elsewhere be left implicit is a necessity in a digital environment: computers, as we are often reminded, cannot tolerate the ambiguity typical of humanities texts and interpretative methods. Because digital metatexts are designed to *do* something to texts (divide elements by content, type, or behavior) or to do something as metatexts (in databases, markup languages, metadata) they are performative.

The term *structured data* applies to any information on which a formalized language of analysis has been imposed. In textual work in digital

humanities, the most common mechanism for structuring data is known as markup language. "Markup" simply refers to the act of putting tags into a stream of alphanumeric characters. The most familiar markup language is HTML (HyperText Markup Language), which consists of a set of tags for instructing browsers how to display information. HTML tags identify format features—a <header> is labeled and displayed differently than a
 (break) between paragraphs or text sections. While this may seem simplistic, and obvious, the implications for interpretation are complex. HMTL tags are content-neutral. They describe formal features, not types of information:

<italic>This, says the HTML tag, should be rendered in italics.</italic>

But the italics used for a title and those used for emphasis are not the same. Likewise a "header" is not the same as a "title"—they belong to different classification schemes, one graphical and the other bibliographical. While graphic features—bold type, italics, fonts varying in scale and size—have semantic value, their semiotic code is vague and insubstantial.

XML (Extensible Markup Language), in contrast, uses tags that describe and model *content*. Instead of identifying "headers," "paragraphs," and other physical or graphical elements, XML tags identify titles, subtitles, author's names or pseudonyms, places of publication, dates of editions, and so on:

<conversation>
 <directquote>"Really, is that what XML does?"</directquote> she
 asked. <directquote>"Yes,"</directquote> he replied, graciously, trying
 to catch her gaze.
</conversation>

All this seems straightforward enough until we pause to consider that perhaps this exchange should take a <flirtation> tag, given the phrases the follow:

[or perhaps <flirtation> starts here?]
<conversation>
 <directquote>"Really, is that what XML does?"</directquote> she
 asked. <directquote>"Yes,"</directquote> he replied, graciously, [or
 should <flirtation> start here?] trying to catch her gaze.

</conversation>
<flirtation> [or start here?]
His glance showed how much he appreciated the intellectual interest—
and the way it was expressed by her large blue eyes, which she suddenly
dropped, blushing. <directquote>"Can you show me?"</directquote>
</flirtation>

Can we say with certainty where <flirtation> begins and ends? Before
or after the first exchange? Or in the middle of it? The importance of
defining tag sets and of placing individual tags becomes obvious very
quickly. XML tags may describe formal features of works such as stanzas,
footnotes, cross-outs, or other changes in a text. XML tags are based on
domain- and discipline-specific conventions. The tags used in marking
up legal or medical documents are very different from those appropriate
to the study of literature, history, or biography. Even when tags are stan-
dardized in a field or within a research group, making decisions about
which tags to use in a given situation involves a judgment call and relies
on considerable extratextual knowledge. In the example above, the con-
cept of <flirtation> is far more elastic than that of <conversation>.

XML documents are always structured as nested hierarchies, or tree
structures, with parent and child nodes and all that such rigid organiza-
tion implies. The implications of this rigidity brought the tensions be-
tween mathesis and aesthesis to the fore in what serves as an exemplary
case. The hierarchical structure of XML was reflected in a discussion of
what was called the OHCO thesis. OHCO stands for "ordered hierar-
chy of content objects." The requirements of XML were such that only
a single hierarchy could be imposed on (actually inserted into) a docu-
ment. This meant that scholars migrating materials into electronic form
frequently faced the problem of choosing between categories or types of
information to be tagged. One recurring conflict was between marking
the graphic features and the bibliographic features of an original docu-
ment. Did one chunk a text into chapters or into pages? One could not
do both, since one chapter might end and another begin on the same
page, in which case the two systems would conflict with each other. Such
decisions might seem trivial, hairsplitting, but not if attention to mate-
rial features of a text is considered important.

Returning to the example above, imagine trying to sort out, not only
where <flirtation> begins and ends, but how it overlaps with other sys-
tems of content (<technical advice>, <XML queries>, <social behavior>).
The formal constraints of XML simply do not match the linguistic com-

plexity of aesthetic artifacts.[25] Even saying that texts *could be considered* ordered hierarchies for the sake of markup, rather than saying that they *are* structured in modular chunks, registers a distinction that qualifies the claims of the formal system. But despite these philosophical quarrels and challenges, the process of tagging goes on and is widely accepted as necessary for pragmatic work.[26]

Because XML schemes can be extremely elaborate, a need for standardization within professional communities quickly became apparent. Even the relatively simply task of standardizing nomenclature—such that a "short title" is always <short title>, not <ShortTitle> or <ShtTtl>—requires that tags be agreed upon. Creating significant digital collections would require consensus and regulation, so an organization called the Text Encoding Initiative was established. TEI, as Matt Kirschenbaum once wittily remarked, is a shadow world government. He was right of course. An organization setting standards for knowledge representation, especially standards that are essentially invisible to the average reader, is indeed a powerful entity. Protocols and practices that require conformity are the subtle, often insidious, means by which computational culture infiltrates humanist communities and assumes an authority over its operations. One can shrug off a monopoly hold on nomenclature as a smoothing of the way, akin to standard-gauge rails, or suggest that perhaps transportation and interpretation involve similar power struggles. But standards are powerful ideological instruments.

Discussion of tags is a bit of a red herring, as they may disappear into historical obsolescence, replaced by sophisticated search engines and other analytic tools. But the problem raised by XML tags, or any other system of classifying and categorizing information, will remain: they exercise rhetorical and ideological force. If <flirtation> is not a tag or recognized category then it cannot be searched. Think of the implications for concepts like <terror> or <democracy>. A set of tags for structuring data is a powerful interpretative grid imposed on innately complex and ambiguous human expression. Extend the above example to texts analyzed for policy analysis in a political crisis and the costs of conformity rise. Orwell's dark imaginings are readily realized in such a system of explicit exclusions and controls.

Paranoia aside, the advantages of structured data are enormous. Their character and content make digital archives and repositories different in scale and character from static websites and will enable next-generation design features to aggregate and absorb patterns of use into flexible systems. Websites built in HTML hold and display information in one fixed form, like objects in a display case or shop window. You can read it in

whatever order you like, but you can't repurpose the data, aggregate it, or process it. A website might contain, for instance, a collection of book covers, hundreds of images that you can access through an index. If it has an underlying database, you might be able to search for information across various fields. But an archive, like Holly Shulman's Dolley Madison letters, contains fully searchable text.[27] That archive contains thousands of letters, and theASCII text transcription of each is tagged, marked up, structured. Information about Madison's social and political life can be gleaned in a way that would be impossible in a simple website.

Through the combined force of its descriptive and performative powers, a digital metatext embodies and reinforces assumptions about the nature of knowledge in a particular field. But the metatext is only as good as the model of knowledge it encodes. It is built on a critical analysis of a field and expresses that understanding in its organization and the functions it can perform. The intellectual challenge comes from thinking through the ways the critical understanding of a field should be shaped or what should comprise the basic elements of a graphical system to represent temporality in humanities documents. The technical task of translating this analysis into a digital metatext is trivial by contrast to the compelling exercise of creating the intellectual model.

Models and Design

Structured data and metatexts are expressions of a higher-order model in any digital project. That model is the intellectual concept according to which all the elements of a project are shaped, whether consciously or not. One may have a model of what a book is or how the solar system is shaped without having to think reflectively about it, but in creating models for information structures, the opportunity for thinking self-consciously abut the importance of design is brought to the fore.

A model creates a generalized schematic structure, while a representation is a stand-in or surrogate for some particular thing. A portrait, a nameplate, a handprint, and a driver's license are all representations of a person. None are models. All are based on models of what we assume a portrait, a name, an indexical trace, or an official document to be. The generalized category of "official document" can itself be modeled so that it contains various parameters and defining elements. A model is independent of its instances. A representation may be independent of its referent, to use the semiotic vocabulary, but it is specific and not generalizable. A model is often conceived as a static form, but it is also dynamic, functioning as a program to call forth a set of actions or activi-

ties. The design of the e-book, to which we will return in a later chapter, provides a case study in the ways a model of what a common object *is* can be guided by unexamined principles and thus produce nonfunctional results.

A textual expression may encode all kinds of assumptions yet not explicitly schematize a model. Text modeling, however, creates a general scheme for describing the elements of a text (form, format, content, and other categories each of these, as will become clear below, ask us to think about a text differently), but it is also a means of actively engaging, producing an interpretation. Modeling and interpretation can be perilously iterative—and the creation of metadata can involve innumerable cycles of rework. Even when metadata remains unchanged, its application is neither consistent nor stable. Just as every reading produces a new textual artifact, so any application of metadata or text models enacts a new encounter.

Many information structures have graphical analogies and can be understood as diagrams that organize the relations of elements within the whole. But the models of these structures are often invisible. An alphabetical ordering is a model. So is a tree structure, with its vocabulary of parent-child relationships and distinct assumptions about hierarchy. Matrices, lattices, one-to-many and one-to-one relationships, the ability to "cross walk" information from one structure to another, to disseminate it with various functionalities for use by broadly varied communities, or to restrict its forms so that it forces a community to think differently—these are all potent features of information architecture.

All of this work, whether it is the design of a string search, the graphical presentation of a statistical pattern, the creation of a set of metadata fields or tags, or the hierarchical or flat architecture of a data structure, is modeling. It is all an expression of form that embodies a generalized idea of the knowledge it is presenting. The model is abstract, schematic, ideological, and historical through and through, as well as discipline-bound and highly specific in its form and constraints. Different types of models have their origins in specific fields and cultural locations. All carry those origins with them as an encoded set of relations that structure the knowledge in the model. Model and knowledge representation are not the same, but the morphology of the model is semantic, not just syntactic. On the surface, a model seems static. In reality it is, like any "form," a provocation for a reading, an intervention, an interpretive act. These statements are the core tenets of SpecLab's work.

The ideological implications of diagrammatic forms have been neu-

tralized by their origins in empirical sciences and statistics where the convenience of grids and tables supercedes any critique of the rhetoric of their organization. The arrangement of arrival and departure times in a railway schedule, as closely set columns of numbers, emphasizes their similarity over their difference. But is the predawn departure from a cold, deserted station really commensurate with the bustle that attends a train leaving from the same platform on a holiday afternoon? What, in such an example, constitutes the data? Formal organizations ignore these differences within the neutrality of their rational order.

The cultural authority of computing is in part enabled by that neutrality. Likewise, the graphical forms through which information is displayed online are shot through with ideological implications. The grids and frames, menu bars and metaphors of desktops and windows, not to mention the speed of clicking and rules that govern display, are all ripe for a new rhetoric of screen analysis. The graphic form of information, especially in digital environments, often *is* the information: design is functionality. Information architecture and information design are not isomorphic. Therein lies another whole domain of inquiry into the rhetorical force of digital media.

When design structures eliminate any trace or possibility of individual inflection or subjective judgment, they conform to a model of mathesis that assumes objective, totalizing, mechanistic, instrumental capability readily absorbed into administering culture. Why is this a problem? Because of the way generalizations erase difference and specificity and operate on assumptions that instrumentalize norms without regard for the situated conditions of use. Collective errors of judgment constitute the history of human cultures, and when the scale at which these can be institutionalized is expanded by electronic communications and computational processing, what is at stake seems highly significant. The chilling integration of IBM technology into the bureaucratic administration of the extermination machines of the Third Reich provides an extreme example of the horrific ends to which managed regimes of information processing can be put. That single instance should be sufficient caution against systematic totalization. On a smaller scale, the darkly comic narrative of the film *Brazil* turns on a bureaucratic typo: the confusion of the names Tuttle and Buttle has dire consequences for the bearers of those names—a scenario too frequently replayed in the real-world (mis)management of medical, insurance, and credit records. One needn't have exaggerated fears of a police state to grasp the problematic nature of totalizing (but error-ridden) systems of bureaucracy—or of subscrib-

ing to the models on which they base their authority. The ethics and teleology of subjective inflection, and its premise of partial, fragmentary, nontotalizing approaches to knowledge, cannot, by contrast, be absorbed into totalizing systems. On that point of difference hangs what is at stake in our undertaking. Finding ways to express this in information structures and then authoring environments is the challenge that led us to speculative computing.

1.2 Speculative Computing: Basic Principles and Essential Distinctions

With speculative computing, we moved beyond the instrumental, well-formed, and increasingly standardized business of digital humanities. We used the computer to create aesthetic provocations—visual, verbal, textual results that were surprising and unpredictable. Most importantly, we inscribed subjectivity, the basis of any and every interpretative and expressive representation, into digital environments by designing projects that showed inflection, the marked specificity of individual voice and expression, and point of view as a place within a system. We wanted to show interpretation, to expose its workings. We wanted to force questions of textuality and graphicality to the fore. To do this, we (a small core of SpecLab participants) created a series of experimental projects that ranged in their degree of development from proof-of-concept to working platforms for use. But we also created a theoretical and methodological framework.

Our readings and conversations led us to develop a specialized vocabulary that borrowed from disciplines concerned with bringing issues of interpretation into a new intellectual framework. Most important among these for my development were radical constructivism,

as articulated in the work of Ernst von Glasersfeld, and the work of second-generation systems theorist Heinz von Foerster. A reformulation of knowledge as experience, based on these two sources and the work of biologists/cognitive scientists Francesco Varela and Umberto Maturana, allowed us to shed the old binarism in which subjectivity is conceived in opposition to objectivity.[1] In this reformulation, knowledge is always interpretation, and thus located in a perceiving entity whose position, attitudes, and awareness are all constituted in a codependent relation with its environment. The system is always in flux, and thus has the complex heterogeneous character of a cultural field shot through with forces that are always ideological and historical. Because we are all always simultaneously subjects of history and in history, our cognitive processes are shaped by the continuous encounter with the phenomenal and virtual world such that we constitute that world across a series of shifting models and experiences. These are familiar concepts within cognitive studies and constructivist theories of knowledge, as well as within critical theory (though implementing these ideas within knowledge production environments poses new challenges). Alan MacEachren's synthesis of an information-processing model of visual perception (which sounds far more mechanistic than it is) incorporates the constructivist approach touched on above, provided another methodological touchstones.[2] Integrating these precepts into the design, or at the very least, the conception of the design of digital environments meant to expose models of interpretation, was a challenge that may still have eluded our technical grasp, but it motivated the projects at SpecLab from the beginning.

In addition to the basic concept of codependent emergence and constructivist approaches to knowledge we incorporated the ideas of probability from quantum theory and various tenets of the turn-of-the-twentieth-century poet Alfred Jarry's 'pataphysics. Our sources for creating a probablistic rather than a mechanistic concept of text came from the work of Heisenberg and Schrödinger, largely through McGann's influence.[3] Adopting their theories of probability and potentiality, we shifted from mechanistic models of text to quantum ones. A text became defined as a field of potentialities, within which a reading intervened. We conceptualized a text, thus, not as a discrete and static entity, but a coded provocation for reading; constrained by those codes, a text is formed anew with each act of interpretative intervention. Here again the echoes of deconstruction are perceptible, but shifted into problems of modeling and representing such activities within an electronic space. The *n*-dimensionality of texts, to use McGann's term, engages their so-

cial production and the associational matrix through which meaning is produced in a heteroglossic network, combining the dialogic method of Mikhail Bakhtin with influence from the thick readings of a generation of French textual theorists.[4] But speculative computing is neither a rehash of poststructuralist theory nor an advanced version of either dialogic or dialectical approaches. Speculative computing is grounded in a serious critique of the mechanistic, entity-driven approach to knowledge that is based on a distinction between subject and object. By contrast, speculative computing proposes a generative, not merely critical, attitude.

My approach to graphical knowledge production came from the semiotic studies of Jacques Bertin, the history of visual languages of form, work by MacEachren, and an extensive and systematic reading of materials in information visualization, psychology and physiology of vision, and cultural history of visual epistemology.[5] This last is an enormously underdeveloped field, one that calls for serious study, now in particular, when visualization is becoming so ubiquitous within digital environments. Finally, our reading of Charles Peirce provided a method of interpretation based in abduction as well as a tripartite theory of signification (a sign stands for something to someone and does not operate merely in the formal signifier/signified structure outlined by Ferdinand de Saussure).[6] This theoretical foundation provided a platform on which to elaborate a theory of enunciation and subjectivity.

Within our definition of the concept of subjectivity, we considered both structural and inflected modes. McGann's reference for the structural approach is Dante Gabriel Rossetti's idea of "the inner standing point." This idea posits subjectivity in a structural way, as the inscription of point of view within the field of interpretation. This maps readily onto linguistic theories of enunciation and the contrast of speaking and spoken subjects within a discursive field.[7] The second aspect of subjectivity is that of inflection, the marked presence of affect and specificity, registered as the trace of difference, that inheres in material expressions. I once referred to this as the "aesthetic massage coefficient of form." Though this was a deliberately wry and overwrought phrase, its compact density contains a real description of the relation between differential traces and material expressions—that is, "forms." Bringing in aesthetics links the concept to perception, or the idea of knowledge as experience. All of these concepts became working keywords for us, shorthand used in our elaborate conversations: subjectivity, the inner standing point, inflection, graphical knowledge production, aesthetics, and experiential rather than totalized approaches. I've referred to this attitude as "post-

Cartesian" to indicate the leap from subject/object distinctions and the mind/body split to a conceptualization that escapes such binarisms. In a post-Cartesian frame, subjectivity is not opposed to objectivity but instead describes the codependent condition of situated knowledge production informed by poststructuralist and deconstructive criticism, second-generation systems theory, probabilistic approaches, and radical constructivism.

So while speculative computing builds on certain competencies developed in digital humanities, its theoretical polemic overturns the latter's premises in many respects. The humanistic impulse has been strong in its dialogue with "informatics" and "computing" but has largely conformed to the agenda-setting requirements set by computational environments. Our goal at SpecLab, by contrast, has been to push against the logical constraints imposed by digital media. This is not to deny that such constraints have provided many advantages. Scratch a digital humanist and they'll tell you everything they've learned by being subjected to the intellectual discipline of a field grounded in formal logic (even if, as in the markup debates described above, they disavow the implications). SpecLab projects, though, sought deliberately to challenge the authority of such formality. For anyone familiar with digital humanities, this reads as a radical move. To understand how radical, the contrast has to be sketched explicitly.

As I stated earlier, at the crux of work in digital humanities was a willingness to engage with the task of disambiguation required to process information in digital form.[8] The job of explaining what we do to a "machine" (the quaint colloquial term by which computational and digital technologies are identified in common parlance), in step-by-step procedures, leaves no room for judgment calls or ambiguity of any kind. An intense self-reflexivity results. Even the most apparently simple task—naming or classifying—is immediately revealed as a complex interpretive act. Basic categories of textual activity—the title of a work, name of an author, place or time of publication—suddenly reveal their uncategorizable nuances. Some of these complications are technical (terms in translation versus transliteration, problems of orthography or nomenclature). But some are conceptual: what constitutes the "work" in a piece that exists in many versions, in forms ranging from notes, scrawls, and mentions in correspondence to manuscripts, corrected proofs, and publications?

The accomplishments of digital humanities have been notable: establishing technical protocols that allow texts to be processed in a mean-

ingful way and using various tools of quantitative analysis, pattern recognition, or stylometrics for analysis. The benefits of aggregation and large-scale data processing are immediately apparent to those involved. Scholars can now present original materials in facsimile form online, create linked and hyperlinked text bases and reference materials, and aggregate much that was peripheral or geographically distributed within a single working environment. Translation, searching, collation, and other methods of text manipulation have been automated with different degrees of success or useful failure.

The extent to which the method of digital humanities embodies assumptions about, and thus constrains, the objects of its inquiry is apparent, however, when we look at the terms that delimit its principles: calculation, computation, processing, classification, and electronic communication. Each deserves a momentary gloss to establish the distinctions between digital humanities and speculative computing.

Calculation, based on numerical information and the ability to perform certain functions that can be readily automated through mechanical and digital means, is limited by its inability to represent any content other than quantitative values. Charles Babbage's nineteenth-century devices and more recent office machines are not computers, only automated calculators.[9]

Computation links automated processing to the symbolic realm. Computation makes use of signs whose values can represent *any* information, although their ability to be manipulated through a fixed set of protocols is still determined by a succinct formal logic. The addition of an extra level of articulation in coding symbolic values onto binary entities that could be processed electronically made the leap from automated calculation to computation possible. This leap disconnects semantic values (what symbols mean) from their ability to be processed (as elements in a formal system). Information, as Claude Shannon famously demonstrated, is content-neutral.[10]

Digital processing enacts that logic through step-by-step algorithmic procedures, many specified by programming languages and their different functionalities and syntax. Alan Turing's design for a universal computer transformed this basic capability into an inexhaustible computational engine.[11]

Classification systems build a higher-order linguistic signifying structure on that formal base. The use of digital surrogates (themselves digital artifacts inscribed in code) reinforces the disposition to imagine that all code-based objects are self-evident, explicit, and unambiguous. Schemes

for nomenclature and organization come out of library sciences and information management, as well as long traditions of typologies developed in the encyclopedic and lexicographic traditions across the sciences and humanities.[12]

Electronic communication assumes that information functions in a transmission mode—encoded, stored, and then output. The fungibility of information and the function of noise are certainly taken into account in theoretical discussions, even when these are transmission-based and highly technical approaches to electronic communication, such as those of Shannon and his collaborator, Warren Weaver.[13] Bit by byte, the digital approach reinforces a mechanistic understanding of communication and representation. Knowledge in this context becomes synonymous with information, and information takes on the character of that which can be parameterized through an unambiguous rule set.

This basic terminology is premised on the cultural authority of code and an engineering sensibility grounded in problem solving. But the code base of computational activity is full of ideological agendas, which go unquestioned because of the functional benefits that flow from its use. The formal logic required becomes naturalized—not only as a part of the technical infrastructure but as a crucial feature of the intellectual superstructures built to function on it. I've reiterated this several times because this is the crux of our motivation to differentiate SpecLab intellectually from digital humanities.

Now, of course, many digital humanists have raised such questions. Considerable self-reflexive thought about objects of study has pulled theoretical philosophers of all stripes back into discussions of digital projects.[14] Calling assumptions into question is the name of the digital epistemological game as much as it is the standard of conference papers and publications elsewhere in the humanities. Likewise, the study of artifacts in a digital environment is just as apt as conventional scholarly research to prompt discussions of race/class/gender in hegemonic practices, critiques of imperialism and cultural authority, power relations and disciplinary measures. In this regard, SpecLab is part of a larger critical phenomenon, even if its approaches are deliberately pitted against certain aspects of the base on which it builds.[15] Our focus, however, is not on the artifacts themselves, but on the design of the environments and the way ideological assumptions built into their structure and infrastructure perpetuate unexamined concepts.

Speculative computing distinguishes itself from digital humanities on the basis of its sources of inspiration and intellectual traditions. If,

as I have said before, digital humanities is grounded in an epistemological self-consciousness through its encounter with disambiguation, speculative computing is driven by a commitment to interpretation-as-deformance in a tradition that has its roots in parody, play, and critical methods such as those of the Situationist International, Oulipo, and the longer tradition of 'pataphysics with its emphasis on "the particular" over "the general."[16] Speculative computing torques the logical assumptions governing digital technology. It pushes back in the dialogue between the modes of interpretation native to the humanities and code-based formalism. Obviously, any activity functioning in a digital environment continues to conform to the formal logic of computational instruments on the processing level. But the questions asked are fundamentally different within the theoretical construct of speculative computing, as summarized in table 1.2.1. The digital humanities community has been concerned with the creation of *digital tools* in humanities contexts. The emphasis in speculative computing is instead the production of *humanities tools* in digital contexts. We are far less concerned with making devices to do things—sort, organize, list, order, number, compare—than with creating ways to expose any form of expression

Table 1.2.1. Attributes of digital humanities versus speculative computing.

Digital humanities	Speculative computing
Information technology/ formal logic	'Pataphysics/the science of exceptions
Quantitative methods (Problem-solving approaches) (practical solutions)	Quantum interventions (Imagining what you do not know) (imaginary/imaginative solutions)
Self-identical objects/entities (Subject/object dichotomy)	Autopoiesis/constitutive or configured identity (Codependent emergence)
Induction/deduction	Abduction
Discrete representations (Static artifacts)	Heteroglossic processes (Intersubjective exchange/ discourse fields)
Analysis/observation (Mechanistic)	Subjective deformance/intervention (Probabilistic)

(book, work, text, image, scholarly debate, bibliographical research, description, or paraphrase) as an act of interpretation (and any interpretive act as a subjective deformance).

Here, then, is a brief elaboration of the binary pairs in table 1.2.1:

Information versus 'Pataphysics. The use of information technology in digital humanities has supported development of tools for corpus linguistics: counting, measuring, and thinking differently about the instances and contexts of word use. Other tools allow for searching, storing, retrieving, classifying, and then visualizing data. All of these procedures are based on assumptions of the self-identity of the object, rather than its codependence on those processes. Computational processes constitute their objects of inquiry just as surely as historical, scientific, or other critical methods. Informatics is based on standard, repeatable mathematical and logical procedures. Quantitative methods normalize their data in advance, assuming a system that conforms to standardizable rules. Information conforms to statistical methods.

By contrast, 'pataphysics derives from the study of exceptions and anomalies in all their specificity—the outliers often excluded by statistical procedures. Only a punning method suffices, thus the invention of our term *'patacritical.* If norms, means, and averages govern statistics, then sleights, swerves, and deviation have their way in the 'pataphysical game. Adopting a 'patacritical method is not an excuse for the abandonment of intellectual discipline. Rather, it calls for attention to individual cases without assumptions about the generalizations to be drawn. In short, it takes exceptions as rules that constitute a de facto system, even if repeatability and reliability cannot be expected. Deviation from all norms and constant change dictate that the exception will always require more rules.[17] Such an approach privileges bugs and glitches over functionality. Not necessarily useful in all circumstances, exceptions are valuable to speculation in a substantive, not trivial, sense.

Quantitative method versus quantum intervention. The idea of interpretation as a quantum intervention is based on the insistence that any act of reading, looking, or viewing is by definition a production of a text/image/work. For this to be the case, the work under investigation can't be conceived as static, self-identical, or reliably available to quantitative methods. Instead, speculative methodology is grounded in a quantum concept of a work as a field of potentiality (*poetentiality* might be a better term). The act of reading/viewing is an intervention in the field, a determin-

ing act that precipitates a work. The spirit of indeterminacy goes against the engineering sensibility. Problem-solving methods do not apply in a quantum field. Practical solutions have no bearing on the exposure of interpretation as intervention. Humanistic research takes the approach that a thesis is an instrument for exposing what one doesn't know. The 'patacritical concept of imaginary solutions isn't an act of make-believe but an epistemological move, much closer to the making-strange of the early-twentieth-century avant-garde. It forces a reconceptualization of premises and parameters, not a reassessment of means and outcomes.

Self-identicality versus codependent emergence. Another tenet of the speculative approach, common sense once it is familiar but oddly disorienting at first glance, is that no object (text, image, datum, quantity, or entity) is considered self-identical: A = A if and only if A ≠ A. McGann cites philosopher George Spencer-Brown's *Laws of Form* as the source for this formulation within the field of logic.[18] The poststructuralist critical tradition is premised on the analysis of contingency. Every text is made as an act of reading and interpretation.[19] When this is combined with recent theories of cognitive studies and radical constructivist psychology, it returns the interpretative act to an embodied, situated condition and the object of inquiry becomes a constituted object, not an a priori thing.

Maturana and Varela's theory of autopoiesis, or codependent emergence between entity and system, also changes mechanistic concepts of subject and object relations into dynamic, systems-based reconceptualization.[20] In an autopoietic description, subject and object are not discrete but interrelated and codependent, and an entity's identity (whether it is an organism or an object of intellectual inquiry) emerges in a codependent relation with its conditions, not independent of them. The conventional distinctions of subject and object are not blurred; rather, the ground on which they can be sustained disappears because there is no figure/ground, subject/object dichotomy, only a constituting system of codependent relations. The subject/object dichotomy that structures text/reader relations was as mechanistic as Newtonian physics. To reiterate the quantum method cited above, and integrate it here, the intervention determines the text. The act of reading calls a text (specific, situated, unique) into being.

Induction versus Abduction. Under such circumstances, scientific techniques of induction and deduction don't work. They are structured and structural, assuming self-identicality in themselves and for their objects, and

inscribe relations of causality and hierarchy. By contrast, methods of comparative abduction, taken from Charles Peirce, do not presume that a logical system of causal relations exists outside the phenomenon and supplies an explanation for their relations. Configured relations simply (though this is far from simple) produce semantic and syntactically structured effect independent of grammatical systems. The contingently configured condition of form—a hefty phrase indeed—points to the need to think about forms as relations, rather than entities. This requires rewiring for the Anglo-analytic brain, accustomed as it is to getting hold of the essence and substance of intellectual matter. Even the mechanisms of the dialectic tend to elude the empiricist sensibility, despite its device-driven process and hierarchy of thesis, antithesis, and higher-order synthesis. Abduction adheres to no single set of analytic procedures. Every circumstance produces its own logic—as description rather than explanation.

Discrete versus heteroglossic. Traditional humanistic work assumes its object. A book, poem, text, image, or artifact, no matter how embedded in social production or psychoanalytic tangles, is usually assumed to have a discrete, bounded identity. Our emphasis was instead on the codependent nature of that identity. In this conception, a book is a sort of snapshot, an instantiation, a slice through the production and reception histories of the text-as-work. The fiction of the "discrete" object is exposed as a function of its relation to what we call the discourse field. This comprises the object's composition and distribution, including its many iterations and versions, as well as its multidimensional history of readings and responses, emendations and corrections, changes and incidental damages. A discourse field is indeterminate, neither random, chaotic, nor fixed, but probabilistic. It is also social, historical, rooted in real and traceable material artifacts.

The concept of the discourse field draws directly on Mikhail Bakhtin's heteroglossia and the dialogic notion of a text. Heteroglossia tracks language into a semantic field and an infinite matrix of associations. It brings about shifts and links across historical and cultural domains. Behind every word is another word, from every text springs another, and each text/word is reinvigorated and altered in every instance of production (including every reading, citation, and use). These associations are constantly remade, not quantifiable and static in their appearance, meaning, or value.

The dialogic approach underpins a theory of media (including texts

and artifacts) as nodes and sites of intersubjective exchange (rather than as things-in-themselves). A film, poem, or photograph or other human expression is a work spoken by someone to and for others, from a situated and specific position of subjectivity. Its very existence as a work depends on its provoking a response from a viewer or a reading from their own conditions and circumstances. The work is not an inert or fixed text or image, no matter how stable it appears in print or on a screen. It is not an information delivering system but a medium of exchange in social space, the instrument for creation of value through interpretative activity.[21]

Analysis versus deformance. Finally, speculative computing draws on critical and theoretical traditions to describe every act of interpretation as *deformative*. It is not merely performative, bringing to life, or replaying, an inert text, but also generative and productive. Like Situationist *détournement*, intepretation is charged with social and political mobility, but also aesthetic mutation and transformation.

The theoretical agenda of speculative computing may seem to be thick with unsupported claims, but it supplies a brief for project development. Our thinking developed with the projects, not in advance, and the relation between theoretical work and practical design was and remains generative and fluid, necessarily so. Speculative computing takes seriously the destablization of all categories of entity, identity, object, subject, interactivity, process, or instrument. In short, it rejects mechanistic, instrumental, and formally logical approaches, replacing them with concepts of autopoiesis (contingent interdependency), quantum poetics and emergent systems, heteroglossia, indeterminacy and potentiality, intersubjectivity, and deformance. Digital humanities is focused on texts, images, meanings, and means. Speculative computing engages with interpretation and aesthetic provocation. Like all computational activity, it is generative (involved with calls, instructions, encoding), iterative (emergent, complex, nonlinear, and noncausal), intra- and intersubjective (dealing with reference frames and issues of granularity and chunking), and recursive (repeating but never identical deformances).

Speculative computing struggles for a critical approach that does not presume its object in advance. It lets go of the positivist underpinnings of the Anglo-analytic mode of epistemological inquiry. It posits subjectivity and the inner standing point as the site of intepretation. It replaces the mechanistic modes of Saussurean semiotics, with their systems-based structures for value production, with Peircean semiotics, which

includes a third term (a sign represents something to someone for some purpose). It attends to the moment of intervention as deterministic of a phenomenon within a field of potentiality. It attempts to open the field of discourse to its infinite and peculiar richness as deformative interpretation. How different is it from digital humanities? As different as night from day, text from work, and the force of controlling reason from the pleasures of *delightenment*.

Projects at SpecLab

Projects form the core of SpecLab. Putting theory into practice by building things has forced our ideas to become concrete. The route from idea to product is neither passive nor direct; the idea of a game becomes very different when one gets into the nuts and bolts, the step-by-step distillation of its moves and rules. This attitude connects SpecLab to other digital humanities projects, but also to the design or art studio and even the traditional print shop. Making things, as a thinking practice, is not only formative but transformative. Our SpecLab projects brought design to the forefront of our intellectual activity and intensified my understanding of what it means to think about the design of intellectual projects and expressions in a humanities context.

In the design of our SpecLab projects, iterative conceptualization, visualization, production, and rework are the means by which intellectual work takes shape (literally and metaphorically). Thus my focus here will be on the way argument is presented through design, by creating an infrastructure through which the content of individual examples comes to have functional value. As we learned to design the conceptual primitives,

the screen and interactive spaces, and the relations of content models to functionalities, I came to understand their integral connection and interpretative force as elements of a text or a data set. Design in this larger sense forms the substantive core of these projects and thus of the lessons learned at SpecLab.

The full theoretical shape of SpecLab was not clear at the outset. As in any substantive research investigation, its dimensions could not have been known in advance. The issues that came under discussion with each project were informed by our reading and theoretical inclinations. But the work also pushed on these theoretical ideas until our ideas consolidated in a specialized vocabulary of concepts and principles. Only as the projects followed on each other did their common features come into real focus: the design of environments for knowledge production that supported the principles of subjectivity, codependence, and emergence and put interpretation in the foreground.

Another aspect of our learning experience came from the necessities of figuring out how to work in groups and through relationships other than the traditional student-teacher or supervisor-employee structures. Institutional and administrative restraints are also factors in any complicated, long-term humanities research. Consultants, collaborative work spaces—such logistical matters are outside the habits of humanistic scholarship. Rather than detail such challenges, however, I will focus on the intellectual and aesthetic aspects of the projects. We actually built Temporal Modeling and Ivanhoe, so they have the most substantial documentation and histories. For Subjective Meteorology, I made drawings, animations, and a complete study. This is an imaginative art project carried out to demonstrate an idea, not functioning software, though it could and may be built. Artists' Books Online (AbsOnline) is ongoing. Its innovations have to do with using structured metadata to try to shape critical discourse in a field that has almost none. In that sense, for all its apparent modesty, it is a radical attempt to transform scholarship and critical practice within a community by using networked capabilities. I present it as a study of the ways metadata models critical thinking. As for the 'Patacritical Demon, speculating on its design remains important, if only because its elusive nature shows that our horizon of conception continues to expand.

: : :

Temporal Modeling was the first SpecLab project. In fact, it came into being in advance of SpecLab's founding and helped establish the viabil-

ity of an approach to the design of digital projects that emphasized subjectivity and interpretation.

In 1999 or early 2000, John David Miller of Intel (or JDM, as he prefers to be known) came to the University of Virginia to demonstrate a project named Grand Canyon, which he had developed at MIT with designer John Maeda. This was a beta version of timeline software intended to make it easy to organize and display (mainly graphic) information on screen. JDM's primary role at Intel was to scout interesting activities in universities and to help fund experimental projects at early stages. I responded to JDM's demo and also to his official role and sent him a proposal to rework Grand Canyon's design using humanistic premises. I was lucky enough to get two years of funding from Intel, beginning in spring 2001. By the time the funding cycle came to an end (Intel had gone through some reorganization and was no longer providing support for these experimental projects), the team I assembled had created a proof of concept of our "playspace"—an environment for creating graphic timelines.

Temporal Modeling was built with a team of players. Bethany Nowviskie guided the design process in technical, conceptual, and graphical ways. She educated me in the realities of digital humanities and helped keep our goals in focus and the project on track. Jim Allman, a freelance Flash designer who had worked with other projects at UVa, particularly at IATH, created the programming structure for the project. To compensate for the lack of a graphic design culture at UVa, we coordinated with designer Louise Sandhaus at Cal Arts, along with a group of her students. We gave the students small assignments dealing with time and temporality, and they created designs. The young designer whose approach offered us what we were looking for, Petra Michel, came and worked with us briefly and helped give the project an elegant look and form. A conference-workshop in early summer 2001 brought scholars and designers together for conceptual and technical discussions of the project. Much of the really imaginative exploration of subjectivity as inflection, as individuated and highly specific notation, was never developed, however, since our efforts focused on a workable proof of concept. Also, the display space, the piece that would have taken XML files and created a display based on their parameters using our visual system, remained unbuilt. Still, the project taught us a great deal and demonstrated a crucial principle to a community that had previously been almost entirely text-based: that a visual theater for knowledge production could create primary information and analysis, not merely serve as its display.

Ivanhoe, the second SpecLab project, arose from an e-mail exchange between Jerry McGann and myself. The Walter Scott novel of the same name was the point of departure for the game, but any work could have filled that role, for the guiding principle was that any act of interpretation is an intervention within the discourse field that constitutes a work's existence. In May 2000, McGann had given me a copy of *Ivanhoe*, proclaiming its many virtues. A fan of nineteenth-century fiction, I began reading with enthusiasm, only to be discouraged by the grim dullness of a text flattened by pageantry that seemed hopelessly clichéd. The antihero postured, the heroine advanced toward her unfortunate fate—it was all weirdly nonclimactic.

Registering my lack of interest, McGann protested. Look at this amazing scene, he said, and that engaging character. Look, particularly, at the scene between Bois Guilbert and Rebecca on the balcony, when he could, should, might have swept her away to Arabia Deserta, there to indulge their mutual passion. Huh? Yes, yes, he replied. And we set about a series of exchanges involving such a rewriting of the tale.[1] My relation to the novel changed dramatically. From a dull, unengaging text it turned into a territory I was eager to know intimately. Charged to identify points at which I would intervene and turn the story to a new advantage, I became focused on its structure and design. We began to play, making what we would later call "moves." Every text we generated was an alternative to the existing one, deforming or transforming it. We each wrote from a point of view, unacknowledged at first, that later became formalized as a role. Our exchange became the basis of Ivanhoe the project, a game of interpretation. We structured the design to reveal what we felt was at stake in exposing assumptions about texts and textuality, reading and production, the "discourse field" as a rich, ongoing assembly of artifacts of which the text in question was but an instance. And then we set about building Ivanhoe as a real space for play.

Subjective Meteorology extended the idea of Temporal Modeling into an art project that allows subjectivity to be mapped and marked. The project was sponsored by the Digital Cultures Institite at the University of California, Santa Barbara. Bill Warner and Alan Liu were kind enough to let me spend a month with them and their group drawing, writing, and creating animations and proof of concept sketches. The project makes use of the vocabulary and graphical system of traditional meteorology as metaphors and templates for graphing individual subjective experience. One might, for instance, represent a morning storm of anger generated by a front of frustration colliding with a cloud of

anxiety. An idiosyncratic project, unapologetically imaginative, Subjective Meteorology resonates with many individuals. Giving form to such experience as a way to apprehend it, and in some versions of the project to develop a predictive or therapeutic dimension, is all part of the goal. Realized as drawings, a manual, and animations, this project is another demonstration of the possibilities of visual knowledge production.

The 'Patacritical Demon has been envisioned as many things, but above all it is the essential interpretation-modeling device, the means of exposing the process of interpretive activity in its many dimensions. It serves to demonstrate ideas about signification and subjectivity by expressing the transformed and deformed versions of texts produced anew in every reading. The Demon is thus a way to express the way we can understand a "text" or other artifact as an indeterminate field of potential within which a reader intervenes. It is the text/work that is produced as a projection (imagine a hologram) in the spaces between a reader and the planes of discourse and reference. I made sketches of the Demon. We made notes from conversations about its design and form. These may, ultimately, constitute a project. I'm certainly willing to imagine that one SpecLab project might remain purely speculative, emblematic of the always receding horizon of the possible. Our projects sought to bring into being things that seemed just out of reach, but as soon as they became realized, the energy of imagination, like some errant and unruly spirit, would dash off to another corner of the room and again hover beyond our grasp. I'm content to let the Demon be that energy and its sign.

SpecLab's days as a forum for experiment are probably done, even as our projects continue to develop in various ways. Its working unit, Applied Research in 'Patacriticism (ARP), is now given over to various tools projects, especially Collex (an online collections development environment) and Juxta (a textual collation tool). These are part of McGann's ambitious large-scale project Networked Infrastructure for Nineteenth Century Electronic Scholarship (NINES), which aims to demonstrate the viability and necessity of building an online scholarly community. The fissionable energy that charged our conversations has been put to other activities, at least for now. The game of "Designing Ivanhoe," or conceiving of the parameters for Temporal Modeling, or designing the document type definition (DTD) for ABsOnline, were all highly compelling. The act of making, designing, bringing these adventurous projects into being, is where the learning occurs. Other projects may come along, but I hope that the imaginative and once seemingly strange energies of SpecLab will serve as an example of work that began without any clear

outcome, highly risky and much laughed at—only to be realized and recognized as useful in fact as well as concept.

The lessons of SpecLab are substantive. Most importantly, they show the possibility of a genuine synthesis of high-level theoretical concepts and digital humanities projects. More specifically, they demonstrate that the design of environments for knowledge production has to be based on a foundation of subjective and partial approaches if humanistic values are to operate within the otherwise instrumental and administered terms of digital ideology and its cultural practices. But perhaps the ultimate lesson of SpecLab is that all forms of interpretation and scholarship are *design* problems premised on models of knowledge that make assumptions about what their object of study is. Discourses, as is well known, constitute their objects; they do not simply apprehend the world—or a text—as it *is*. In our current working lives, we are all digital humanists, and the task of modeling knowledge is part of our daily business. We work within the models embodied by digital environments and instruments, and we ignore the implications of this at our peril. The legacy of SpecLab seems vital to the next phase of our collective endeavors—creative, critical, and scholarly.

2.1 Temporal Modeling

Temporal Modeling provided the first test of our conviction that humanistic principles could be used in the design and implementation of digital projects, and that graphical means could serve as a primary mode of knowledge production. The project, as mentioned above, began as a response to a demonstration of an interface for the display of images and texts designed by John David Miller and John Maeda. Though their software was clever in its use of screen space and creation of conventions for ordering materials, it was based on what I considered nonhumanistic, objective conventions. Such timelines are derived from the empirical sciences and bear all the conspicuous hallmarks of its basis in objectivity. They are unidirectional, continuous, and organized by a standard, nonvarying metric. They are therefore almost useless for describing the experience of time in humanistic documents where retrospective, simultaneous, and crosscut temporalities are discontinuous and move at very different rates (from flash forward to the stilled moment). Temporal Modeling was designed to create a visualization scheme appropriate to the analysis and study of such experiences.

We began with research into the ways the experience

of time had previously been understood and represented. We expected that if we read across a wide range of fields and disciplines, we would discover striking cultural and historical differences. But the basic concepts and conventions we unearthed comprised a small and unified array, most of them central to the ways time and temporal relations (the difference between these being quite significant, as will be seen in a moment) are used in computational models.

The basic approaches to measuring and marking time traced back to ancient mappings of the sun's movements, seasonal cycles, and planetary activity, with little alteration of basic methods or units since the Babylonians. The structure of the year, the counting of days, and other metrical devices might vary in particulars, but conventions for their representation were standardized: lines and grids, or circles divided radially. By the time a fully rationalized system of timekeeping appeared, with water clocks and hourglasses, the conceptual foundation of time was well established. The authority on which Western empirical sciences draw to establish the linear, regular, continuous parameters of time for statistical analysis and data gathering was supported by philosophical and mathematical assumptions unchanged from the classical period.

The distinction between *time* and *temporality* is among the basic principles bequeathed from classical philosophy. The Greeks understood time as an absolute, a priori condition or field but conceived of temporality as a description of relations among elements that constitute that field and its values. Most of the issues still attached to these two concepts (such as the crucial problem of "the dividing instant") were described in classical literature. When relativity and quantum theory challenged mechanical models in physics, they introduced new concepts into the scientific and mathematical understanding of temporality for the first time in several millennia. Writers of fiction and fantasy have long developed their fluency with elastic models of time, unexplained simultaneous occurrences at a distance, and the conventions of flashbacks, crosscuts, jump cuts, and foreshadowing. But the disciplinary lines between aesthetic work and empirical analysis were well-defined and defended. One of our primary goals in this project was to bring these worlds together.

As I stated at the outset, in the mechanistic, empirical worldview of traditional mathematics and natural sciences, timelines and graphs are premised on common assumptions of time as unidirectional, neutral, and homogenous. We based Temporal Modeling on counterassumptions. First, we set out to model temporal relations—not time. Rather than approach time and space as already existing boxes into which events or things are put, we chose to embrace the premise that temporality and

spatiality are constructs grounded in relations among phenomena. A phenomenological approach is better suited to modeling the temporal relations contained in the aesthetic artifacts and documents that comprise the basic materials of humanities scholarship.[1] These materials are often fraught with complexities and contradictions regarding the ordering of elements in a temporal scheme. The experience of events and their interpretation is grounded in subjective perspectives. The simple fact that any human-authored document represents an individual and inherently fragmentary point of view from within events, rather than an objective record from a presumed external stance, suggested that our counterassumptions were essential if our designs were to serve a humanities community.

We did not, however, want to proliferate idiosyncratic or novel concepts without justification. The challenge was to develop our novel, graphical system for representing the subjective experience of temporality while at the same time situating our project within an existing literature. In the first phase of our work, this entailed a literature review on which we drew for the outline of our conceptual primitives—the basic elements of the Temporal Modeling system. In the second phase, we distilled a content model and designed a space in which it could be used.

Defining the Project in Conceptual and Technical Terms

We knew that we wanted to design a notation scheme that would allow us to represent such notions as anticipation or regret, since retrospective and prospective ways of conceiving of future and past inherently involve transformation of the record and representation of events. To do this, we needed a system that supported the representation of multiple narratives simultaneously, even narratives based on contradictory accounts, since this is often characteristic of the ways individual memory works against the backdrop of official history. We tried to develop a set of metaphors and templates that would accommodate mutable and inflected timescales and be useful as a research tool not only for interpretation and analysis of temporal data, but for their display. The challenge was to create a graphical communication scheme capable of representing a subjective, inner standing point within temporality in a legible manner.

The project was framed, therefore, within these assumptions:

- Time may be experienced as a unidirectional flow within human perception, but the interpretive ordering of temporal events has forward-

branching (prospective) and backward-branching (retrospective) options.

- Temporal relations are inflected by emotions, mood, atmosphere. Not all moments can be measured on the same scale, or on a homogeneous scale; the shape of time intervals (granularity, scale, and metric) varies according to subjective perception.
- Temporal relations are not necessarily continuous. Breaks, ruptures, repeats, and overlapping events occur within different points of view from a single event or within relations among events.

The technical problem was to create an interactive tool set for representing and modeling temporal relations from humanities data, *in advance of* creating a database, document type definition (DTD), or XML markup scheme. That is to say, instead of first making a model of temporal relations in a text or group of documents and then displaying it, we wanted to make a space in which visual tools could be used for primary representation and analysis that would then give rise to interpretation.

In a typical digital humanities scenario, a set of letters or family papers, or a set of incidents in a narrative text, might be analyzed. This analysis would give rise to a hierarchical scheme in which different levels of a time-based system would structure the organization. The representation of the events would follow, conforming to the already established conceptualization (modifications to the content model would require going back, changing the scheme, and repeating the subsequent steps). Events (information, texts, other data) would then be marked with a set of XML tags. Finally, these items could be displayed on a timeline according to parameters already fixed within the hierarchy.[2]

This practice of developing the content model initially in XML is a methodology imported from data management. Information structures are essential for organizing materials in archives, collections, or any digital repository. They are powerful interpretive instruments, but they don't always behave according to the principles of humanistic interpretation and its many theoretical approaches. The habit of creating an elaborate content model in advance of display had come to be a conceptual limitation. Because information display was always a second phase in that approach, visual representations were always secondary. They might be convenient and efficient ways of showing information, but digital humanists rarely thought of graphical displays as ways of *generating* information.

We wanted instead to design a system capable of representing the

complex and fragmentary information typical of human records *before* designing the data structure. If we read a group of family letters and documents, our goal would be to place them in some temporal relation to each other in a graphical scheme, and let that activity determined the model of chronology among them. The idea was that if we designed the composition space within sufficient technical constraints (so that every mark, line, and point could be parameterized), it could be used to give rise to a formal knowledge representation scheme.[3] But we were also keen to return interpretation to the field of digital humanities, which had in many ways subjected itself to the mindset of analytic and empirical approaches as it borrowed the technical methods of data capture and information organization.

Our readings included works from a considerable range of disciplines: humanities fields (philosophy, narratology, structuralist discourse analysis, history, knowledge representation), social sciences (particularly anthropology and religious studies), informatics (formal logic, linguistic analysis, temporal database development), the natural sciences (biology, geology, physics and relativity theory), and visual design (art history as well as graphic methods for information design). We imagined we would eventually graduate to topological mathematics and the spatial modeling of events (the "rubber sheet" metaphor always seems appropriate to the distortions of subjective experience), the analysis of temporal elements in narrative and linguistics (including deixis and tense modalities), and the field of diagrammatic reasoning and semantics.

From our literature review, we distilled a set of conceptual primitives for the representation and modeling of elements in temporal relations. The review itself is worth summarizing briefly, since the act of culling basic concepts into the smallest possible usable set of conventions was one guiding principle of our work at the formative stage.

Literature Review of Time and Temporality

Though the literature on time and temporality cuts across humanities, social sciences, natural sciences, and informatics, our survey yielded a surprisingly concise set of terms and basic concepts. Philosophical concerns focused on issues of ontology and metaphysics. Logicians devised formal systems that were useful for informatics and met their requirements for instrumental and practical applications. Discourse analysis and narratology provided a basis for thematic description and material encoding of concepts of time and temporality in natural language. With

the exception of twentieth-century developments in relativity, the ideas about time and temporality shared across disciplines had been understood and established by the early centuries of the Common Era.[4] More specialized terminology and more elaborate scholarly schemes of analysis have emerged in recent decades, but the fundamental conceptual underpinnings have remained remarkably consistent across historical periods and fields of intellectual inquiry.

We found that in almost every discipline an important distinction was made between absolute and relational time. *Absolute time* is a given, conceived as a structural container of events, while *relational time* emphasizes temporality as a product of the relative sequence and duration of events within a frame of reference. These distinctions, however, are not always clearly observed. In many cases, the assumptions on which they operate are inherent in a disciplinary perspective. For instance, the idea that time preexists events has a strong foothold in the natural sciences, where the ontological existence of time goes largely unquestioned. Even the most intuitive interpretations of the subjective experience of temporality are often framed in relation to this a priori concept and the empirical premises it reinforces. We wanted to be aware of these assumptions but focus on the ways temporality is understood thematically and encoded in representations such as language and other symbolic forms. Our goal was to create an interface for *interpretation* of temporal relations in humanities data. To do so, we had to jettison the idea that time or temporality in themselves were going to be modeled in our system.

Beginning with philosophy and metaphysics, we situated our inquiry within what computer scientist Fabio Schreiber terms the study of temporal ontologies or "the major issues in the nature and structure of time."[5] An empiricist bias was evident even in the simple assumption that "the nature and structure of time" could be described as a singular, homogenous entity. Working within the field of informatics, Schreiber had pragmatic reasons to establish such parameters for temporal consideration—such as the need for synchronization of distributed computational systems. But his survey of the literature at the intersection of philosophy, history, and informatics provided us with a useful list of descriptive approaches to understanding what time *is*. These begin with a distinction between linear and circular conceptions of time. The linear conception reinforces the idea of the unidirectional flow of time's arrow, while the circular suggested the repetition of life cycles, circadian rhythms, and other apparently identical replications within temporal sequences. But the idea of ontological understandings (what time is) can

be confused with the ways it can be represented. For instance, no intellectual or mathematical support exists for the idea that time could take a circular or cyclic form even though recurrent activities in human or mechanical realms are often casually referred to as cycles.[6] The "cycle" is actually a flattened view of a spiral in which repeating activities flow around the same set of milestones or markers but the whole process unfolds along a unidirectional axis. Schreiber's inventory also included other, more self-evident concepts: the contrast between a belief in infinity and the human experience of the finiteness of time; the experience of discrete moments or units of time as against its perceived continuity and flow; an absolute sense of time described as past, present, and future; and a relative sense of time described in terms like before, after, or during.

For Schreiber the flow of time is an objective feature of the physical world, and this provides Western science with philosophical support for its assumptions. This flow can be understood in the language of formal logic and linguistics. The very idea that temporal measures are arbitrary (hours, minutes, seconds) reinforces the conviction that time "itself" exists as a container for events. Conventions for measuring time, marking its divisions and subdivisions according to named intervals, follow calendrical, horological, and other extrinsic systems—sidereal, physical, biological, or time-stamped and dated—each of which is bound to historical and cultural realms. (Religious and sacred times overlay and interpenetrate secular calendars even when the same system of dates was used as a scaffolding for both.) Anthropological research offers evidence of temporal schemes that mark complex, parallel multiphase systems, but no matter how many different patterns they entail, these systems' premises do not challenge the a priori existence of time or its unidirectional flow.

Schrieber has a pragmatic agenda, distilling basic information about temporal ontologies for applied use. The scholar J. T. Fraser, on the other hand, systematically examined the ways time was understood from various disciplinary perspectives. His list of descriptive rubrics differs dramatically from the information-based categories into which Schreiber organized his survey. Fraser's list includes:

- eotemporality: the rational progression of temporal events in an apparently sequential form;
- nootemporality: time experienced by the human mind;
- psychotemporality: perceived time, psychologically inflected;
- sociotemporality: time proper to a specific social system or condition;

- biotemporality: temporal distinctions operating within a continuous, organic present (with apparently cyclic and other purely linear patterns);
- atemporality: the temporality of physics, in which the universe is simultaneous, unordered, chaotic; and
- prototemporality: undirected, discontinuous, primary.

In Fraser's discussion, these concepts also assume that time is an a priori condition, available to description either as a sequence of events in human experience or as events that can be ordered within a descriptive schema. Even such a subjectively oriented concept as psychotemporality would be measured against a normative extrinsic temporality, defined, that is, as a contrast with "time" as an absolute.

Fraser takes the concepts and systems as descriptions of time itself, not as intellectual constructs to be analyzed, and thus neglects the materials most important for humanities work and interpretation—the linguistic, visual, or symbolic systems in which concepts of time are encoded. So we added a single category to Fraser's list:

- discursive temporality: the representation of time in discourse.

We also modified Fraser's discussion by making a clear distinction between the assumption of an objective perspective (in either metrics for charting time or the assumption of time as an a priori given) and the recognition of subjective experience with temporal dimensions. By distinguishing the intellectual representation of concepts of time and temporality from a conviction regarding the a priori ontological existence of time as a thing in itself, we based our work on a self-conscious attention to representation and its interpretative contingencies, rather than a presumption of external realities and their absolute, unconditional existence.

Fraser provided a panorama of temporal schemes designed to suit individual disciplines. This extended the terminology we had derived from Schreiber and others, including logicians who describe the relations of intervals and events in a linear system that emphasizes the relative ordering of temporal events. Their work is different from what we called "discursive" temporality in one significant respect; it is not grounded in analysis of the specific qualities of linguistic expression. Formal logicians, such as James Allen, though focused on language, are characterized as "de-tensers" because of this feature of their approach. They have

a vocabulary for describing relations among time intervals rather than focusing on the language in which temporal experience is marked and represented.

In "Time and Time Again," an essay much cited in the liteature, Allen's relational diagrams offer a logical framework for all possible orders and sequences of events.[7] These events are assumed to exist outside of their representation, and the formal scheme is a way of elaborating a typology of these relations. Allen's approach is useful for analyzing such relations (temporal logics), particularly when they can not be correlated to an absolute or extrinsic dating system (calendar or clock time), or when they can be linked only with what are referred to as pseudodates, an intrinsic dating system. The formality of Allen's logical system allows for a fully disambiguated description of such temporal relations. It also accommodates forward-branching options, a desirable feature for computational situations in which a single, determinate past might connect to a multiplicity of future options.

Allen's logical relations are defined by a succinct set of terms (and their complements): before, meets, overlaps, during, starts, finishes, equals. These lend themselves to representation as sets of arrows whose formal, schematic relation precisely matches the temporal relation and corresponds to its verbal description. For Allen, the concept of tense is cast entirely within formal language, which has made his work useful for the requirements of informatics. The concepts of temporality needed for time-stamped database operations make use of similarly formal logic in distinguishing the moments at which a fact is stored in a database, the moment of a query, or the moment at which a fact might be true within a modeled reality. These systems depend upon internal clock mechanisms, intrinsic systems of highly formal, unambiguous temporal relations. They therefore lend themselves to formal description rather than either correlation with extrinsic systems or subjectively inflected and ambiguous tense modalities.[8]

In contrast to the formal approach provided by logicians, linguists and scholars of language in literature and narrative offered us terms appropriate to the analysis of fictional, historical, or other documentary narratives. Their work focuses on the encoding of assumptions about temporality in symbolic representation in natural language, whether in an utterance, document, or narrative. In such an approach, the first problem is to identify the linguistic markers of tense or other temporal features. The next is to understand the cultural, psychological, or other symbolic value by which the temporal system is inflected.

Mark Steedman's study "The Productions of Time" provided an extensive catalog of tense modalities or tense logic in language, incorporating classic work in discussion of speech, reference, and event points within linguistic representation, as well as a summary of contemporary work in this area.[9] Rather than attempt a description of events grounded in formal relations of intervals, Steedman and his colleagues sought to elucidate the semantic implications of distinctions embedded in linguistic terms. *Achievements,* measured at or in a particular moment were contrasted, for instance, with *accomplishments,* which were extended in time, and *activities,* which endured for a set period. These sorts of descriptive categories clarify the means by which natural language encodes cognitive concepts about time and temporal relations.

Extending our research into narrative theory, we encountered the realm of constraint logic programming. From this we derived analytic and interpretive tools for defining narrative elements within a system of internal references that describe temporal relations; each element is analyzed and its temporal identity constrained within a formal system in order to extract an ordered sequence of referenced events out of the language of experience, action, or description in the narrative.[10] These approaches are dependent upon the careful analysis of tense indicators in syntax and discourse structure.

In one such study, Pamela Jordan, a linguist studying narrative, made use of tense markers to demonstrate distinctions among narrative reference frames.[11] Tense markers such as "here" and "now" not only describe relative time frames, but also link the representation of time to individual subjectivity. The concept of deixis, derived from structural linguistics and applied to narrative theory, refers to the way subjectivity (individual speaker identity and position) was structured in language. Though classical narrative, as defined by Aristotle's unities of character, action, and location, assumes that time and space are universal, continuous, and coherent, such assumptions are certainly not part of all narrative frameworks. Self-conscious manipulation of these unities has been part of modern literature and its theoretical and interpretive approaches, and can be brought to bear on the analysis of documents in historical studies.

Historians and anthropologists note that ideological and cultural values often inflect time systems. Herbert Bronstein, in "Time Schemes, Order, and Chaos: Periodization and Ideology," points to the repetitive cyclic conceptions inherent in a notion of an eternal being and the radically contrasting ways this concept has operated within Jewish and

Christian approaches to historical chronology.[12] The difference between believing that the Messiah is still to come or has already appeared serves as an organizing feature of all historical events, and casts a markedly nonneutral interpretive frame on the description of human experience. Bronstein's example shows dramatically that any historical scheme embodies a worldview laden with a sense of movement toward or away from a culturally sanctioned goal such as progress, salvation, enlightenment, or rebirth. The very division of history into discrete epochs or periods— ancient, medieval, modern—reflects assumptions about shifts in cultural paradigms along an irreversible temporal axis.

Cross-cultural perspectives demonstrate the bias inherent in concepts of temporality that are taken to be intuitive or to organize social relations into a network of cultural activities. These distinctive formulations are most conspicuous in the use of various timekeeping schemes but also extend to notions of dream time, ideas of the present as a point floating within a nonlinear past and future, and other alternatives to the rational system of logical, unidirectional order in Western time concepts.[13] These approaches are in many ways more appropriate to our subjectively organized approach than those that derived from formal language and empirical sciences.

At the end of our study of tense and alternatives to linear, unidirectional time-arrow frameworks, we looked briefly at the literature on relativity and its influence across a wide spectrum of cultural activities.[14] Fiction and narrative, as well as scientific discussions of event modeling, historical patterns, and events within the realms of physics, all lend themselves to description according to models derived from what is termed space-time.[15] Scientific debates about the absolute existence of a time arrow focus on the second law of thermodynamics (the tendency of chaos to increase in the physical universe along an apparently asymmetrical temporal axis). But in narrative imagination, the theory of relativity provides suggestive starting points for the reordering of perception.[16] The multiple temporalities available in such systems fragment the unity of time as well as its illusory order in human experience.

In summary, we could see that the apparent order of time as a given, a priori container for experience, had a counterpoint in the conception of temporality created and shaped by the ordering of events, objects, elements, and effects in increasing layers of complexity. Sharp differences existed between objective and subjective conceptions of temporality, and among variously inflected interpretations of the value of events within temporal orderings. This literature provided us with a stable

OBJECTS/ELEMENTS (basic temporal elements to be represented)

 line or axis
 calendar grids
 clock faces
 points
 intervals
 events
 granularity tics
 metrics (intrinsic and extrinsic)
 notations and inflection markers
 start and stop points
 now and the now-slider

RELATIONS/STRUCTURES (attributes or connections among elements)

 order (or temporal direction?)
 rupture
 multiple and/or inflected granularities
 the dividing instant
 visual positioning of elements
 certainty of temporal position
 determinacy of boundedness
 alternative iterations (now-slider–generated lines)
 degrees of inflection and relation among inflected elements

ACTIONS/OPERATIONS (activities a user should be able to perform)

 generating and viewing time slices
 positioning and labeling elements
 ordering and reordering
 attaching and detaching a metric
 choosing/inflecting/zooming a metric
 defining intrinsic granularities
 now-sliding (generating alternative iterations)
 inflecting temporal relations

Table 2.1.1. Initial conceptual scheme of objects, relations, and actions

nomenclature of concepts. These in turn informed the elaboration of our "temporal primitives"—the basic elements that comprised our conceptual scheme (tables 2.1.1, 2.1.2).

Graphical Conventions

In parallel to this literature review, we conducted a survey of visual conventions for the representation of time and temporally marked information and quickly became aware of how limited the graphic conventions were for picturing data in time.[17] These conventions also shared the assumptions that time is unidirectional, neutral, and homogenous.

The two fundamental elements of any temporal diagram are the *reference frame* through which it is structured and the *notational vocabulary* with which temporal relations are expressed. Reference frames make the expression of temporal relations possible by defining the rules under which the visual system operates. These frames are either extrinsic to the data (assuming an objective time framework against which the absolute temporal position of an element can be measured) or intrinsic to it (based solely on the relations among the elements themselves but traditionally assuming a linear chronology). In some instances, reference frames present a combination of intrinsic and extrinsic measures (e.g., the perceived time of an experience and the actual time of the event measured against a standard timekeeping device). Conventional vocabularies for temporal notation contain three types of markers: *points,* or discrete instants in time; *intervals,* or segments of time; and *events,* which are occurrences in time.

Diagrammatic representations of temporal relations fall into three basic categories: *linear, planar,* and *spatial.* Linear diagrams, or timelines, are by far the simplest and most prevalent forms. Almost every diagram we found was, in essence, linear, by virtue of the way it used its axes and metric scales. The archetypal timeline consists of a single axis on which a stable metric and a sequence of markers or labels representing the progression of events in time are organized. The timeline is a linear spectrum with homogenous granularity. On a linear diagram data can exhibit only three relative temporal conditions: *earlier than, later than,* or (sometimes awkwardly) *simultaneous with* (or overlapping).

Planar diagrams chart temporal relations on two axes. Sometimes, as in calendar grids, which mark days against the larger structure of weeks, both of these axes are temporal. Often, however, time is marked according to a uniform metric along a single axis and data representing some

Time	absolute time: container of events relative time: relations among events
Temporality	system constructed as a way to visualize temporal relations
Axis or **line**	time arrow
Point	(no extensible duration) **start point** **end point**
Interval	demarcated segment of time
Event	occurrence in time Linguistic vocabulary for modal expressions of events (Mark Steedman, "The Productions of Time") achievements (at or in a particular period of time) activities (for a set period of time) accomplishments (extended in time) Formal logic (James Allen, "Time and Time Again") extrinsic (absolute dating system) intrinsic (pseudo-dating system) forward branching (multiple future options) logical relations of temporal intervals: before during meets overlaps starts finishes equals
Metrics	**extrinsic metric:** conventional measure (e.g., hours, days, weeks, years) physical measure (e.g., quartz clock cycles) **intrinsic metric:** in relation to lived experience (e.g., birthday) **chronon:** smallest unit in any time system
Ordering	sequencing without regard to a metric
Iterations	versions of temporal sequence reordered through subjective perception

Now-slider	fundamental reference point within the field of interpretation
Granularity	change of scale of a fixed order or chosen metric
Slice	state of elements at a specific temporal moment
Date-stamped	element with certain and determined form
Dividing instant	point at the intersection of two segments

Vocabulary inflections (apply to points, intervals, events to give character attributes)

> **determinate/indeterminate** (with respect to start and end)
> **certain/uncertain** (with respect to date-stamped accuracy)
> **rupture**
> **user-definable terms**
>> mood,
>> atmosphere
>> importance

Grammatical inflections (structural relation of elements)

> **prospective effects**
>> foreshadowing
>> causality
>> anticipation
>> user-defined relations
> **retrospective effects**
>> causality
>> regret
>> user-defined relations

Table 2.1.2. Nomenclature scheme for conceptual primitives
Note: Terms in bold type were adopted for use in our conceptualization.

other quantitative value is charted against the other axis. Diagrams in this category—which includes the familiar bar and line graphs—may present information about a single data type (bivariate graphs) or about multiple information streams (multivariate graphs). In most cases, this form does not emphasize temporal relations but rather the evolution of a specified attribute over time. Like linear diagrams, the planar form presents the flow of time as unidirectional and asymmetric.

A spatial diagram, the least common representational scheme, attempts to map data on multiple axes—sometimes literally tracking events as they move in time and through geographical space, and sometimes modeling data in a three-dimensional format in which none of the coordinates measure literal space. Digital spaces offer new opportunities for three-dimensional diagrams and fourth-dimensional progressions. But the conception of *n*-dimensional space-time would need to be invoked if the rich conceptual potential of modeling chaos, complex fluid dynamics, and even topological forms and processes were brought into play. The difficulty with such complex visualizations is graphic legibility. The ideas and the notations are unfamiliar, and legibility depends on familiarity and habits of reading. New conventions no doubt lie ahead but have yet to be designed and tested for the kind of project we are describing. We did play with sketches and schemes for such representations and sought graphical models of relativity, topology, and quantum effects. But realistically, such models were beyond our computational and conceptual capabilities, not to mention being difficult to produce except as schematic indicators, provocative and suggestive rather than useful. Such horizons point toward future development for this project.

Modeling Temporal Modeling

Our modeling scheme challenged the three basic assumptions of conventional models: unidirectionality, continuity, and homogeneity. We felt we could create a visual scheme in which alternatives could be represented for purposes of basic research and visual display. We proceeded with the conviction that humanities scholars, dealing with many variables in the temporal relations expressed in documents and accounts, need a less rigidly empirical and more flexible system of representing these relations.

Instead of a time arrow, we designed our system to include branching narratives that could go back as well as forward in time. A map of

Figure 2.1.1. Preliminary design sketches for Temporal Modeling

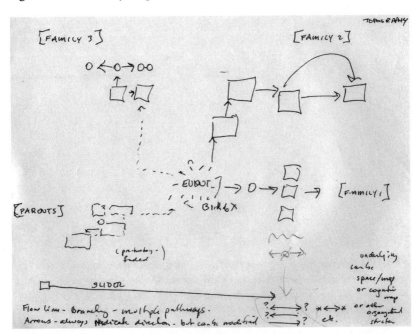

2.1.1a. The original conception of the design included multiple narratives and branching paths. Here the central event ("Birth of X") is shown in the center of a field of documents, each of which is positioned within the temporal space. The central event creates a common reference for different sequences of reactions, responses, or other information registered in documents. As this is meant to serve humanities research purposes, all information is linked to some kind of artifact or reference (hence the little boxes). Note that the now slider is present, even in this early sketch, allowing forward and backward movement.

past events may change dramatically in response to new information or occurrences that do not merely recast our interpretation of events but alter our conviction about what actually occurred. (For example, the development of theories of geological history in the nineteenth century subjected biblical accounts of past events, until then taken seriously as metrics by historians as well as theologians, to radical reconfiguration in order to conform to empirical evidence.) Similarly, anticipation of future events and the degree to which this anticipation shapes the present, a major aspect of narrative practice in prose and drama, is difficult to chart on a standard time line. These shifts, in our model, gave rise to branches, which were linked through what we called a "now-slider" (figure 2.1.1).

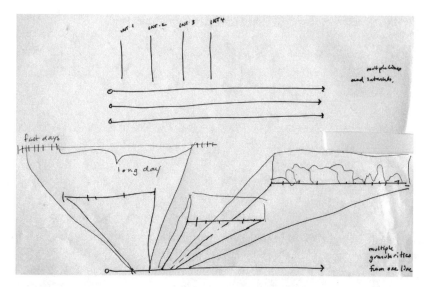

2.1.1b. Our interest in varying the granularity of the temporal metric prompted a scheme for expanding selected segments; the aligned vectors in the upper register allow these different scales to be read against each other using a standard metric. The stretchy timeline concept is shown at center left, where the unevenly spaced tick marks (labeled "fast days" and "long day") register the experience of time passing more quickly or more slowly along a single continuum.

Instead of treating time as a neutral, containerlike setting for events we wanted to be able to show (and manipulate) the tensions and pressures exerted by events that inflect temporality with subjective qualities. The idea of "the distant future" or "someday" or "after my lover comes back"—all quite logically compatible with subjective experience of temporality—resist being absorbed into a neutral concept of time with a stable, extrinsic metric. The relation among events separated by time, rather than an experience of time itself, is the focus of such experience.

Finally, we wanted an alternative to the standard metric. The idea that temporal relations can be mapped on a single scale is based on the supposition that time is homogenous and consistent. In much humanities-based research, as in lived human experience, subjective notions of time differ depending upon circumstances and emotional or other investments. The perception of granularity changes with context. (Clearly the appropriate granularity for a historian documenting the burning of Atlanta during the Civil War, for instance, is quite different from that used in the narrative of *Gone with the Wind* in either its film or book versions.) And the relation of parts to each other, parts to a whole, or metric scales

to each other cannot always be unified within a single homogenous frame. Breaks, inequities, and discrepancies in pacing are all elements of the lived experience of time and its record in humanistic documents. These ruptures or lacunae are often the periods of greatest interest to the humanities scholar and lay user of time-based digital media alike. One of our solutions was an elastic timeline that introduced malleable and variable metrics into a single line. Another was to change granularity from one segment of a line to another, or to introduce different metrics within a single representation.

With this conceptual framework in place, our work became focused on the elaboration of an effective visual design for the interactive tool

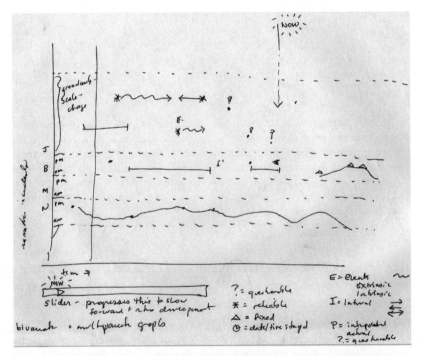

2.1.1c. Thinking about various ways the now slider could work within varied narratives of a single event led us at first to a single moving slider that would advance or replay a sequence of events. "Now" was conceived as a moment in the overall temporal scheme, not linked to a particular, individual point of view. We also explored graphic effects that would indicate emphasis and inflection. A well-defined legend was always a requirement, since conventions of legibility for affect are not established in any existing form. Customized and customizable graphic modes were deliberately designed to undercut the notion of an external or transcendent authority exercising objective judgments.

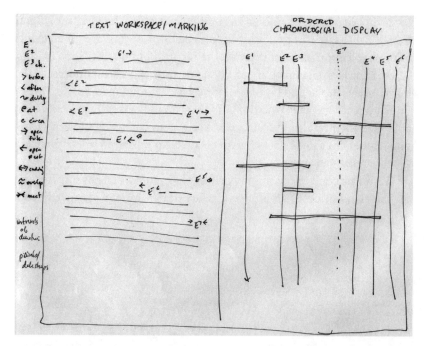

2.1.1d. This diagram links a textual analysis and a chronological display of information that has been marked up in the text. The idea was to generate structured data that could be exported and then repurposed for analysis and display. By marking different references within a text as "before," "after," "during," and so on, according to the basic logical categories from our research, we could map the temporal relation of the events (E in the markup). This coded set of references could then be moved into the display space for analysis and manipulation.

kit and composition space. Our final designs included several distinctive features: the now-slider mentioned above, multiple and multidirectional timelines, and semantic and syntactic inflections. The now-slider was designed to indicate the point of view from which any particular representation was occurring, as well as to advance the interpretation along its own temporal axis. This innovation became more developed in our designs of Ivanhoe, where we allowed each player/role to have a point of view within the game space. But its appearance in the Temporal Modeling space marks a definitive commitment to marking subjectivity as the place within which the system registers all of the information it displays. The use of timelines that branched, broke, or, in various experiments, bent or sagged, was a way to include prospective and retrospective views. Semantic inflections allowed for a customized legend of themes,

characteristics, or other values to be attached to individual points, lines, and events in the system. Syntactic inflections were designed to indicate relations of influence or interdependence among elements.

The design process itself involved paper-based sketches and, as I mentioned before, subsequent coordination with a group of students at Cal Arts, followed by work with a Flash programmer. The results were attractive, and the labeling system for the composition space allowed for much information to be entered and used. The crucial shift we enacted was to move from picture making (rich depictions of relations, concepts, situations, circumstances, and effects) to designing software. This was an

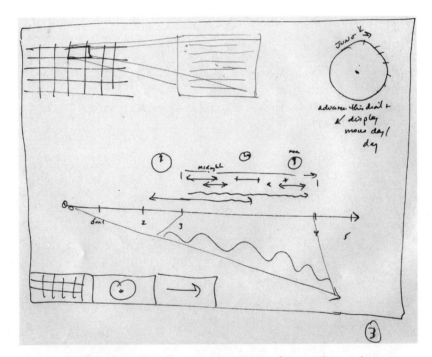

2.1.1e. In the early stages of design, we used projections from one line or plane to another as a way of displaying influence or effect. Our aim was to create a language of affect for semantic and syntactic relations (foreshadowing and anticipation, for instance, were conceived as forces that had their own impact on the unfolding of events). In this sketch event segments of different duration are shown floating above a time line under which a vector shoots downward. The projections from events above can be expanded upon in the graphics display, their relative importance and impact shown by the area, density, and frequency of graphic inflections. Correlation between that vector and the timeline is arbitrary. The menu bar (bottom left) was meant to indicate that one could choose various methods of display: grid, dial, or line.

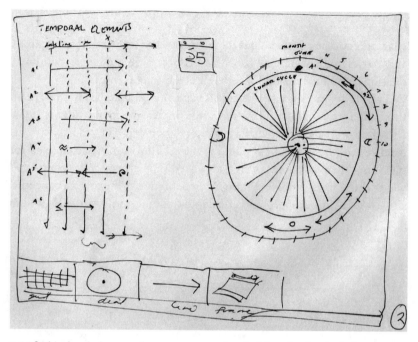

2.1.1f. This sketch shows various systems correlated with each other, including a calendar, dial, grid, and line.

2.1.1g. We experimented with multiple now sliders and "rubber sheet" timelines to suggest the effect of subjective perception on a set of elements and their relations. The neutral, exteriorized, "objective" view of events (left) is reconfigured when point of view is taken into account (right).

multiple men standing

2.1.1h. An image could also register multiple viewpoints and their effects within a field of events.

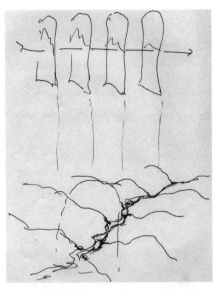

2.1.1i. We experimented with spatial, topographic images of temporal events—a time landscape—with the idea of being able to map experience. The time-slice offered a way to cut through such complex fields for analysis. The difficulty in these conceptions is assigning a value to the z-axis.

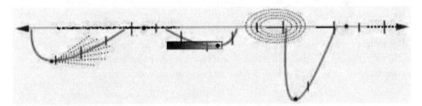

2.1.1j. The warped timeline, created by Bethany Nowviskie as one of our early experiments, had much aesthetic and imaginative appeal. Although "stretchy" timelines were part of our conceptual vocabulary from the outset, we did not develop this feature. Anomalous experiments such as this often demonstrated possibilities that could be usefully incorporated into future designs. In Subjective Meteorology, such anomalies and affective expressions are the basis from which the system is generated (see chap. 2.3). Thanks to Bethany Nowviskie for permission to use this image.

Fig. 2.1.2. Screen images of composition space

2.1.2a. The Temporal Modelling composition space was very clean and elegant. Basic temporal elements—line, point, event, and interval—could be repeated indefinitely, renamed, annnotated, assigned labels, colors, and intensity, and manipulated on many distinct layers. The menu bar at the top provided access to existing models, views, editing tools, help tips, inflections, and the inspector (see figure 2.1.2e). The bottom bar held a tool that allowed different layers to be foregrounded or made to recede, a now slider (the eyelike figure), a compression/expansion feature for horizontal display, and adjustments for focus and scale. Individual layers could be named and manipulated independently and displayed with different degrees of transparency.

enormous leap and involved a major tradeoff between aesthetic richness and functionality (figure 2.1.2).

The constraint on the design imposed by the technical requirements of making the composition space generate XML output ultimately proved very limiting. A relentless linearity remained in the structure of the lines and the parameterization of the space. We were not able to render *n*-dimensional space, or to create the warps and breaks and ruptures essential to the subjective nature of phenomena. We did, however, produce a usable system, one that was capable of modeling data directly from visual input. That demonstration of visual activity as a primary mode for

2.1.2b. Simple single-layer model with some of semantic inflections displayed. This untitled layer, identified in the bar at lower left, is unlinked from other layers at this point.

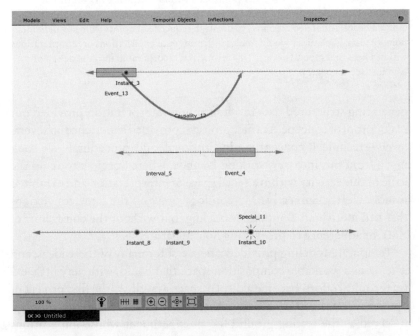

2.1.2c. More complicated single-layer model showing causality arrow. Causality was one of the basic syntactic inflections, while the glow around "instant 10" is a semantic inflection. Syntactic inflections always involve a relation between one or more elements, while semantic inflections can be attributed to any single element.

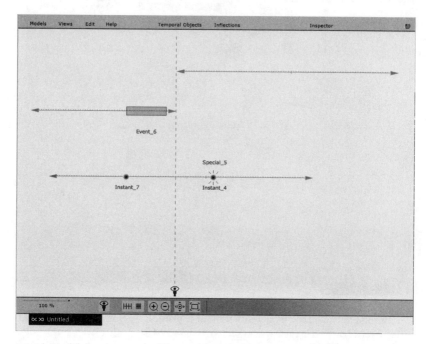

2.1.2d. Model showing a now slider positioned within a sequence of events. The design included plans for multiple sliders so that branching paths could be used simultaneously (and independently) to display a sequence of events from any individual point of view. Each slider would track a different set of expectations or interpretations within a field of temporal events. This feature was incorporated into the design of Ivanhoe (see chap. 2.2).

generating structured data in a humanities interpretation provided our major proof of concept. As a first project it provided experience on several levels—technical, conceptual, institutional, and procedural. We took much from this into our work on Ivanhoe, where SpecLab took up the issue of subjectivity within a social space of interpretation and exhibited it more clearly. Subjective Meteorology drew on the same convictions that had motivated Temporal Modeling, but without the constraints of XML or adherence to preexisting nomenclature.

Temporal Modeling provided a beta test for many of these ideas, and it remains a workable composition space that could, with very little extra technical effort, become a display space as well. As the first project of SpecLab, conceived even before that entity formally came into being, it served as the testing ground for an experiment whose implications were not fully clear at the time but, refracted through the experience of designing Ivanhoe and Subjective Meteorology, have since become

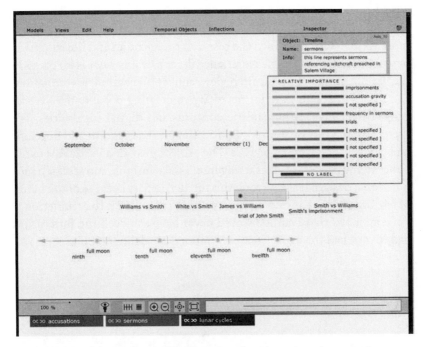

2.1.2e. A view of the inspector, a labeling system for using color values, entering data and labels, and creating a legend that can be stored and used within a model or exported for use with other models.

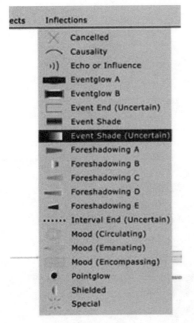

2.1.2f. Detail of the palette showing some of the semantic and syntactic inflections included in the prototype.

more vivid. I have described the research background and development in some detail, because the experience demonstrates what is involved in the various stages of literature review, conceptualization, investigation, and iterative design practice necessary to creating a viable intellectual project that engages humanistic concerns and digital capabilities. We spent several years on Temporal Modeling. Its conception and development cycles took time to mature. The project provided invaluable experience in the process of abstracting intellectual insights and research into functional design. Ivanhoe took this further, in part because of the influx of resources—human and monetary—that propelled it to completion.[18] I'm convinced that Ivanhoe would never have achieved the form it did had we not had the experience of Temporal Modeling to build on.

2.2 Ivanhoe

Temporal Modeling succeeded in demonstrating that visualization could serve as a method of creating interpretative analysis, and not merely of displaying it. To the extent that the semantic and syntactic inflections were designed, they embodied a vocabulary for indicating values and relationships among elements that carried interpretative judgment. The now-slider feature, though still primitive at the time we stopped working on the project, embedded a subjective point of view within the system. We could not make the stretchy timelines, with their variable metrics, work within the technical constraints imposed by the design, and the overall linearity and underlying rational grid structure undercut some of the premises the sketches and original conception had envisioned.[1] Ivanhoe continued some of these ideas. Other aspects of our initial project were extended in Subjective Meteorology.

Ivanhoe came into being through a number of impulses. Chief among these was the desire to design a project that could embody and demonstrate critical principles while providing a model digital environment for next-generation pedagogy and scholarship.[2] We were keenly aware of the disconnect between the

experiences our undergraduate students brought to the classroom and the academic environment. Broader social issues with regard to literacy, democratization of education and access to knowledge, and changing patterns of reading, writing, and use were present in our minds, and our projects at SpecLab engaged with the altruistic goal of fostering social change.

We found that educators seemed immune to the siren call of theory, while theoretically inclined colleagues often seemed baffled by the role of digital technology. Ivanhoe may prove, ultimately, too esoteric in its aims and design for broad adaptation— the idea of a game of interpretation to save the humanities gained few converts—but its virtue was that it was a toy and a tool, not packaged content, and its design was premised on a theoretically sophisticated set of premises. When finally built, it successfully demonstrated its theoretical principles.

We had been asking whether digital media could be used to provoke critical modes of reading within literary studies. Ivanhoe, a game of analysis and interpretation, was our answer. It was designed to integrate traditional bibliographical materials and other artifacts of literary study within an online environment while pushing to the fore critical issues in literary studies: the non–self-identical condition of texts, the relation of any text to its field of production, the intersubjective activity of readership and scholarly work, and the development of reflective self-consciousness as a fundamental goal of humanities activity.[3] Our goal was to create an electronic environment in which these issues can be integrated into practice.

The bulk of digital humanities projects had focused on library and information management systems for the administration and delivery of materials. While these uses of technology were important, they were not sufficient to engage with either the cultural or theoretical agenda we had in mind. Ivanhoe was meant as an imaginative, provocative space that would move beyond instrumental management and statistical processing of text-based materials. It was designed in response to the question of how the future of literary and humanities scholarship might be provoked by electronic instruments, and on what foundations adequate tools could be established. We were also keen to be sure that surrogates and virtual facsimiles for the study of print-based materials be included in their design.

Deconstruction left a legacy of metaquestions that informed our research. For instance, in a paper titled "From Work to Text," one of the touchstones of the literary theoretical turn in the 1960s, Roland Barthes

set out an approach to reading and interpretation that established terms of play and difference as productive in their capacity to generate a text-as-reading.[4] Within the sphere of deconstruction and poststructuralist approaches, the term "text" came to stand for a tectonic shift in approaches to the task of interpretation. Readings, not meanings, were the focus of this method, with the text as a field of signifiers in play. As we conceived Ivanhoe, we made an obverse, but not reactionary, move to reconceive the "work" as a constituted field.

Just as earlier twentieth-century literary critics addressed questions of style, authorship, attribution, meaning, and interpretive relations to ideology, politics, or culture, we drew on the developments of the last quarter of a century, creating Ivanhoe so that it would provoke questions about the ontology of texts, the intersubjective condition of their production and reception, and the ways their material existence is contingent upon a discourse field—an aspect of their capacity to function as elements within a signifying practice. The metaphors of networked culture find a corollary in the dispersed condition of discursive practice, and in the contingent condition of texts within a diffuse field of artifacts. Nonetheless, students of literature and even many scholars of renown seem to forget these lessons when they sit down to the daily activity of interpretation. Students regularly come to the classroom intent on finding the "meaning" of a poem within an apparently stable text, as if it were a self-evident and self-identical work. Such attitudes prevail in the visual arts and media studies as well, with a strong vernacular strain of criticism in the popular press. Visual artworks are regularly subjected to description-based analysis (hardly worthy of this final term) and film to narrative recounting based on story, plot, and character description. The ideological and epistemological interlinkings of deconstruction get little play in such circumstances. While lip service to the theoretically informed agendas of critical inquiry persist in the research university, literary studies or pedagogical work that genuinely engage theoretical principles remained exceptional.

In conceiving Ivanhoe, then, we combined our cultural concerns about the place and perception of the humanities with our commitment to critical issues in literary studies in the early twenty-first century. We explored technological possibilities for facilitating humanistic research and the potential of aesthetic provocations in the design of digital reading environments. But we also kept our theoretical goals in the foreground.

Our cultural concerns were fairly straightforward, even if in 2000–

2001 they still seemed slightly heretical to our colleagues (many of whom still think of themselves as nondigital in their orientation as teachers and scholars, in spite of their daily use of electronic tools and resources). We were and are aware that a considerable gap exists between the activities and artifacts of mass media culture and academic life. The very acts of reading required by traditional humanities seem alien to many of our students, whose daily experience of interconnectivity and interactive media involves e-mail, online games, networked information systems, and other small-scale, short–attention span environments. Literary texts, particularly historical and experimental works, appear to be peculiar artifacts—remote, antiquated, or esoteric. More crucially, dialogue and self-conscious reflection are barely present in the structure of media discourse, with its emphasis on the commodification of information and experience.

The role of the humanities, with its focus on the creation and preservation of cultural artifacts, particularly works of imagination and subjective experience, felt imperiled, at risk of being swept away by a rising tide of seemingly philistine cultural influences. In some sense, the humanities are equally threatened by several forces: popular disinterest in cultural traditions (beyond the banal "produced" culture of the entertainment industry), the esoteric self-involvement and obliviousness of academic institutions (with those at the highest level of research seeming most immune to changes in the cultural context of their activity), and an inadequate engagement with the critical issues that broke theoretical ground in the last decades.[5]

All of this high-minded rhetoric would never have brought Ivanhoe into being, I think, if not for a playful yet highly charged collegial exchange between Jerome McGann and myself. That exchange, as I mentioned in the introduction to part 2, turned on the novel by Sir Walter Scott from which the project took its name. McGann had suggested that we see the book in terms of an opportunity for rewriting—for all of the possibilities within the book that it held out as potential tales. Tasked with the challenge of thinking about where and how we might change it, our relation to the text shifted radically. My own motivation as a reader suddenly spiked, fueled by an investment in finding the right place for an intervention. This realization of the power of shifting from passive to active reader, from spectator to participant in a project-based exercise became the basis of my commitment to Ivanhoe.

Ivanhoe was not intended as a recast version of Clue, or a dinner mystery for the amateur scholar. It was a game, but it was also meant to pro-

mote collaborative and intersubjective fields of exchange. McGann and I played a round of Ivanhoe, largely through an e-mail exchange of rewritten endings to Scott's tale. From that epiphany came the outlines and basic principles of the game:

Role Playing. To begin the game, each player had to assume a role, or "embodiment metaphor." This provoked a self-conscious identification of subjectivity, making explicit the usually implicit framework of critical writing. Every move, every comment, remark, or research gesture was clearly identified with the point of view or position from which the player was writing—including historical and social circumstances, education, gender, motivation, professional credentials or other interests. No neutral articulation of critical positions could be assumed.

Roles could be specific. For instance, in one game played with Emily Brontë's *Wuthering Heights,* I chose to "be" Isabel Arundel, the woman who married the nineteenth-century author and traveler Richard Burton. I chose to engage her persona at the time of her betrothal, when Burton was traveling and Arundel was imagining her own escape from the confines of convention. In her character, I rewrote the attitude of young Catherine Earnshaw as Arundel's exploration of feminist fantasies of independent adventure while she waited for the wandering Burton. The levels of embeddedness were often multiple, since we were players taking on personae in order to enter the characters in the various tales. The game of masks was part of the pleasure of the social exchange in play.

Other roles were more vaguely defined, with characters coming into focus over the sequence of plays. I played the *Turn of the Screw* in the persona of an Oulipo-inspired graduate student assistant working with the compilers of a concordance of the text. In that character, I chose to rework the text at every occurrence of the name of the character Flora. I reconfigured the work as a feminist protest of Henry James's conception of the girl's sexual imagination. In this case, I had a sense of the strategy I would use to generate moves but not of the specific outline of the persona through which the texts would be enacted. More and less erudite engagements were possible, but every move had to be accompanied by a journal entry justifying the intellectual basis of the contribution from the point of view of the assumed role. The point of such self-conscious masks was to debunk the myth of authorial neutrality. We worked to enact our authorial conceits and constructed subjectivities, in accord with lessons from critical theory, and to enact the social production of scholarly or critical work.

Discourse field. Every text, document, or artifact that came into play had to be introduced deliberately (or "called") into the discourse field; each document was conceived, not as "original" or "primary," but as part of a social history that included its production and reception. Exposing this field though connections, links, associations, and readings was part of the task of Ivanhoe. In order to show that no text was self-identical or self-evident, the game registered the alterations rendered by each interpretation. The text literally changed, according to the interventions of the players, who could alter the document or refract the text through commentary, links, or other glosses. By making an environment where a text was constantly altered or deformed, we created a discourse field in which reception and production were integrated and registered in the material structure of the text and game space. Every act of interpretation remained part of the structure and display of the document.

Moves. Ivanhoe was conceived as a writing game. Though "moves" were not limited to text-based activity, and could include visual, and in principle, time-based audio or video material, the primary mode of intervention in the game was through text. Each act of interpretation, whether the creation of a note, node, or link or the introduction of a new document or commentary into the discourse field, was accompanied by a justification or explanation in the player's log. (In one version of our design, a player could be challenged to justify a move, and if no log existed, or it didn't make a strong enough argument, then the player would "lose" the challenge.) Ivanhoe's role-playing structure and open-ended discourse field allowed for creative and imaginative writing as well as critical or scholarly production.

Point of view. All features of the game—creation of roles, introduction of elements into the discourse field, moves, comments, player logs, and so on—were linked to particular players and roles. This structured subjectivity into the game space, since the game was always seen from the point of view of one of the players/roles. No "outside" view existed. A now-slider feature, marked with ticks that showed each player's contribution to the game in sequence, could be advanced to show the progress of the game from someone's point of view. An Ivanhoe game is always read from within the space of game-play.

Social space. We quickly became aware of the importance of the social space of Ivanhoe as an impetus for motivating game-play. The motivation to make a clever move to delight or pique one's fellow players upped the

ante for reading considerably. This was an important aspect of Ivanhoe's effectiveness. We were intent to demonstrate that scholarship and criticism, as well as authorship of creative and imaginative works, take place in social space, but also to make that part of the game in a substantive way. Skills in bibliographical work, wit, aesthetics, or composition were rewarded in versions of the game in which points and scoring systems are put into play.[6] Though we later abandoned the idea of a scored game model, we noted that Ivanhoe fostered some of the competitive dimensions that motivate performance in social space, simply by virtue of the public nature of players' moves.

: : :

To reiterate, the basic principles on which Ivanhoe was conceived were the non–self-identicality of texts; theoretical engagement with a discourse field; attention to bibliographical artifacts and their materiality; attention to documentary evidence and the trail of works through their production histories; the transformation of a text through its reception (marked in responses and versions); the situatedness of every reader within a role whose historical and social conditions had to be made explicit; and the social space of play. The task of designing Ivanhoe arose in parallel discussions and experiments.

Ivanhoe went through several technological and design iterations. Each had an impact on the reading experience and on the ways computational capabilities could be engaged in the game-play. The fundamental game can be played with pen and paper as well as in electronic space (as was done in a middle-school version), and the lower technological requirements refocus social and personal goals toward a classroom experience.[7] The use of various Web-based tools for creating an environment for geographically distributed and asynchronous play increased the capacity for participation among a wider group of players in the *Wuthering Heights* and *Turn of the Screw* games. But the tools we were adapting had significant drawbacks, relying on long scrolling screens of accumulated exchange to log the progress of the game. These environments were difficult to navigate and harder yet to conceptualize in any cognitive gestalt. We realized we had to design a customized environment.

Designing Ivanhoe

Creating designs for Ivanhoe's interface advanced our critical thinking about the project, perhaps even more so than in the case of Temporal Modeling, in part because we talked about the design in so many con-

texts and with such a varied cast of characters.[8] Key ideas emerged from visual sketches, and implementations of critical and technical issues derived from the way activities were visualized. But grappling with this design also reinforced my understanding of the ways an interface exists at the intersection of two distinct practices—engineering and information design. Each discipline has its own priorities and values. Engineering emphasizes functional implementation, while information design draws on the capacity of graphic expressions to communicate clearly to a user. Yet both approach visuality with certain shared assumptions about communication and visual forms. And both operate far from the influence of critical thinking about visual representation. Though it may seem a reach to connect engineering-based approaches to human-computer interface and poststructuralist criticism, that is precisely what designing Ivanhoe required. Promoting serious dialogue between the traditions of critical thought and applied knowledge was crucial to Ivanhoe, and reflection on the place of interface design within the larger concerns of visual studies seems useful as a critical frame of reference.

Engineering approaches to interface, such as those perfected by Ben Shneiderman or Stuart Card, are grounded in certain assumptions that serve the task at hand but go unquestioned at the level of ontology. Their approach is pragmatic, drawing on cognitive psychology, with its attention to the problem of designing environments that work with the operative limitations of human intelligence rather than against them, and with increasing computational speed and capabilities. Such design is guided by principles of perception and cognition that can be tested and codified, such as the number of items that can be held in short-term memory, expectations about real-time interactivity, hand-eye coordination, and so forth.[9] No one would argue with the soundness of this approach as a basis for the design of everything from air traffic safety systems to operating room feedback mechanisms and ATM machines. After all, less considered approaches are the source of innumerable frustrations. Think, for instance, of being asked to enter information into a space too small to display it.[10] (Try typing "Charlottesville" into the "city" space in most standard forms, and hope that the arbitrarily truncated name doesn't result in your tax documents being sent to North Carolina instead of central Virginia.) Or recall searching for the "enter" button to respond to a question on the gas pump display—only to realize that it happens to be labeled "OK" on this particular keypad. For most practical purposes, the engineering approach to design of human-computer interface is essential.

Engineering and cognition-based approaches place a lower premium on aesthetics than on what they consider functionality. Engineering solutions often stop with a design that works adequately, rather than seeking solutions that emphasize the rhetorical benefits of seductively engaging or rewarding a viewer. Sometimes such literal notions of functionality can prove so restrictive that they undermine the results—as is famously demonstrated in cross-cultural instances in which a machine interface is developed with no regard for the social rituals that would allow it to work effectively in context.[11] (ATM machines in Japan were almost ignored before the introduction of animated figures that greet the customer.) Information designers are well aware that there is no such thing as "mere information"—organization, sequence of access, and relations among parts of an information system all contribute to the success or failure of communication in an interface.

Overall, information designers rate clarity above beauty, as if the two were mutually exclusive, or even separable. The work of Edward Tufte is a notable exception, hence the high regard for his elegant designs. But no matter where they fall on the aesthetic spectrum, information designers—whether we are referring to Tufte, a consummate professional like Richard Saul Wurman, or the producer of garden-variety presentation graphics—share a core belief system with their engineering colleagues.[12] They believe that the formal properties of graphic presentation can create a stable image of data. The quality of *transparency*—the ability to reveal information—is premised on a belief in *apparency,* the conviction that formal structures communicate directly through visual means.

Intent on creating effective means of communicating information in visual form, information designers almost entirely ignore the substantive theoretical problems, posed by iconographical studies, semiotics, and poststructuralist theory, that touch on the identity of images themselves or the cognitive function of aesthetics.[13] An empiricist assumption that what you see is what is there underpins their practice. The self-evident character of graphic entities—lines, marks, colors, shapes—is never itself brought into question, however much the parameters on which they are generated or labeled might be criticized. That images themselves might be dialectical, produced as artifacts of exchange and emergence, is an idea foreign to the fields of engineering and information design. (While information displays can be interactive, and results produced through variable input, they are not imagined to have been brought into being through dialectical relations.)

Even the idea that diagrams or graphics have a cultural history and

resonance carries little weight unless the issues have the kind of impact of the Japanese problems with ATMs.[14] Press an engineer or information designer on these issues, and you will likely be told they are irrelevant. Presentation graphics, though produced with a keen awareness of formal, material properties, are still premised on the notion of appearance as a means of revealing information rather than on a cognitive, performance-oriented model. As if "information" existed a priori and independent of human subjectivity, visual forms are arrived at through a series of design decisions that present the "best"—that is, most transparent—image of that information. Such approaches are consistent with a structuralist semiotics, in which a sign system comprises two related elements in a simple binary relation, both at the micro level (signifier/signified) and at the next higher order of organization (plane of discourse/plane of reference). Such binarisms, and the stable-seeming sign systems they employ, are the legacy of a structuralist tradition that is formal and descriptive (transcendent) rather than dialectical and dynamic (emergent). Ivanhoe's design was premised on the idea that an image is a structure created through an act of intervention in a potential field and that this image calls forth a performance. An image is not a stable form revealing a fixed meaning (or predetermined possible meanings, in the case of interactive display). The implications of this distinction are profound.

We need not resort to the deconstruction of visuality to critique approaches to information design that are based on faith in the a priori existence of data. It is intellectual child's play to conceive of misguided statistical methods that produce inaccurate quantitative results that nonetheless pass for empirical data. Nor is it difficult to demonstrate that the visual form in which information is presented has a great impact on how that information reads and what it is assumed to communicate.[15] But the assumption remains that the rhetorical distortions introduced by an ill-conceived or overly expressive visual presentation can be "corrected" to make the image a clearer, more transparent instrument for revelation of the "truth" of the data. Despite decades of work subjecting truth claims to critical scrutiny, mathesis has had a strong resurgence of cultural primacy thanks to digital technology. The statistical character of data has asserted the validity of quantitative approaches all over again.[16] These are issues I have already mentioned and to which I will return in the essays on aesthetics.

But even if we consider information design on its own terms, many critical issues could be raised about the relation between information and its presentation. These arguments would demonstrate, ultimately,

that the presentation does not embody information that exists elsewhere in another form. Presentation in graphical form creates a structure to engage the cognitive production of meaning. Some of the visualizations we imagined for Ivanhoe operated in familiar ways, serving to create a compact, highly legible display of quantitative information. In other cases, however, we deliberately selected an arbitrary-seeming display format in order to be suggestive or provocative. These theoretical issues arose from discussions in fields other than information graphics and engineering, drawing on traditions that critique the idea of "presence" and the apparently self-evident character of visual images.

The presumption of visual presence, or of graphical form as self-evident, is similar to the attitude toward textuality that construes a literary work to be equivalent to its words—or, worse, its "meaning." (Readings of materiality that emphasize formal characteristics and the discernment of meaning, as if the literal surface were transparent, are equally plagued by the shortcomings of the information-delivery model of graphical presentation.)[17] Ivanhoe's interface design attempted to use visual and graphical means to make critical awareness central to the game, while also, incidentally, raising issues about visuality that complement those underlying its conceptualization from a textual studies perspective. The graphic vocabulary of Ivanhoe thus calls attention to emergent, generative, iterative, procedural, and transformative activities. These dynamic characteristics are conspicuous properties of digital media and, once they are really understood, of *any* artifact, no matter what the medium. Electronic interface design, in our approach, is premised on the idea that a visual form *does* something, rather than that it *is* something. In Ivanhoe, this principle was foremost. As will be clear in my discussion of e-books in chapter 3.3, this insight is relevant to understanding paper-based and print artifacts as well as electronic ones. We borrowed from systems theory and cognitive science, rather than engineering and formal graphics. But we also drew on the theoretical context of visual studies in formulating the aesthetics on which the design of Ivanhoe is based.

Our theoretical conversations were informed by information-processing theories of vision that have displaced older, mechanistic models of perception. Here, again, cognitive science and psychology combine to create an iterative conception. Instead of imagining vision as a one-way communication channel—an eye receiving stimulation and sending a signal to the brain—cognitive approaches describe an optical system. A feedback loop connects a learning eye and a continually revised cognitive model. In this system, neither image nor idea exists a

priori, and sensation is an effect of cognitive capability. This shift in models of vision has implications for the way images are understood. The work of the biologists Humberto Maturana and Francisco Varela, pioneers in the cognitive approach to human knowledge, demonstrates that we constitute the objects we perceive through our capabilities, and they, in turn, act on and transform our capabilities as well as our understanding.[18] Vision is an emergent activity. An image is an entity constituted through a perceptual act. In other words, as Alan MacEachren says, the information processing model of vision has undermined previous ideas about the autonomy of images, sensations—and of individuals as discrete entities simply reacting to or perceiving preexisting elements as a set of stimuli-response mechanisms.[19] Instead, we have to understand all of these as components of a dynamic system in which interaction among elements produces effects. Such an approach doesn't disregard the intrinsic properties of, for instance, texts, graphics, and images. But it emphasizes that these formal and material properties define a set of contingencies, conditions from which an intervening perception can be produced. An image is constituted by this act as well as giving rise to it as a performance of its structured codes and possibilities. The idea that an eye "learns" through exposure to various kinds of stimuli lends support to arguments for aesthetic agency and the formative power of expressive means.

The idea of autonomy, undermined by this cognitive turn, came directly out of modernist art and aesthetic theory.[20] Indeed, one distinctive characteristic of modernism was its insistence on autonomy, defined, first and foremost, as the insistence that images are self-sufficient presences, rather than representations. ("You present a baby," Picasso famously stated, making an analogy between paintings and other progeny, "you don't represent it.")[21] On this belief are built ideas of autonomous art as a form of cultural expression, but the founding premise is that images are self-evident and apparent. This concept of self-evident autonomy is qualified by the recognition that many signs are legible only with specialized knowledge of their codes; nonetheless, visual *forms,* it is asserted, can be grasped directly by the eye in their full and replete self-sufficiency. This conviction is integral to the still-persistent tenets of structuralist semiotics, in which the apparency of the signifier is never up for question. Formalist approaches to visual images are based on these assumptions, and Ferdinand de Saussure's lectures of 1911–1912, famously transcribed as the founding texts of structural linguistics, incorporate the same formalist precepts.[22] We can see evidence of the idea of visual autonomy in every

critical articulation of modern art. Emile Zola, writing of Edouard Manet's painting in the mid-nineteenth century, stressed the "thereness" of visual art as "nothing but simple facts"—with an emphatic insistence on the formal presence of images.[23] This idea of aesthetic autonomy can be traced to mid-nineteenth-century critical writings, but it reaches a crucial turning point in the early twentieth century. In the 1910s and 1920s, theories of representation—visual, linguistic, and semiotic—align under the banner of full-fledged modern formalism. Since this is also the historical epoch in which graphic design as we know it came into being, it is hardly surprising that a field like information design continues that sensibility into the present. The terminology of visual communication, the so-called "language of design," is itself a direct legacy of the work of artists like Wassily Kandinsky and Paul Klee, whose attempts to fix the rules of abstract composition, color, and form had such a influence on early-twentieth-century art and design.

Other intellectual traditions lend credibility to notions of formalist autonomy. The formalist turn is a part of the larger "rationalization of sight" described by print historian William Ivins. The virtue of printed images, their capacity for "exactly repeatable" replication, contributed to the stable representation of knowledge and its dissemination in standardized form. Ivins argued that standardized, conventional, stable representation in graphical or pictorial formats gives visuality a unique role in modern epistemology. Like the work of imaginative artists of the early twentieth century, Ivins's work is based on Cartesian principles of rationality. Principles of post-Cartesian graphics—non-Euclidian geometry, nonlinear analysis of event-formations—have yet to serve the daily business of information graphics or to become a staple of display design. For current purposes, the simple critique of formal autonomy should be understood in relation to the way assumptions about presence—a legacy of modernism—persist in current electronic information design. When put to specific use in the display of empirically gathered data, an image is considered a stable entity whose materiality is conflated with its presence. The tendency is to collapse the materiality of images with their formal value. An image *is* by virtue of its formal properties. But just as a text is a field of possibilities that engages a reader, so an image—and graphical forms of text are included in this term—should be seen as a work to be performed through interaction and response. This approach to vision cycles us back to the information-processing model described above and contains the suggestion that the very field of visual presentation should shift in response to the active engagement of a viewer. Ivanhoe's inter-

face isn't designed merely to "represent" individual subjectivity, but to provide the space in which it can be performed.

The applied aesthetic challenges of Ivanhoe were just as daunting as the theoretical ones. First, we faced the challenge of making visible critical concerns that were almost intractably abstract. How could we present a "discourse field," conceived as encompassing a social and production history and field of associations, within which any particular text is simply one snap-shot instantiation? Was it possible to make evident through graphical means the "non–self-identicality" of a text? Could the dynamics of play be given a configured form as a visualization that becomes a primary site of activity rather than simply a display? The technical challenges were nontrivial, as were the design tasks. What were the conceptual primitives of a schema for such a design? What set of objects, relations, and behaviors defined the structural foundation of this system, free of specific content but able to provide a framework for the activity of critical studies? Our ideas became increasingly concrete as we proceeded. We moved from named and identified areas of a screen subdivided into windows to a fluid, activity-based, space of activity zones—in other words, from a rigid, formal structure with a priori labels to a dynamic field configured to show emerging relations and contingencies.

The earliest versions of the interface design, hand-drawn in the summer of 2000, used conventions of software design based on windows, icons, and pull-down menus. This allowed us to schematically represent all the functionality we wanted to include in the design. We dealt with the limited screen real estate by collapsing many of the activities of Ivanhoe into spaces that could be clicked open. The sense of "thereness" in this design was overwhelming. To begin with, the interface was organized around a "source text" (a term we subsequently discarded in favor of "called text" and "declared edition"), which dominated the screen. This text, and the workspace below it, were strongly reified by framing devices that fixed their relationship into a hierarchy while making it almost impossible to display any other documents from the discourse field. While this scheme worked well as a sketch, as a design it was flawed. The software interface wasn't Web-friendly, for one thing. And the windows structure was at odds with the basic premise that entities will define each other through contingent relations. By creating fixed spaces, labeled in advance for each activity and type of text or move, this interface embodied many ideas we had set out to counter. It provided a useful point of departure, however, for all those reasons (figure 2.2.1)

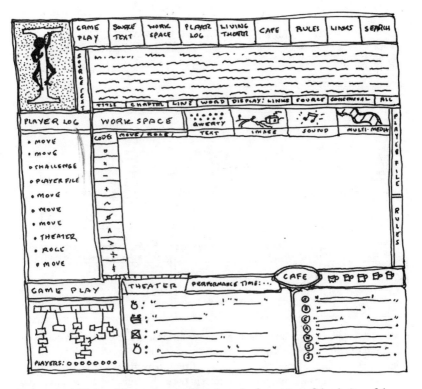

Figure 2.2.1. This hand-drawn image of Ivanhoe, the first vision of the design of the game space, uses the idiom of existing software, with menus and bars and spaces for work all fixed into a grid. A remarkable number of these elements ended up in the final design: access to a source text and the capacity to modify it; spaces for players/roles to engage the text, log their moves, and record exchanges with other players; tools for visualizing game play; a list of rules , search capabilities; and outside links. The figure of Ivan was redesigned, made more streamlined and robotic, but his figure remained as well (he is shown here embracing the *I* on the upper left). Our struggles with moving from codex-style texts to online display are marked in the small menu bar below the source text where title, chapter, line etc. are aligned. We also envisioned the possibility of different media—visuals, sound, video, and other time-based artifacts—being brought into the discourse field.

We formalized that initial design as a storyboarded exercise so that we could see how it would work in step-by-step user scenarios. This interface included visualization spaces for various aspects of the game that lent themselves to iterative and procedural presentation, such as the game-play diagram and a space for showing linked elements of the discourse field (figures 2.2.2, 2.2.3). From the beginning we knew that visualizations had to play a key role—not only in providing the graphical

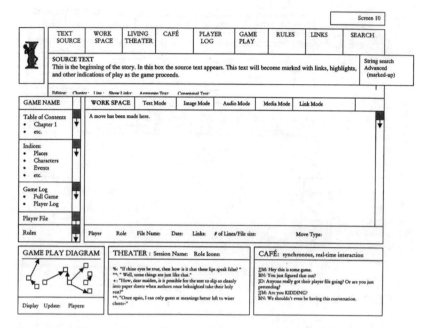

Figure 2.2.2. This translation of the hand-drawn image into a screen design has greater clarity but introduces no substantive changes. The image shown is Screen 10 from a series of storyboards tracking the game from an opening menu to this state. Storyboarding was part of our design process in the early stages, before we did any coding or programming.

form of texts, but as a means of analyzing the dynamics of an emergent work and social field of activity.

As we struggled with alternatives to the windows-based interface, we considered the possibility of the archive, library, or codex as a foundational metaphor. In one version, we took this idea to a literal extreme, conjuring an interface design that "looked like" a library space (figures 2.2.4, 2.2.5). Abstracting function and activity from literal representation of spaces took some time. The tendency is to imagine that a simulated space, because it can be visualized on a screen, will function in the same way as a real space. The specific properties of a digital environment, however, its irremediably flat surface and limited screen real estate, are fundamental to its display capabilities. Thus very different design conventions were needed. We imagined a desktop environment capable of flexible arrangements and interlinked documents (figure 2.2.6). So we overturned this rather literal metaphor and turned our attention to imagining ways to create a deep-space, nonrepresentational topography

DISCOURSE FIELD – GAME LOG					
METATEXTUAL MOVES					
INTRO					
TEXTUAL MOVES					
Chapter 1		**			
Chapter 2					
Chapter 3					
Chapter 4					
Chapter 5	%				
PARATEXTUAL MOVES					
NOTES	☐				
BIBLIOGRAPHY					
APPENDICES					
INDEX					
EXTRATEXTUAL MOVES					
PLAYERS	A: % $	B: **	C: ^!^	D: +	E: #
PLAYER FILE					

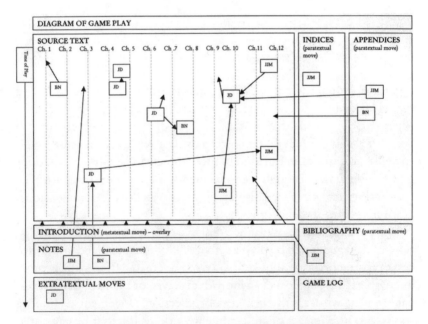

Figure 2.2.3. Details of the game play are shown in these diagrams. These visualizations, not part of the functioning software, were modified only slightly in the final designs, changed more in look than in functionality. The mapping of the social space of interpretation was central to our designs from the outset.

Figure 2.2.4. This sketch of books and papers in play pushed the issue of literal representation in the interface design into focus. Even in its preliminary form, it was dismissed by the design group, but it occasioned a useful discussion about the distinction between imitation of form and replication of activity or functionality.

organized by coordinate axes. The question of parameterization, and of what semantic values to attach to these axes, came up immediately. We may well concede that a book is a three-dimensional object that we encounter along a fourth, temporal axis. But we don't navigate a text spatially, at least not in the kind of three-dimensionality that is used for fly-through views. Though we jettisoned the idea of creating artificial conventions for spatialized display, we preserved the use of dimensional illusion in some of the designs.

A persistent feature of Ivanhoe designs was the presence of visualizations of data generated by player activity. We were interested in the process of abstraction that allowed displays to be created from such seeming intangibles as the choices of an individual player, or the character of their engagement with a particular text or selection of elements. The idea was to produce images of an "emergent work" as it might be generated through the intersubjective exchanges among participants and artifacts. The arbitrariness of assigning values for display was evident. But we were not trying to model any a priori evidence; rather, we sought to support a model as an emergent manifestation of activity. The idea of the visual

presentation as an aesthetic provocation, as a primary interpretive act, was at work, along with a willingness to suspend allegiance to empirical models of statistical information gathering.

Our experiments with screen display included exploring the ways resizable elements, tabs, stacking and layering, and careful variation of

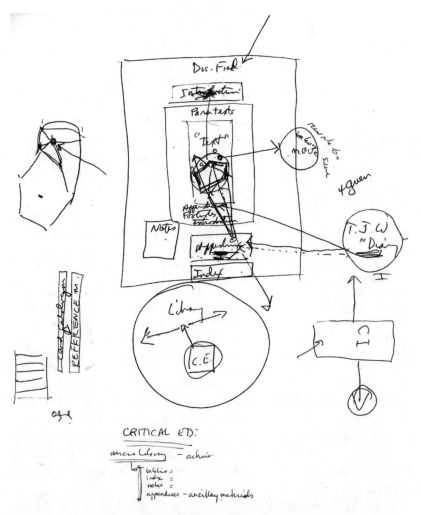

Figure 2.2.5. This is another literal diagram, but instead of simply copying the image of the books (as in figure 2.2.4) it combines images of a discourse field and a library workspace. The exercise was to make clear to ourselves how we understood the research process as a series of specialized zones and activities. This kind of modeling created an abstract scheme on the basis of which we could design an environment that arose from within the specific constraints of digital media.

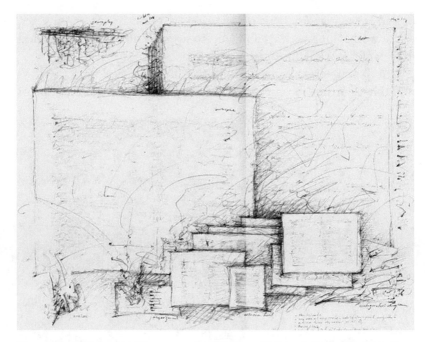

Figure 2.2.6. This image of documents in a discourse field shows the production of a reading through relations and association trails and traces (very much in the spirit of the 'Patacritical Demon; see chap. 2.5). The crucial idea was to design a space in which connections among documents and the readings they provoked would be visible. A small game-play diagram (upper left) tracks interactions among players in the game space. Though not directly applicable to our designs, drawings such as this helped keep our visualizations from shutting down into already established interface conventions.

transparency and opacity might take full advantage of electronic environments. Bethany Nowviskie's visualizations of emergent avatars gave form to on-the-fly characterizations of play, creating abstract figures, in a prototype demonstration of the aesthetic provocations originally sketched by hand. Many of these elements found their way into the "frames-based" hand-drawn sketches from which our final designs were derived.

Other electronic renderings included a modified version of a blog, created by Nowviskie for playing *Turn of the Screw* in spring 2002, and a Web-based windows version designed by Nathan Piazza. Nowviskie's design, though quite simple (no dynamic, on-the-fly diagrammatic features or elaborate navigation), provided a legible way to separate the several areas of game-play. The source text, moves, player journals, evaluations,

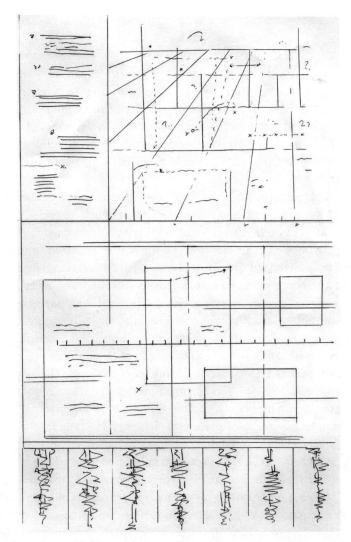

Figure 2.2.7. This schematic visualization of areas of a workspace grew directly out of the previous image. The perspectival lines (top) are meant to chart a discourse field. Document-based features appear in the overlapping planes of a work/play space below. And images of emerging avatar/players are arrayed along the bottom edge. We imagined that these figures would be spontaneously generated by the computer and that players would adjust their games to change the shapes of their avatars, thus responding to their own "look" and "style" as manifestations of their approach to the game.

and challenge spaces that constitute the game each had a color code and individually logged sequence of moves.

Piazza's interface used standard Web-space conventions (sidebars, navigation bar, etc.). In that version we confronted, more than in any previous visualization, the reifying effects of an on-screen presentation of a text. The flat surface, the seamless unity of the windows environment, reinforced a sense of "thereness" that spoke volumes about the need to modify our electronic space dramatically, and to rethink the relation between theoretical precepts in textuality and those derived from visual studies.

The subsequent iteration of Ivanhoe's interface was derived from reflection on these previous versions. The design followed a few basic principles. First, that screen display is governed by two fundamental properties: the flat surface and the illusion of depth. All display in Ivanhoe acknowledged that flat surface—with artifacts displayed in the convention of the picture plane, perpendicular to the viewer's point of view. Within the screen, even within a document, a potentially unlimited number of deep-spaces could open along other coordinate or perspectival axes. For instance, if a series of associated terms (e.g., the heteroglossic field of a word) was to be shown, it could open from any place in the text as a deep space receding from or toward the viewer for purposes of display. The layering and palimpsestlike character of textual interpretation and bibliographical study could be accommodated by adjusting the transparency of particular elements. No text would simply appear; rather, every text would have to be "called" through a "discourse portal" and then "declared" as an edition or version in which to work. As interpretive play began, the text was to be "claimed" and marked, its "codes" revealed, and its structuring principles made graphically evident through the patterns of play. Size and scale were to be used to facilitate the stacking of documents, support materials, palimpsest versions, moves, workspaces, journals, logs, and other materials. And no fixed windows or frames would unify the space. All the elements in play at any time, both within an individual player's space and in the game as a whole, were to be represented in some visualization, as were the configured relations among these (figures 2.2.8, 2.2.9).

These premises counteracted the idea of display as the extrinsic visual manifestation of already present or known "information." We intended to take advantage of the efficiencies of visual modes of gestalt for complex, large-scale sets of information. Visualization was instead conceived as an aid to intellectual and imaginative thought, not simply a means to

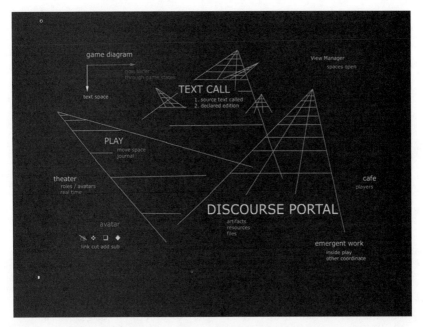

Figure 2.2.8. This diagram, a translation of the schematic features of our conceptualization into a free-floating field, was an enormous leap forward. We had determined that no text would be specified as a "source text" since that would give it a priori identity and authority. Instead texts would have to be "called" and then "declared" the working copy or edition for the game. This element became part of the game space of Ivanhoe in the sense that a player's bringing a text into the game constituted a "move." The discourse portal was the place where all the texts called into the game were versioned and accessed. The "emergent work" was the text being constituted within the game. Café space and theater spaces allowed for in-game role playing and discussion. And the two axes of the game diagram allowed the now slider to progress through game states even as the text space continued to evolve. Link, cut, add, and substitute functions for altering a text hover near an avatar, since it is likely that the avatar image will be formed by the sum of the activities of the player. This schematic, though it couldn't be realized directly, did create a model of the game as a set of intersecting zones of activity. It functioned as a visual model of the conceptual primitives (content types and functions) in Ivanhoe.

provide access to a fixed set of structured relations but a primary mode of theoretical query. The design called for a fluid, dynamic, and highly iterative and emergent interface, one that allowed for transformation of the information within the field of play at the level of material. Visualization was a means for intervention as well as display. The interface included basic zones of activity, rather than rigidly defined areas, a priori subdivisions, of its limited screen real estate. No activity had a predefined

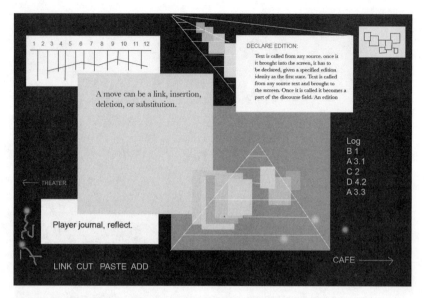

Figure 2.2.9. This visualization took the schematic diagram from 2.2.8 and made it into a screen-based work environment. The ghosts of the previous diagram show in the background, and degrees of transparency allow the visualization to register some of the crucial aspects of versioning, game-play, available functions, avatar development, and so forth. This was the last of the sketches and visualizations made before we actually created Ivanhoe.

area or space, though the basic elements of "text call," "discourse portal," and areas of "play" and "commentary" were assigned zones within the overall screen. As the process unfolded, a work emerged from the elements brought into play and the relations configured among them and the participants. The dynamic web of relations could be viewed from any number of subjective positions—no view existed outside the game-play, just as no work preexisted its performance in the electronic space.

At that stage of design and theorization, when actual software development took over from the conceptual design process, Ivanhoe's interface drew on a host of concepts from the history and theory of information in emergent spaces. These are touched upon in the following list of attributes. (See figure 2.2.10 for images of Ivanhoe as implemented in working prototype.)

Dialogic and networked. Ivanhoe was created at the intersection of individual subjectivities in dialogue with each other through a work

and its interpretive field. The interface was meant to permit the mapping of these interrelations, and emphasized the social nature of the production of imaginative work and the collaborative character of interpretive acts. The critical foundation for this approach drew on conceptions of the Web as a social space. Envisioned in H. G. Well's prescient vision of the world mind, this notion of virtual communication and exchange was the impetus for J. C. Licklider's work in the 1960s on human-computer symbiosis as the basis of virtual communities.[24] Reinforcing the idea of interface as a portal to social interaction, Ivanhoe was designed to discourage solipsistic play and to encourage the recognition that creative and scholarly work takes place in a social space.

Figure 2.2.10. Elements of the game in action

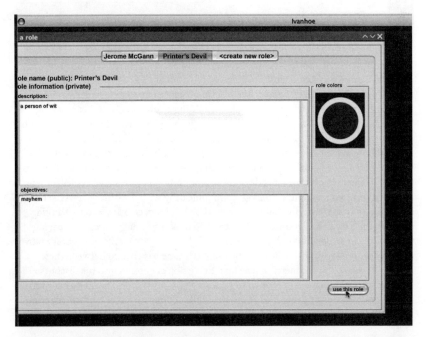

2.2.10a. Role definition. The first task for a player wishing to enter the game is to create a role and then to define the game by giving it a description and objectives. Here player Jerome McGann created the role "Printer's Devil." Though the name was public, the description and objectives were not. These were elements that were scripted into the game either for pedagogical purposes or for use in group tasks where assessment or self-assessment might be useful. But even within the realm of criticism or research, they serve to increase self-consciousness about the tasks and approaches the player is taking on as a role. A player could have more than one role. (Thanks to Jerome McGann for permission to use these images.)

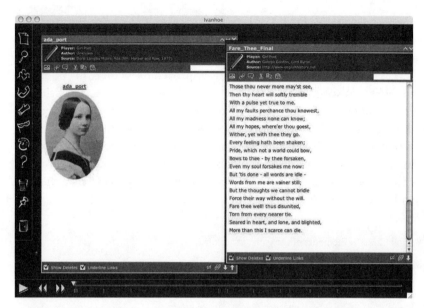

2.2.10b. Initial contributions to the discourse field. This screen shot shows some early moves in a game we played with Lord Byron's poem "Fare Thee Well." The examples that follow will be from this game. Every action in the game space is called a "move," whether it involves introducing a document, adding a comment or link, or making some other change to the game state. Girl Poet (my role) has introduced two elements, one the photograph of Ada Lovelace, whose author is "unknown," and the text of the poem, whose author is identified. Sources are given for both objects. Note that each window has a pencil in its upper left, indicating that Girl Poet can edit or work in this space. The menu bar on the left side of the screen shows the various activities the game allows: adding a document, searching, communicating with the other players, sending a personal message, entering information in the player log, creating a role, changing colors in the play space, getting help, discarding moves, posting moves, and leaving the game. On the bottom of the screen a now slider with tick-marks shows every move made by every player, with ellipses indicating that time has elapsed between these that is not marked in the metric of the line. Every object entered into the discourse field has its own identity but is open to versioning by any player. The menu bar in the window of each object shows that it can have links, comments, cuts, and other actions performed.

Generative and procedural. Max Bense's discussion of generative aesthetics in the early 1960s established the idea that visual forms, even those he defined as artistic, have an algorithmic foundation.[25] Extended through the study of complex systems, the idea of rule-based, procedural production of imaginative works or interpretations is grounded in computational methods. Bense's vision was limited by his mechanistic conception of form, but certain features of his premise remain useful. Generating

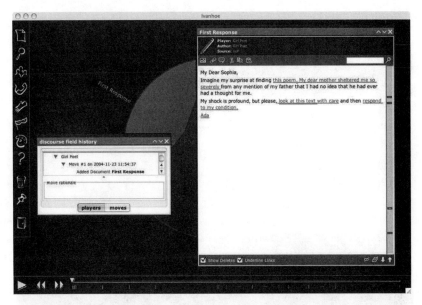

2.2.10c. This game, like most of our test games, involved playful invention. Here the Ada character, as envisioned by Girl Poet, is writing to a girlfriend, Sophia, in order to justify the discoveries she is making about herself, her father's feelings about leaving her mother, and her own changes to the poem he wrote. Every underlined area is a link, or double link, and tick marks in the side bar indicate changes or additions to the text in the window.

2.2.10d. Annabella Milbanke's poem was written by Girl Poet, though another source is speciously identified. All kinds of display bugs show in this artifact, especially where special characters were to be set. This was an early design glitch.

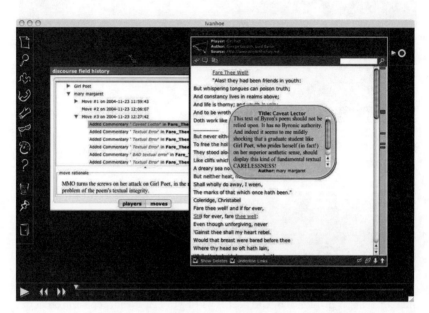

2.2.10e. As the game progressed, the character Mary Margaret, pretending to be a student, made comments and interventions. Her icon in the marble tray (upper right) is highlighted, indicating that the screen represents her point of view. Her move is being entered in the discourse field and recorded in the discourse field history.

visualizations, or moves, from prescribed procedures is one aspect of this approach, but reversing that process and generating rules and procedures from visualizations is the other. The latter implements the potential of an image as a primary, first-order expression of knowledge, whose algorithmic foundation can be revealed. In addition, the notion of generative aesthetics applies to every graphical visualization of text or other artifact within the space of play, since these involve "calling forth" a document and then rendering it through an algorithmic transformation of the data.

Emergent. Visualization through on-the-fly processing of information that is itself constantly changing manifests degrees of complexity not contained within or accounted for in the first generation of instructions. Emergent behaviors, such as those generated by swarm systems, or even by simpler artificial intelligence engines that use probabilistic methods to produce statistically varied results, were used to create player avatars and other game-play diagrams and representations. These were meant to return to the game as aesthetic provocations. The shape of game-play would produce the "emergent work" that was the ongoing outcome of

interpretive actions among players. This would necessarily be a continually evolving form.

Relational. Ted Nelson's earliest notions of the Web as a space of associative meaning extended Vannevar Bush's concepts of Memex from the mid-1940s.[26] Ways of thinking about knowledge as an interlinked field have been a part of the mythology of networked knowledge systems since their invention, and earlier, paper-based diagrammatic organizations of knowledge and argument can be traced to Ramus and his method in the late Middle Ages. Reconfigured conceptions of this approach are part of Renaissance formalizations of knowledge (classification systems, textual and paratextual apparatuses, and well as graphical modes of information representation), but the electronic environment has awakened aware-

2.2.10f. The discourse field history is date stamped and shows every alteration, comment, link, or move made by the player/role in the game space.

2.2.10g. The version of "Fare Thee Well" shown here is the final copy of the poem from Girl Poet's point of view. Underlined text indicates changes and comments, such as the one that is in the bubble in the window. Girl Poet's marble is highlighted, and the discourse field (background disk) is coded with her colors.

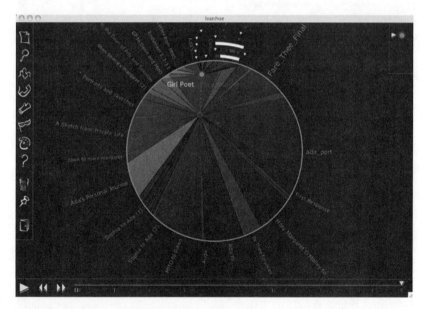

2.2.10h. View of the game in its final stages, from the point of view of my character, Girl Poet. The size of the poem's title shows its importance, measured in terms of the attention given it by players in the game. The productive, generative dialogue in the game is shown by the relative positions of the players, their dotted lines of influence, and the many rays of connection and relation to each other.

ness of the living character of associative thought processes.[27] The notion of a text as a single, incidental instance of a larger discourse field—as a snapshot in the sequence of production events—was one central theme of Ivanhoe. The bibliographical or genealogical relation of artifacts to each other was presented according to production and reception histories within recursive, nonhierarchical, and contradictory models.

Iterative and manipulative. The interface permitted versioning, and the palimpsest of meaning production could be perceived as a thick field of interpretive activity and meaning production. Game-play states, their continual transformation and relation to each other, to the initial state of the game, and the basic work and rework of a series of recursive interactions were all available for presentation and analysis. The lessons of responsive interface and direct manipulation (or its illusion) in work by Ben Shneiderman and others established conventions for a reversible, navigable, legible design.[28] Going beyond menu-driven options, or combinations of preset data, Ivanhoe's interface was designed to allow manipulation of the elements of the game at the information level (coded data), not only that of display. Display and visualizations provided a point of direct access to the structured data of the emergent work or the game-play.

Dialectical. The interface demonstrated the non–self-identical character of visual artifacts. No work existed a priori in Ivanhoe. Images or text had to be called and then declared, that is, given a presentation form. This reinforced the realization that any visual form is a constitutive intervention in a field of potential, rather than the display of an inert or fixed artifact. This principle, of calling and declaring, echoed the process of intervention crucial to quantum mechanics, where the act of intervening determines an outcome from a probability distribution. Ivanhoe's interface called artifacts, game-play, player profiles, activities, and behaviors into being so they could be configured as visual entities. On another level of display, the continually shifting configuration of elements in play constituted the "work." The design emphasis was on contingency and relational production of configured form rather than on any formal or a priori structures. Through algorithms that respond to a participant's activity, the computer became an active player, engaged in a dialogic exchange of activity and display.

Transformative. The transformation of information at the level of material instantiation in code and visual presentation was perhaps the key over-

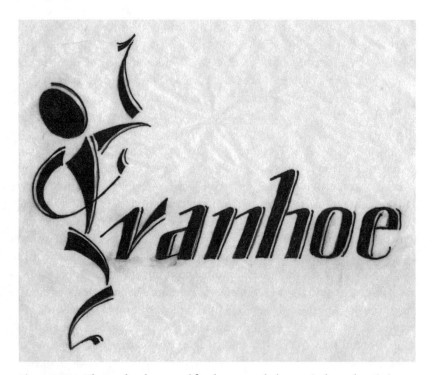

Figure 2.2.11. The Ivanhoe logo, used for the game splash page, is shown here in its hand-drawn original.

arching concept of the interface design as a whole. This emphasized our conviction that interpretation is a performative transformation of the material condition of an artifact. This is always the case, and the electronic environment extends, rather than innovates, in this tradition. The dramatic possibilities for making evident the effects of interpretation as acts of deformance were drawn from a legacy of such approaches. Some of these have their roots in esoteric practices, such as gematria and kabala, some in the ludic sensibility that governs combinatoric visual and verbal artifacts (volvelles, movable books, mobile and kinetic works of art), and some in the critical traditions of potential literature (Oulipo). Ivanhoe's interface intended to make this graphically evident.[29]

In summary, then, Ivanhoe's design was conceived to counter the idea of self-evident materiality—the idea that an object or artifact simply is what it is—by offering instead a set of conditions for the creation of what can be. This set of contingencies was structured into the interface so that every game state was clearly generated as a possibility within a potential field. The interface was responsive and emergent, perceiving

the participant as part of the information of the system, while insisting that an emergent work is always constituted at the intersection of the participants' aggregate activity within a social sphere of production.

Ivanhoe's generative aesthetics opened the screen as field of play, of ludic invention. Iterative visualization provoked an emergent, rather than self-evident, representation. Ivanhoe's initial design recovered an alternative tradition of inventive and generative approaches to visual epistemology and representation that is at odds with rational modernism and traditions of visual epistemology that derive from fine art and scientific visualization. The modern sensibility made critical approaches to literature into what McGann terms a "spectator sport." Both textual and visual fields were governed by the assumption that materiality was a stable fact, unproblematic, a priori, and self-evident. By contrast, Ivanhoe assumes a complex system in which a work is produced by the dynamic interplay of an individual interpretation and a set of possibilities structured and encoded in an emergent field. Ivanhoe's interface was designed to make these principles part of the experience of play, as well as to open the horizon of research onto wider application of what I term post-Cartesian approaches to graphesis, or subjective, situated approaches to visual knowledge production.[30]

2.3 Subjective Meteorology: A System of Mapping Personal Weather

Subjective Meteorology was created entirely as an act of aesthetic provocation and a work of imagination. It mades no concession to the standards of digital humanities or to the exigencies of disambiguation or any other technical constraints. My intention was to create a work that demonstrated the capacity of graphical forms to be a primary mode of capturing subjective experience for later analysis and understanding. In Temporal Modeling we conceived of subjectivity as a combination of *position* and *inflection*—the point of view from which any experience was represented and the affective or qualitative values attached to the elements of these experiences—which are structured into the design as a "now-slider" and other elements. In Ivanhoe, subjectivity is again structured into the design as a position within the game, a point of view or inner standing point. But in Subjective Meteorology, subjectivity is marked at the level of inscription, in the hand-drawn traces of pencil lines and forms that show the mark of individuation in their material production. These marks contribute to a higher-level system, in which emotive and personal experience comprises the entire representational code. What makes Subjective Meteorology distinct, and in

some sense more extreme and unfamiliar, is that the *content* of its expressions is subjective experience. Thus, it provides a system for mapping individual psychic experience—"personal weather."

Could Subjective Meteorology be built in a computational environment? Absolutely. The software for modeling atmospheric systems and conditions would provide a foundation. The elements would need to be renamed and parameters for their behaviors specified. But the principles and methods would be the same as in traditional meteorology, with its complex and subtle ability to describe (even predict) shifts in mood and atmosphere.

This project has deep roots in my graphical work, going back into the 1970s, when I first did a series of "event" drawings. This theme has manifested itself in numerous projects I've undertaken in the intervening decades, usually as series of drawings concerned with the capture of experience as energy fields, flows, and forces and the deconstruction of apparent entities into these dynamic components. With Subjective Meteorology, I set out to be extremely systematic. I had the benefit of being a fellow at the University of California, Santa Barbara, in the Digital Cultures Institute in the spring of 2004. During the month I spent there I did a series of experimental/experiential drawings, studied the nomenclature and representational modes of traditional meteorology, and created a graphical system of notation and nomenclature that would make use of traditional methods for the innovative system of mapping personal weather. The project was conceived within the larger context of work on visual epistemology and the authority of graphical forms of knowledge production, on which I was working at the time.[1] The project extended critical questions about inscribed and inflected subjectivity while insisting on the ability of graphical systems to produce partial, situated, and aesthetic knowledge. I see this work as a part of SpecLab, especially as some simple digital animations were produced to demonstrate the feasibility of creating dynamic representations of activity over time within the metaphoric language (verbal and visual) of the system. Although it was undertaken independently of SpecLab, where the focus had shifted to applied tool-building and development, Subjective Meteorology is intimately related to the other projects in which I played a part, and the design of the project builds on lessons learned, while raising the level of imaginative expectation within our digital activities.

: : :

Mathematician and philosopher René Thom asserted that there were only two stable, reliable modes of knowledge representation: natural language and mathematics. Graphical methods seem equally compelling and useful for creating and analyzing knowledge, and for calling into question issues of epistemology and representation. Do we know something and then draw it? Or can we make a graphical record and through it come to know something?

Subjective Meteorology makes a case for graphical knowledge as a primary method of producing as well as analyzing phenomena. But the particular, even peculiar, theme of this project pushes the capturing of knowledge through graphical means toward an investigation of subjective experience. Several levels of abstraction and translation are involved in this activity. As stated above, Subjective Meteorology is a system to describe "personal weather" or the psychic moods and atmospheres of subjective experience. But what does this mean? The system takes the metaphors of traditional meteorology and uses them to represent the dynamics of lived experience. Not such a strange notion, and one that many viewers resonate with intuitively. The conception of Subjective Meteorology is radical, given longstanding habits of subjugating the possibly unruly character of visuality to the rules of information design or logocentric disciplines (Thom's mathematical and natural languages). Yet the approach—pushing perception through imaginative, rather than rational, processes—is well within the conventional bounds of image making in the fine arts. It is certainly proper to characterize Subjective Meteorology as an aesthetic project that makes an argument for affective rhetoric.

To create the basis for a workable digital project, I used the drawings and notes as a preliminary stage of content modeling. This allowed me to create the basic elements of the generative system from within the recording of subjective experience across a series of days. This approach was a deliberate experiment, controlled and delimited by time and the number of drawings I set out to do (ten). The project intentionally countered the repression of this micro level of inscribed subjectivity (at the level of the mark) in the design of works of digital humanities (and traditional humanities, as well) in that it was not based on the constraints built into rationally grounded systems of representation. Whereas mathematical and natural languages are relatively stable, as Thom makes clear, with regard to the relation of notation to value, in graphical systems— systems that rely on handwriting, analog notation, or other variable but materially rich qualities—this relation is unstable.[2] The highly charged

term "disambiguation" defines the border along which traditional humanities approaches encounter the digital environment but can have no bearing on an asystematic condition dependent on marks and traces that are not part of a limited, finite notation system. Subjective Meteorology stretched digital humanities, enamored as it had become with the idea of clarifying one's thought in formal and systematically formalizable terms. As the field strove to shift humanities onto firmer ground, closer to that of other, more formal knowledge systems, it had moved very far from the fundamental premises of the humanities, in particular the humanistic commitment to subjective and partial knowledge. Subjective Meteorology used the digital environment differently, to construct a system of analysis grounded entirely in subjective experience—and focused exclusively on representing it.

Graphesis, aesthesis, and speculative computing find common ground in the conviction that visual knowledge production can be driven by affective rhetoric. Using image production as a primary means of grasping experience as form creates a base of material expressions from which a systematic scheme of content modeling can be elicited as the basis of a generative system in a digital environment. In other words, the drawings come first. They are intuitive, not formalized, and serve as source material from which to generate analytic principles. They do not serve as display of preexisting rules or formal structures. Subjective Meteorology is thus an experiment in knowledge creation, artistic insight, and imaginative work.

The anxieties that this work seems to engender are indicative. The specters of Thom's natural language and mathematical notation arise regularly, potent and demanding: Will there be a stable notation system—a *legible* one that stabilizes the ambiguities of visual form in natural language? And how will I parameterize experience, that is, make use of a mathematical metric? Systems of knowledge constitute their objects, bringing into view only what the system can conceive. These drawings, with all their particularity, complexity, ambiguity, and subjectivity, show graphical methods as a primary mode of knowledge creation. Objectivity is the watchword of empirical science, and the distinction between observed phenomena and observing subject is assumed. Subjectivity invoked as the counterpoint term does not distinguish the humanities from the sciences but, rather, calls the basis of objective knowledge into question. Subjective Meteorology uses the metaphors and templates of meteorology (fluid dynamics of the atmosphere), to create a system for representing the always situated and partial dynamics of subjectivity (personal weather, in vernacular parlance).

In this regard, Subjective Meteorology, like other SpecLab projects (to varying degrees), is conceived in the spirit of Alfred Jarry's 'pataphysics, the science of exceptions and imaginary solutions. Keenly aware of the way scientific knowledge was constituted by the premises on which it conceived of its objects, Jarry offered 'pataphysics as an alternative based on particulars. Jarry's 'pataphysics had a few basic tenets: syzygy, clinamen, ethernity.[3] Syzygy, a term used to describe planetary conjunctions, came to signify the reification of relations into figures or forms. The concept of the clinamen is derived from the work of the natural philosopher Lucretius, who suggested that deviation in the activity of atomic particles was essential to the creation of the universe. Lucretius's approach was opposed to that of Democritus, for whom, as for many observers of the natural world to the present day, the atomic universe was to be understood as regular in its behavior. When twentieth-century theories of quantum mechanics began to grapple with phenomena that did not fit the classical models of physics, Lucretius's clinamen found some scientific credibility. Jarry, aware of these scientific writings at the turn of the twentieth century, took clinamen as a fundamental force for creativity in the universe. And ethernity conjures a transcendence of traditional notions of space-time into a continuum whose elasticity is limited only by the imagination. (The punning play in itself makes the shift in language into a performative gesture of invention, and thus provides a demonstration as well as a tenet of Jarry's beliefs.) As a serious approach to the pursuit of knowledge, 'pataphysics remains largely the province of poets, rather than of physicists or mathematicians.[4]

An aesthetic undertaking, Subjective Meteorology is serious in its conception. As an attempt to create a systematic understanding of the ways experience can be grasped and analyzed, it begins with the conviction that intuitive investigation can give rise to systematic study. This is neither a top-down, rule-based approach to knowledge nor a bottom-up, sensation-based one but a subjective, immersive, embodied approach. What we know, and how we know, depends upon the cognitive schema we build. What we experience through embodied perceptual means can be transformed through processes of attentive, concentrated study and imaginative leaps, remodeling the basis of knowledge.

The working premise for my approach to this project, as I stated above, is that graphical activity can be used to capture and analyze subjective experience in a primary set of drawings from which a notation system can be derived. This served in turn as the basis of a generative system of making and showing dynamic principles of "personal weather."

The drawings are the primary research, and they stand on their own,

Figure 2.3.1. This was one of my first drawings plotting the events of a day. The task was to capture experience and give it form without any preconceived code or system of signs: I drew first and analyzed after. The final system of graphical elements—and to some extent, the conceptual elements, was derived from these studies put into dialogue with research and readings in traditional meteorology. In this image, the temporal sequence unfolds from right to left. The vertical axis was used to map degrees of proximity, with somatic events at the bottom, remote or distant forces (including telecommunications) at the top, and social activity and moods in between. Legend: (a) compression of exhaustion on rising; (b) communications at a distance; (c) rising energy; (d) residual dream associations; (e) a field of work or task potentialities; (e-2) communications in proximate space; (f) anticipated interruption; (g) vectors of interest; (h) rising front of dynamic activity; (i) more vectors of interest; (j) ridge of resistance to interest and opinions.

with their annotations (figure 2.3.1). From them I distilled the working elements of a graphical system, and a table of equivalents between the language of fluid dynamics of the atmosphere, or standard meteorology, and the system of Subjective Meteorology (figure 2.3.2). This is basic and in its details can be elaborated to a very fine degree. The poetics of such a system are inexhaustible, since they arise from individual experience. The conceptual schema for a digital model of elements, forces, conditions, behaviors, and perceptual positions is finite, even as it allows for infinite variation in execution of any given condition (tables 2.3.1, 2.3.2).

: : :

Atmospheric (fluid) dynamics is an extremely complex systematic analysis of natural phenomena. The forces of wind, heat, temperature gradients, and relations to terrain and physical features vary at every level of granularity within the atmosphere. The subjective experience of daily life can only be described in such a system with all its inexhaustible repleteness. The shift from tradition to Subjective Meteorological systems is marked by a vocabulary change, but it also involves a conceptual shift. The fluid dynamics used in the analysis of atmospheric systems can be grounded on classical physics and Euclidian geometry. But topological mathematics, quantum mechanics, and 'pataphysics offer alternatives. Subjective Meteorology is premised on a conception of space-time that it shares with Temporal Modeling. Its coordinates and metrics can be nonlinear (multidirectional and multidimensional), heterogeneous

Figure 2.3.2. Graphic forms for a working system. These elements were distilled from a series of day drawings that charted changes in mood, activity, events, formations, conditions, etc. Legend: (a) charged field of potentialities showing (b) areas of perturbation with (c) activity line giving rise to (d) a dynamic wave; (e) singular entity at a distance causing disturbance; (f) complex entities in dynamic exchange; (g) line of anticipation; (h) clouds of anxiety; (i) concentrated task energy breaking at (j) interruption behind (k) front of concentration; (l) temporal grid.

Table 2.3.1. Table of equivalents

Traditional meteorology	Subjective meteorology
atmosphere	atmosphere (charged field of potentialities)
radiation	energy
heat	activity (anxiety)
boundary layers	zones, ruptures, limits, event breaks
moisture	emotional intensity
stability	contingency index
cloud formation	mood formation
precipitation	productivity/consumption cycle
dynamics	interactions
local winds	entities and presences
global circulation	social activity
air masses and fronts	lines of break (attention, intention, etc.)
cyclones	interactions and other events
thunderstorms	intense events and dramatic state changes
hurricanes	catastrophic transformations
air pollution	illness or malaise
climate change	change of personal, social or cultural circumstance

(with variable density, granularity, or intensity and variable metrics), and noncontinuous.

The principle of *nonlinearity* permits simultaneous, ruptured, broken, replicative, redundant, and other synchronous and asynchronous, continuous and noncontinuous event spaces. That of *heterogeneity* permits varying (rubber-sheet) degrees of intensity, as well as variable scales of temporality and metrics with elastic coordinates. And the *noncontinuous* nature of the system permits discrete zones of differentiated activity. These are the premises on which the system of Subjective Meteorology is based. Though they echo the tenets of Temporal Modeling, the design principles of the project are different. In Temporal Modeling, we designed the general principles first and from those created a system of representations and graphical notations. Our content model became the basis of a working system of elements that could be used to represent humanistic temporality. In the case of Subjective Meteorology, by contrast, the system arose from specific examples and their study, from which the

Table 2.3.2. Conceptual categorization of equivalents

Forces (dynamic rather than substantive, providing energy for change)	energy: perceptible and potential emissions: propagative distribution effect: activity = manifest evidence of energy conviction: free/forced inevitable: gravity/levity mutable: momentum/perturbation systemic/local: circulation, mean flow, forcing remote: actions at a distance pervasive: drives and desires dynamic: expansion/contraction of moods pressures: gradient force (tension/relaxation)
Conditions (aspects of the field within which elements and forces engage)	rigidity/flexibility, buoyancy/stability in terrain or circumstances turbulence, drag, stress, friction, roughness, free and forced conviction somatic factors (food, sleep, temperature) climatic factors (weather) psychic factors (recollected dreams)
Behaviors (ways in which elements, forces, and conditions interact)	approach, avoidance, autonomy, stability, communicative exchange, reflection, refraction, tangents and unexpected turbulence or perturbation, occlusion, vorticity/spin, feedback/response/reaction, contraction, contradiction
Perceptual positions (point of view from which situation is produced/perceived)	Self: anticipation (anxiety, trepidation), presentness, mirages, retrospection (relief, nostalgia, longing, mourning), critical angle, scattering, distraction Other(s): parallax, contradiction, complication, alignment

general principles, always subject to revision, were then elicited. The descriptive vocabulary draws on specific instances. Animated, digital versions of the system, also created as proof of concept, brought this project to a certain point of design completion, and in that sense the images that accompany this chapter embody the principal arguments made by the text, whether or not Subjective Meteorology is ever realized as a working digital environment.

2.4 Modeling a Critical Approach: Metadata in ABsOnline

Subjective Meteorology, like Temporal Modeling, had been an exercise in creating a system of graphical notation. In the process of their creation, a content model had been designed for each that was a nomenclature scheme and a template for design. In Ivanhoe, we had modeled and designed spaces for critical intervention and theoretical engagement with texts. In creating the metadata scheme for Artists' Books Online, I took what I had learned from these activities and created a template to model criticism for a field that is sorely lacking in such discourse. ABsOnline is a digital collection of facsimiles and metadata meant to provide a resource for access to and study of artists' books. Defined as original works of art made in the book format, artists' books are often created in very limited editions and are usually held in special collections. Criticism and research in this field has been slow, and a larger picture of collections development, publication patterns, and other large-scale historical patterns is limited. Because of my own long involvement in this field as a practitioner, scholar, and critic, I felt the need to design metadata to provoke scholarship and criticism. Thus ABsOnline is an exercise in using metadata as a modeling device

within an intellectual project where the design of the intellectual field draws on digital techniques to shape and structure a critical approach.

The metadata for ABsOnline is structured on bibliographical principles, and contains fields at three levels: work (idea or conception), edition (material expression), and object (individual instance). In each level, the information called for is organized to provoke a particular set of readings of specific aspects and features of an artist's book. The metadata scheme was put together with the input of several working groups comprised of librarians, catalogers, curators, bibliographers, artists, critics, and scholars. We drew on existing controlled vocabulary and created local terminology culled from shared sources to create a list of descriptive terms for such fields as binding, production methods, materials, and so on. But the overarching project is designed to demonstrate that metadata can bring critical discourse into being by the way the fields model a reader's relation to a book work. In that sense, ABsOnline is a case study in the way metadata function as criticism and interpretation. It was conceived very differently from the graphic projects in which subjective experience and point of view were paramount.

Electronic metatexts are more dramatically performative than print texts with respect to way they model content and configure conditions for use. Because these metatexts actively structure a domain of knowledge production in digital projects, they are crucial instruments in the creation of the next generation of our cultural legacy. No other textual form will have more impact on the way we read, receive, search, access, use, and engage with the primary materials of humanities. So rather than focus on the display and representation of texts and artifacts, I'm going to examine the ways in which the metatexts *model* digital texts and artifacts, with specific reference to ABsOnline.

Metalanguages and Metatexts

A metatext is a subset of metalanguage, one that is applied to a specific task, domain, or situation. In ABsOnline, a collection of virtual representations of artists' books, the metadata deliberately attempts to shape a field of scholarly inquiry.

In creating the metadata structure for ABsOnline, I came to understand more fully the ways in which digital metatexts are dynamic and performative.[1] All textual production is rule-bound and code-based, in oral and print culture, but these constraints become dramatically apparent when texts are created in or migrated into electronic environments.

Metatexts not only express such rules, they describe and encode the rules that govern the composition of texts and their use in textual systems. They also contain instructions that call forth behaviors, prescribe and delimit domains, and set out the parameters on which knowledge is shaped and bounded. The epistemological power of a metatext in a digital environment comes from the way software parsers determine when a text is well-formed—when it fits the requirements and outline of information set by the metatext—or from the constraints it places on what can be entered as data and in what order and form. Because conformance is rigorously enforced (and nonconformant documents rejected) the relation of metatext to document (rules of expression to instances) is quite explicit. Information, interpretation, knowledge—everything has to fit the model encoded in the metatext. Print formats are far more forgiving. A "stanza" written in nonstandard form won't be rejected by the page, for example, but malformed metadata does not "parse." The relation of rules and expressions is thus very explicit.

In conventional print formats, paratexts and metatexts assist in navigation as well as providing interpretative materials and explanations about the shape and content of textual works. Paratexts are often structural (tables of contents, headers and footers, and indexes, for instance, provide signposts even though they encode sharply defined arguments and assumptions, while footnotes, marginal notes, and other elements are charged with analytic functions). Metatexts have *descriptive* power that, wittingly or not, becomes a model for the texts they describe. The model is comprised of types of textual elements (semantic and syntactic but also bibliographic, graphic, semiotic, social, pragmatic, etc.) and the order of elements in the structure. The model fully articulates the shape and system of these typologies and their orderings in a generalized schema. The description is an interpretation, selectively emphasizing certain features and characteristics of a text. Digital metatexts thus act upon other texts to perform an analysis, generate a display, act out a search, or make other interventions within the textual field.

A digital metatext also embodies and reinforces assumptions about the nature of knowledge in a particular field. And it is only as good as the model of knowledge it encodes. The metatext is built on a critical analysis of a field and expresses that analysis in its organization and the functions it can perform. The intellectual challenge comes from trying to think through the ways the critical understanding of artists' books should be shaped or what should comprise the basic elements of a graphical system to represent temporality in humanities documents. The technical task of

translating this analysis into a digital metatext is trivial by contrast to the compelling exercise of creating the intellectual model.

Models

As I noted in chapter 1.1, a model creates a generalized schematic structure while a representation is a stand-in or surrogate for a particular thing. A table of contents is in effect a content model of a work, as is an index. Each provides an abstracted version of a text's contents that includes some things, excludes others, and has a structure of its own that is in certain respects isomorphic to the text (the order of chapter titles in a table of contents) and in others utterly independent of it (the order of the items in the index). But insofar as a table of contents or index exists as part of a document, it exists on the same level, as another element of the text, and this muddies the model/text distinction. A generalized scheme that outlines what a table of contents is (and what a header is, and a text page, a text block, a footnote, an index, etc.) is a content-type model for a print text.

In electronic environments the process of creating content models creates several new kinds of documents and textual artifacts that are not quite of the same order as those familiar in print culture. Content modeling for digital artifacts depends on creation of a metastructure (an XML file known as a DTD or document type definition) to which every other file of a given sort must conform. The classification schemes created for structuring data in a digital collection thus encode a model of that field of knowledge. In my own experience, creating the DTD for the Artists' Books Online project did much to clarify a critical approach to these objects. At another level of granularity, this gesture was meant to control the critical discourse in the field and its assumptions about how to constitute artists' books as an object of study.

A DTD is a specialized kind of metatext that expresses the rules for a potentially infinite number of XML documents that conform to its outlines. It is built of XML tags, a set of labels identifying various elements (for instance, the tags <altTitle> and <altTitle> would surround a word or phrase that was an alternate title for a work). But a DTD structures the relationships among these elements in specific ways, and this constrains the documents to which it is applied.

For an XML document to "parse" it must conform to the rules of the DTD. The DTD requires that the correct elements must be present in the correct order within its hierarchical scheme, just the way a game's rules

constrain moves or a recipe stipulates the order in which ingredients are combined. You cannot hit a home run in football or make a mousse by first scrambling the eggs. The rules are a model; the game is an instance, a specific, concrete, and particular expression of those rules. Thus a DTD governs the files that are created in its image. The DTD is the site of content modeling for textual artifacts.

To model content for a field one must first consider the elements that constitute its specialized domain of knowledge. In ABsOnline, we created a set of fields that call for examination of an artist's book in terms of various aesthetic design features. What are the typographic features of the work? The pictorial elements? Are the turnings (movement from one spread to another as a page is turned) particularly well used? If so, how? Is the graphic organization of the work a conspicuous aspect of its effects? How does the development of the book register within the work as a whole? Identifying and naming these areas as fields into which text will be entered makes it possible to aggregate information across the corpus of files in a collection as a whole. A minor act, perhaps, to ask scholars, critics, artists, curators, and catalogers to look at and attempt to describe these features, but it is a deliberately provocative act. These are the ways to think about an artist's book, the metadata asserts. To fill in the specified fields, a person has to attend to various features of these artifacts. Thus the metatextual documents in ABsOnline propose to model a critical discourse by creating protocols for enhanced cataloging and description.

In addition to descriptive metadata—extended cataloging records, such as those just described—there are metadata files about who made the electronic files, scanned the books, and contributed to the data. Yet another kind of metadata document consists of a style sheet to selectively transform data in the files into displays. Metadata schemes create the file structures that hold all text and image files within several levels of hierarchy—the files for each book work (structured as work/edition/volumes/objects/images), each collection and each exhibit, essay, and resource. Metadata schemes may be designed at a later date to aggregate information and records from outside ABsOnline's home source files with those authored explicitly for ABsOnline. Others may be brought into being as style sheets capable of customizing different functionalities or views of the information with ABsOnline.

We began with the basic problem of making a DTD for the metadata that describes an artist's book. This seemingly simple task took a year from initial consideration to completion. The elaboration of a descrip-

tive scheme for a book, at first just laid out in text as a set of fields to be filled in, turned out to be very different when it came time to implement. Calling for description of various elements and features, a production narrative, and detailed analysis of texts, images, their relation, and so forth, as per the first iteration of the metadata scheme, turned out to be prohibitively difficult, even though I was both the author of the scheme and the user. Elaborating the conceptual framework for "what a book is as a work" was one thing, keeping in mind one's place in that conceptual framework while describing a book in hand quite another. The urge to tell the story of the book—its background, production details, human and artistic history—clashed with the structured metadata, which only asked for a Note on the Title of the Work in the first fields. (The very idea of the Work as a larger category of conceptual project within which the book came into being was confusing and unfamiliar. The tendency was to want to describe the Edition, the instantiation that one held in one's hands.) Turning the "natural" sequence of observational events— picking up, handling, looking at, reading about, and reflecting on the book—into a form that could be organized as structured data was an enormous challenge. Especially since the desire to structure the data logically, categorically, from the largest to the smallest detail (the speck of dirt on the inside back cover, the personal inscription, an isolated in-stance of overprinting) so contradicted the associative patterns of read-ing and encountering an artwork.

This conflict was never resolved. But by reorganizing the sequence in which the metadata was structured, we were able to put a descriptive field near the top, thus allowing for someone entering data who was fa-miliar with the book to pour out everything they knew at the outset, instead of pulling out requested bits of information piecemeal. Specific details—binding, paper, or place of publication and printing history— are subsequently called out in order to provide search capabilities across the collection (all books with spiral bindings, all works made at Nexus Press, etc.).

The metadata for ABsOnline is performative in a social sense as well as a technical one. By insisting on the need for critical discussion of the specific properties of artists' books, it makes a strong statement to a field that has been without gatekeepers and critical discourse of the sort that makes for professional standards. Ideally, the project would, in the long term, provide information about the production and collection of art-ists' books that would push scholarship by assembling information on which new kinds of questions could be based. The great advantage of

Work >> Edition(s) >> Object(s) >> Images

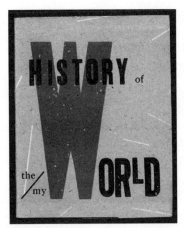

History of the/my Wor(l)d
Johanna Drucker

title note: The many themes of the book are encoded in the title, and the Word/World and the/my oppositions announce the language/knowledge and history/memory oppositions that are crucial to its textual and conceptual dynamics. *[J. Drucker]*

Agents

Johanna Drucker
type: initiating
role:
author
printer
designer
nationality:
born: United States
active: United States
citizenship: United States
dates:
birth: 1952-05-30

Publication Information

publisher: Druckwerk
dates:
publication: 1990-06-00

Project Statement
by J. Drucker

Several themes interweave in this book: a feminist rewriting of the history of the world, an opposition between official history and personal memory, a critique of feminist theoretical attitudes towards language as patriarchal, and all sorts of graphical and textual puns and play. The book is a tribute to my mother, and the drum majorette who opens

Figure 2.4.1. Screen shot showing metadata scheme at the Work level. We used standard bibliographical description in AbsOnline, breaking our organization of information into three levels: Work, Edition, and Object. The Work level is meant to include the concept of the project in the largest sense, from the germination of an idea to its many and various executions in sketches, editions, mock-ups, research, study, and so on. The Edition is any instantiation of the Work in published or issued form. The Object is the single entity that a cataloger, student, researcher, or scholar has in hand and from which the description is being made. While these are useful intellectual constructs, they proved counterintuitive and difficult to reconcile with the experience of looking at and describing a book. Also, since we wanted a representative image at the Work level, we used the cover of the first edition, and this created an additional level of confusion and ambiguity.

electronic processing is the aggregation of data, distributed participation, and the capacity to collect in virtual space artifacts that are separated in physical space. All of this functionality is enabled by the metadata and the metatextual apparatus (including the scripting languages that bring dynamic capabilities to the Web) (figures 2.4.1, 2.4.2).

: : :

ABsOnline uses metadata in several ways. It organizes a critical approach to the field. It organizes the file system and structure of textual and

Work >> EDITION(s) >> **Object(s)** >> **Images**

Edition 1 | Edition 2 |

History of the/my Wor(l)d

Agents

Johanna Drucker
type: initiating
role:
author
printer
designer
nationality:
born: United States
active: United States
citizenship: United States
dates:
birth: 1952-05-30

Publication Information

edition type: editioned
publisher: Druckwerk
place: Bow and Arrow Press, Harvard University
dates:
publication: 1990-06-00
edition size: 70 copies
note: I loved making this first edition, and Gino Lee was a major presence

Production Narrative
by J. Drucker

This book was fun to make and to print, though it took longer than I had imagined. The original conception came in 1989, when I walked into the Bow and Arrow, saw the cut of the drum majorette who reminded me of my mother, and thought, I'll make a book that will be a history of the world by taking images from these cuts, letting them fall in random sequence, and writing a narrative to fit. Of course I

Figure 2.4.2. Screen shot showing metadata scheme at the Edition level. The information about the Edition is more specific than that at the Work level, with details of the physical form, the production narrative, and other particulars relevant to the actual issue of an edition in print.

graphic artifacts in the collection. It records information about the production of files and contributions to the collection. And it could eventually facilitate integration of the collection with other records in electronic file formats that live on the Web.[2] Metadata is both the repository of and the instrument for enabling these activities.

Metadata thus models texts and artifacts, collections, and behaviors at several levels. It models texts through markup and DTDs. It models content for display, search, use, analysis, and interpretation. It models an organizational scheme for the storage, access, and presentation of artifacts that may be text-based or may be images, sound files, video, animation, or statistical files. Through its performative capabilities, metadata enacts the non–self-identical character of texts, creating them anew in each iteration. Metadata encodes the very condition of potentiality, of a text as a field of possibilities called into being in each instance. The social conditions of use, the situatedness of access, and particularly of purpose to which these means are put immediately returns us to the

cultural condition of our own practice—personal, institutional, and historical. Early-twenty-first-century textual studies and cultural studies are most emphatically, and necessarily, digital studies as well. The seductive force of intellectual engagement with shaping knowledge, creating forms for the preservation and study of our cultural legacy, depend upon metatexts and the performative capacities built into them by our expectations. The task of using metadata to give intellectual shape to a field is a charge to our interpretative energies more than it is a labor to produce the protocols with which to execute them. Modeling criticism or knowledge in any field is an iterative process of dynamic exchange between the metatexts that encode our epistemological assumptions and our ability to reflect (individually and collectively) upon these sufficiently to be aware of how they shape our understanding of knowledge and its ideologies. The process of designing a metadata scheme for ABsOnline was meant to engage a community of users, a task that proved more difficult. I wanted artists' books, in all their rich particularity, to have their aesthetic properties codified in order to move the study of printed artifacts beyond literal, descriptive materiality into dynamic, constitutive, and contingent materiality.

2.5 The 'Patacritical Demon

Though the 'Patacritical Demon has never been built, it has been the object of considerable discussion and collective imagining over the course of our SpecLab activities. Its very unrealized condition may be what's essential—in keeping open a space for future engagement, the Demon is the image of the speculative spirit. Indeed, this project goes to the core of SpecLab's concerns: the drive to represent the activity of interpretation, to give form to the very process of intervention that produces a work. Even now, we continue working to visualize the dimensionality of interpretation that can be sustained in electronic space.

The term 'pataphysics has woven its way through these projects and texts. As in the work of Alfred Jarry, who coined the term for "the science of exceptions and of imaginary solutions," its use in our domain, though distinctly ludic, isn't exclusive of serious intellectual purpose.[1] Just as Jarry was sincere in declaring the principles of his new science, so we have been seriously engaged in devising a figure that, like James Clerk Maxwell's demon, sorting molecules into zones of entropy and order, (dis)orders the world of knowledge. Our Demon has been given graphical expression as well as

discursive description. Insofar as the theory of interpretation on which it draws is an extension of poststructuralist approaches, it has a distinct alliance with theories of enunciation and the intellectual framework they provide for describing reading as a productive and generative act. In such a theoretical formation, the Demon becomes the figure through which the operation of aesthetics as a practice of situated, subjective, and partial knowledge is enacted and given expression. Schematic though its outline may be, it seems useful to offer at least a note or two about the Demon's conception, and a few drawings that conjure its activity. In the next section of this book the connection between these concepts of aesthetics and the tenets of speculative computing and digital media will be made explicit.

In November 2002 I made a sketch of the activity of interpretation as we then conceived it (figure 2.5.1). We had been talking about Charles Peirce and the idea of a "third term" that distinguishes his semiotics from that of Saussure. Where structural linguistics relies on a two-part sign (signifier/signified) within a finite system where value is determined by finite constraints, Peirce relies on an interpretant, a person for whom and in whom signification is produced. This keeps signs and signification from being cast as transcendent. Instead, Peirce's sign— representing something to someone for some purpose—is premised on a situated condition of value production through use within a subjective context.

Even when designing Ivanhoe, we had discussed the problem of picturing or representing the constitutive processes of text production. We had elaborated a scheme that follows enunciative theory but combines it with bibliographical notions of the social production of texts, a probabilistic approach to text/image as a field to be intervened, and the rest of the theoretical apparatus I have touched on repeatedly. I sketched this enunciative system in what I called "the double parallax"—a construct in which the discourse field and the intervening subject exist in a codependent relation. The "text" (whether an image, literary text, musical work, or performance) is produced in the space of projection that is the intersection of perceiving subject and probabilistic field. The text "looks back" at the reader-subject in an act of projection that mirrors the subject's act of reading, but the two cones of projection never meet or match. The double-parallax notion is meant to emphasize that the text so produced is never self-identical—within a discourse field, a text is only a possibility, and within an intervening subject, it cannot be separated from the experience of reading. In such a construct, the text has no

Figure 2.5.1. This sketch illustrates the conceptual and theoretical model of the 'Pata-critical Demon in schematic form. The phrase "double parallax" describes the relation of a viewer ("percp," at left) and the discourse field (right). Projections of the discourse field and of the viewer's vision/perception are shown as cones. Where the two projections cross is an area of intervention, the constituted "text," which is neither self-identical nor equivalent to either the material or the virtual text. In the center of the diagram is a sketch of a classic structuralist model of signification. The sketch shows two lines, one a chain of signifiers/signifieds (the plane of discourse) and the other a plane of reference. The "text" is a projection in the intervening spaces, provoked by the two planes and a situated reader. That the text is itself part of the larger field of discourse, of whose social and historical production it is an instance, is indicated by the small square on the left, at the center of the inside cone of perception, which represents the *illusion* of a text as a fixed entity; the viewer's gaze is met by the projection of the discourse field and is always opening outward through the association of texts to each other, even as the reading opens outward.

inherent stability, even if the material object that provokes the reading can be held, looked at, described, and annotated (figure 2.5.2).

In 2003 I was invited to create a drawing for an exhibition of "books that had never existed," and at that moment our group's shared enthusiasm for Lucretius as a proto-'pataphysician was very much in mind. So I

12.1.2002

DEMON DRAWING 1.0

Figure 2.5.2. Demon drawing. The structuralist model of signification (see figure 2.5.1) recurs in the upper part of this drawing, oriented horizontally instead of vertically. The fissure or break along the center of activity is the space between signifying elements, and the links, loops, and energy that project out from this realm show the asynchronous connections made in the process referred to as "reading arising" (where "reading" indicates a "constituted text" or object). The "apparent plane" of the text image (central area) and the complexity of its design show that the signifying process is not a mechanical stringing together of signifying elements but a charged field of possible relations. In the area above that central charged line, trails and traces of association move toward the discourse field. The whole scheme shows the "reading effect" in diagrammatic form. In the lower part of this drawing the "demon" is the "figure" of reference, of the virtual text as an imaged configuration, dynamic, changing, morphing constantly but with rich, specific, particularity.

created a version of the Demon that combined the image of the double parallax with the image of a projection of a "text" and "reader" produced through their mutual intervention of a reading subject in a probabilistic field. I accompanied the image with this caption: "Trialectics— fragments of Lucretius—57 B.C. a discourse intervened within a dynamic field of potentialities—a treatise on the third term, work constituted as a relation of subject, object, interpretation-n-dimensional arising—shift from metalogic to meta-rhetoric in a discourse of non–self-identical- ity—entangled condition of the word—algorithmic unfolding of pro- duction within constraints, speculative methods and quantum poet- ics—autopoiesis and codependent arising—deformance as production, constitutive method—" (figure 2.5.3).

The text breaks off, leaving everything else unsaid and unspecified. The visual image supplies the real information. The largest section of the drawing is taken up with showing what *a reading looks like*. The sketch borrows from René Thom's topological models of catastrophe, events drawn forth and projected simultaneously in a dynamic hologram. A work figured as interpretation comes into being in a third space between reader and text. Subject, object, interpretation—this tripartite structure also depends on Peirce's formulation of the sign. In this image, a book, familiar and iconographic, is shot through with dynamic vectors. The ac- tion of reading is called forth by the text, as a provocation, but the text is produced within the encoded activity of reading. The idiosyncratic trajectory of a specific encounter (different in each case) is figured by the wandering lines. Networked into a series of interacting force fields they create the basin of activity that constitutes the "book" as a perceived and experienced interpretive event. A line of "reading" streaks across the bottom of the image space, like a monitor registering a heartbeat, brain activity, or some other vital function, rising and falling in pitch as the baseline text provokes response.

In the upper right corner two diagrams demonstrate the distance be- tween a classic structuralist reading and a 'patacritical one. The structur- alist linguistic model is binaristic, containing a plane of discourse and plane of reference. The plane of discourse is constituted by a series of bipartite signs, signifiers and signified in an interlocking chain, which is itself interwoven in the plane of reference to which it gives rise.

In the 'patacritical version the model is complicated by the reader's projective acts. Again, this critiques the structuralist model, not allow- ing any element to be taken as stable or self-identical, and the text arises as a result of a combined provocation and projection. The space between

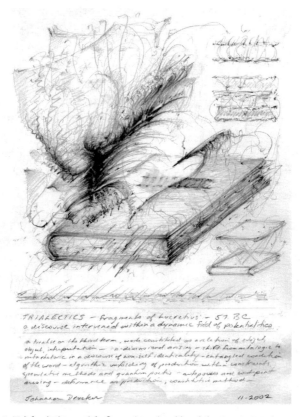

TRIALECTICS — fragments of Lucretius — 57 BC
a discourse intervened within a dynamic field of potentialities

[handwritten paragraph, partially legible] a treatise on the third term, made constituted as a relation of object, object, interpretation — in determinations of non-self identicality — entangled condition of the word — algorithmic unfolding of production within constraints, speculative methods and quantum poetics — antposses and emergent arising — deformance as production, constitutive method —

Johanna Drucker 11·2002

Figure 2.5.3. *Trialectics* is my title for an imagined book by Lucretius about a dynamic system based on three, rather than two, terms. Where a dialectic (thesis/antithesis/ synthesis) acts in an abstract mode, the trialectic incorporates an intervening agent. The image was drawn in response to a call for works for an exhibition of "lost" books—books that had never existed. This provided an excuse to project the figure of the 'Patacritical Demon onto the image of a book whose purported content was this same theoretical construct. The book is shown as a material, literal artifact, but one that is crisscrossed with associative trails, making the plane of discourse into a plane of reference (on the lower right a virtual book floats above the literal book in a plane of projection). The figure of reading, the interpreted or constituted work, rises like the figure of the demon in figure 2.5.2 from the book form, taking over the space. Within its central dynamic field, one sees vague references to the sequence of pages, a flipping action, constant referencing of language, and lines of text across the literal space of the book. The result is the *espace* of configured interpretation, the unique and particular reading intervention into the book/artifact and text/field. The diagrams in the upper right show two stages of analysis, as described in figure 2.5.1. The signifier/signified chain and its asynchronous relations are shown at the top, then the relation between the plane of discourse (signs) and the plane of reference. "Deformance as production, constitutive method" reads the final phrase, suggestive of the dynamic activity of provocation that the demon figures.

Figure 2.5.4. The 'Patacritical
Demon. Original sketch of the
logo for ARP, Applied Research
in Patacriticism.

reader and text that is the "work" is constituted through a dynamic pro-
cess. Quite simply, the book space depicted in the larger image is to be
understood as a series of instructions for action and reading, rather than
as a thing or object to be apprehended. The small drawing in the lower
left simply diagrams the distinction between the literal book and the
phenomenal book, showing the lines of force, vectors of interpretive
activity, that keep the two in productive tension. The image marks the
shift from a dialectical mode, in which thesis and antithesis generate a
new synthesis, toward a trialectic. This trialectic, a space of enunciation

rather than a system, embodies the spirit of the 'Patacritical Demon, de-stabilizing the order of logical things through the introduction of the third term—so that any thesis or its outcome is located in the subjective experience of an interpretant.

The Demon figured in this diagram is an initial demonstration of the event of reading as an experiential and subjective dynamic. On the one hand, it is a kind of game, a dare to the interpretative community. On the other hand, it is a sincere attempt to get hold of the process of interpretation.

Next-phase iterations involve a graphic scheme for showing the refraction of an object through the dimensions of interpretation. The resulting renderings are meant to dissolve the apparent unity of the text, revealing the aspects, sources, and multiplicities of frames and lineages latent in any artifact. These are, in effect, the other possible configurations that might be exposed within the potential field. The infinitely extensible, flexible space of electronic environments, traversed by lines of access or thought, would be charged for and with the tasks of display and authoring. In this way the Demon would demonstrate the modeling of textual interpretation as an event, an act of intervention in a discourse field of poetic potentialities.

From Aesthetics to Aesthesis

As the branch of philosophy concerned with perception, aesthetics provides a useful foundation for thinking about knowledge as partial and subjective. From an aesthetic perspective, knowledge is neither total nor systemic. Nor is it concerned with the apprehension of self-evident entities, structures, or ideas that constitute themselves as autonomous or transcendent. Rather, aesthetic knowledge is constituted in cognitive processes that are situated within interrelated and codependent systems. Our projects at SpecLab were an initial attempt to apply such models of knowledge—building on decades of theoretical work in the field of cognitive studies—to the design of instruments of knowledge representation and production. To mark the specific cast I am putting on the concept of aesthetics as a form of knowledge, I use the term *aesthesis* as a rubric under which to gather these thoughts.

Because I came to digital humanities and speculative computing from the visual arts and contemporary art history, aesthetics was central to my approach to electronic media. This led to the conviction that the purpose of work in new media is to continue the longer project of fine art:

to provide embodied expressions of experience and knowledge. The quality that distinguishes works of electronic *art* from other digital projects is frequently their nonconformity with formal principles in matters of content, expression, function, or behavior. Aesthesis focuses on the generative perception and cognitive production of information and its material expressions in any medium. Aesthesis is distinct from the analysis of representation, but is dependent on recognition of the cultural and historical characteristics of visual forms, their materiality, and the rhetorical assumptions built into formal expressions of knowledge. In the context of digital activity, the examination of aesthetic properties includes discussion of code and its specific materiality, modes of production that are integral to digital media (interactivity, intersubjectivity, iterative and algorithmic principles for production), models and modeling processes, and the specific ideology of virtual artifacts.

The discussion of the way graphical forms of knowledge work in digital environments takes on added urgency because the connection between "information" and "visualization" is so readily enabled by digital instruments. As discussed in chapter 2.3, the engineering sensibility that under girds most information visualization seems to take scant interest in the rhetorical and ideological force of its operation. Exposing the ideology of graphical forms is crucial to our contemporary condition, extending traditional critical discussions of these issues from the study of visual art and language. Critical work in textual and art historical studies has long connected cultural and social issues and the materiality of aesthetic works, but work on visual epistemology, or knowledge expressed in graphical arrangements (diagrams, charts, and other structuring forms), has been less developed.[1] Attention to materiality has too often assumed a literal, mechanistic reading of formal features rather than an analysis of material codes as provocations for cognitive processing. Moreover, information design has commonly been regarded as an engineering field, not an artistic one, and thus has not been subjected to the ideologically oriented analysis essential to its critical review.

The path to this insight began with an argument about visual forms of knowledge and what specific characteristics distinguish them from language and formal systems rooted in semiology or logic.[2] Therefore, the papers grouped here begin with an argument for graphesis in which I suggest that the visual creation of information provides a counterpoint to mathesis, the assumption that all human thought might be able to be properly represented in a formal language. That argument throughout the pages that follow is a continual attempt to open up space for sub-

jectivity, individual expression, and specificity as challenges to the cultural authority of alignment, totalization, and systematic approaches to knowledge. Without romanticizing deviation or idiosyncracy, this argument suggests that acknowledging the difference between subjective knowledge (situated and partial) and objective knowledge (transcendent and totalizing) carries a political as well as aesthetic charge.

My discussion builds on long-established arguments about the value of cultivating the ability to discriminate through informed or attentive differentiation. Recognizing distinctions depends upon nonalignment, a critical resistance to totalized absorption. Those familiar with the history of the field will recognize an allegiance to Alexander Baumgarten's views on the refinement of taste as a basis of knowledge, to Immanuel Kant's notion of judgment as the link between reason and sensation, and to the history of materiality and the specific properties of media as articulated by Conrad Fiedler, the modern aestheticists Clive Bell and Roger Fry, and their followers within high modernist criticism, as well as to Max Horkheimer and Theodor Adorno's notions of critical theory (rather than instrumental reason).[3] In struggling to articulate the specificity of digital media, the field of aesthetics has the virtue of calling our attention to the very forms that, as Aristotle put it, allow sense to appear to sentience. But unlike our classical predecessors, we have no faith in essence outside of difference. Identity must be constituted, not assumed. The critical tenets of Jacques Derrida's deconstruction and Michel Foucault's archaeology, their borrowings from Friedrich Nietzsche and Martin Heidegger, and the work of philosophers Gilles Deleuze and Jean Baudrillard, provided lessons on which cognitive studies and systems theory could readily be grafted.[4]

The ideas worked out in these papers record the theoretical work I drew on for SpecLab projects and discussions. I began writing pieces about digital aesthetics in the 1980s. One of my very first critical essays focused on electronic media and the status of writing as a cultural instrument, asking what would happen when handwriting, forgery, and material codes (bases of identity, authenticity, and history) shifted their foundation from the stuff of paper, stone, and ink to fungible notation.[5] That paper was rejected by a serious academic journal of aesthetics with a phrase that now strikes me as very droll.[6] They said it was "too speculative." Lenore Malen asked me to be on a panel addressing "the work of art in the age of electronic technology" at the School of Visual Arts in 1994, along with Bob Stein of Voyager, Graham MacIntosh, Charles Bernstein and other people who were actively using electronic media in

the arts. Also at Malen's urging, I edited a special issue of the *Art Journal* focused on digital media and the arts. Encounters fostered by a series of Digital Arts Conferences, connections to the Electronic Poetry Organization, and involvement with various exhibitions and works broadened my reference base in this area.

Though inspired by works of individual artists, my interest soon shifted to an investigation of the design conceptions that model digital art and humanities. I studied graphesis, code storage, the generative materiality of digital media, the ontology of digital artifacts, and the specific characteristics of new media. From these investigations emerged a theory of aesthetic knowledge that attends to the conceptual and formal role of design at the level of model and implementation for use. My emphasis on design deliberately shifts from attention to form (or the discussion of content, theme, and form that are the usual stuff of art and literary criticism) to the analysis of models of knowledge production and representation situations. By introducing the term *situation,* as opposed to *system,* I'm emphasizing the codependent relation of user and network in conditions of use. These shifts of emphasis may seem subtle or radical, depending on the degree of familiarity, but all are intended to reframe my approach within cognitive, generative, iterative, and probabilistic models of knowledge and away from rational, logical, mechanistic ones.

Critical hyperbole abounded in the 1990s. The "newness" of digital media seemed to dazzle and confound many writers and curators. But the challenge of skeptical response brought continuities as well as novelty to the fore. I became increasingly interested in the ontology of digital images, and in seeing their material and fungible condition of inscription in critical terms. I still find some of the earliest experiments in digital arts the most compelling—works by Melvin Prueitt, Roy Ascott, and even the Bell Labs engineers (e.g., Kenneth Knowlton)—because they have the figuring-it-out attention to process that is lost in later pieces built using state-of-the-art, off-the-shelf software.[7] The basic properties of digital art are clear: it is iterative, algorithmic, and networked and, in many cases, procedural and generative as well. But many of its surface effects turn out not to be so very different from their print precedents. One of the strongest impacts of digital media has been to provide ways to think about traditional work in new ways—to see print artifacts, for example, as interactive and intersubjective instruments rather than inert forms. The differences between traditional and new media are most strongly registered in the rate at which they change, their relative stability with respect to inscription, and thus, their ability to incorporate

intersubjective exchanges and constitutive activities within their material instantiation. Medieval codices, palimpsests of such intersubjective exchange, are, after all, as dramatically hypertextual as wikis, but their access protocols, the rates at which change was registered, and the character of their material instantiation differentiate them from their digital counterparts.[8]

Discussions of the aesthetics of digital environments have emphasized their formal properties from the point of view of user experience. Navigational, combinatoric features, the collage and pastiche sensibility, and the capacity to present multiple worlds and seemingly inexhaustible sequential permutations have all come in for their share of praise and enthusiasm. So have embodied and affective notions of experience. Many, like those of Lev Manovich, have been conceived in terms of the mechanics of older media, particularly film. Likewise, the structure of code and claims for its value as the essence of digital languages has found its champions.[9] Simplistic descriptions of the materiality of digital media, well intentioned but literal and often undeveloped, have also contributed to the field. But the distinction between the operational effects and the models of digital instruments has rarely been sustained to the end of addressing the latter as a design problem that is at once aesthetic and epistemological.[10] Recalling some of our experience in designing Ivanhoe, I suggest that this has to do with the cultural clash of engineering, interface, and codework in environments that often conceal their mechanistic assumptions under the effects of their representational surfaces.

I now see that understanding the design of digital projects as rhetorical instruments is essential to critical analysis. If imaginative play is to enter into the production and representation of knowledge with any cultural authority, the way we model these projects has to include a higher order of understanding about the ways rational logic legitimates itself through instrumentalization. As an intellectual project, my argument for aesthesis is to promote and legitimate a basis for thinking differently about the basis of this cultural authority. The shift from logical-total systems to subjective-partial situations is the crux of this approach. My discussion takes place within a digital frame, but the implications are relevant to the legacy of Western logical thought wherever it aspires to totalized control. Digital media instrumentalize that logic in a perversely successful way, but they are neither the source nor the simple technological effect of formalized approaches.

In short, my questions about the nature of knowledge and digital artifacts began with an interest in certain properties of visuality, familiar to

me from years of drawing and graphic work, that seemed unassimilable into either traditional linguistic and mathematical knowledge systems or digital systems based on discrete, unambiguous entities. Given the role of visual form in the dissemination of knowledge, as well as its capacity for the production of new knowledge, this exclusion seemed peculiar and troubling. One of the mantras of SpecLab has been that nothing is self-identical—no text, no image, no object. All aesthetic objects are fields of potential. It is only through interventions and aesthetic provocations that a work is constituted as an act. Inherent to visual mark making, expression, are the qualities of infinite variety and great specificity, properties that allow graphical marks to register subjective inflection yet resist the premises of finitude and closure that are central to mathematical and linguistic notation.[11] Visual codes are notoriously unstable, and attempts to describe them in logical terms, semioticians have long recognized, yield at best a semiology of the visual—not a formal system but a rhetorical one that by analogy has some of the properties of a language.[12] Some (even among my colleagues) would argue that text acts similarly, and indeed, in the study of type and typography the finitude of the letters unravels into a plentitude, for the very reason that letters are visual elements: drawn, printed, inked, brushed, scribbled, or inscribed. To what extent is the insistent nonidenticality of both sign and system in graphical inscription a feature of all forms of expression? And what insights into the circumstances of knowledge production and interpretation might be produced by extending this insight to other media and modes?

I remain convinced that aesthetic activity has a crucial role to play in resisting the cultural authority of mathesis, because of its capacity for registering subjectivity (as position and inflection, as partial and situated knowledge) within the highly specific and infinitely variable circumstances of material expression. The development of this argument from the studies of graphesis to the larger questions of design will become clear in the papers that follow.

3.1 Graphesis and Code

The original title of this paper, "Digital Ontologies: The Ideality of Form in/and Code Storage—or—Can Graphesis Challenge Mathesis?," compressed considerable theoretical bulk into its boxcar phraseology.[1] Coming to terms with the basic idea of mathesis was an important phase in the development of my critical thinking about how the cultural authority of digital media is premised and how it might be challenged. So revisiting these matters is useful, even if the late-1990s debates about truth in photographic imagery that arose from digital works have subsided.[2]

The attempt to understand the connections that link human thought to its representation (in language, image or signs) has been central to Western philosophy of knowledge. In every generation, some version of this question has been posed: If it were possible to understand the logic of human thought, would there be a perfect representation of it in some unambiguous, diagrammatic symbol set? This question, informed by classical metaphysics and philosophy, persists not only in contemporary struggles within the very different domains of visual art, information design, and computer graphics, but also in early formulations of cognitive sci-

ence, with its proximity to symbolic logic, and in debates over artificial intelligence.[3]

Because of the emphasis on a distinction between idea and matter or form and expression that pervades Western metaphysics, the question arises whether an idea can exist outside of material form and yet appear to human perception.[4] Many forms and ideas are grasped by the human mind and communicable to a community of persons even though they exist without material instantiation—abstract concepts of law, love, justice, or spirit, for instance, or more concrete-seeming notions within the language of geometry, art, or social behavior ("good form"). But does this question take on a new cast when posed with respect to the digital environment? Should our conception of an image be changed by its capacity to be stored as digital code?[5] Or does code storage, as the defining condition of digital processing, finally satisfy the Western philosophical quest for mathesis, eliminating once and for all any ambiguity between knowledge and its representation? The various misperceptions of digital media as lacking materiality gain some of their credibility through connection to a tradition that idealizes the immaterial, even placing it in a theological frame, above embodied knowledge.[6] The argument that code is *material*, however, seems incontrovertible.[7] Digital code may be relatively unstable with regard to the bond between inscription and configured form (by contrast to a letter carved in stone, for instance), but the pattern of stored values on a silicon chip is ineluctably physical.

The argument can be made that computational media are overwhelmingly material—requiring rather large amounts of hardware to perform what was formerly done in rather minimal means (paper and pencil). But the perverse magnetism that draws concepts of immateriality toward the lodestone of code is provided by the curious belief (even desire to imagine) that perhaps, just perhaps, the configured form of code and the formal logic of configured thought might be analogous. At the very least, they might be made to conform to similar *rules* of logic, to be governed by, if not precisely part of, the same order of things.

A framework for this discussion comes from two disparate positions within twentieth-century philosophy: Edmund Husserl's notion of the "ideality of form" and Theodor Adorno's problematizing of the notion of self-identity of form because of the social-political implications that derive from alignment within totalizing systems.[8]

These two positions are useful as a means to address the formalist assumptions underlying the authority of digital media as construed in the popular imagination. The premise on which this authority is sustained is

a mythic one, as I hope to demonstrate. By moving between Husserl's em-brace of ideality and Adorno's critique of self-identity the link between the idea of "data" and the materiality of its existence in digital form can be interrogated critically. This link is often overlooked in the rhetoric of cybermedia, and data is commonly presumed to be value-neutral, pure or raw, and immaterial. This allows data-as-code to be misconceived as exemplifying self-identicality—the relation of information to itself. If code and data configure each other in a perfect, isomorphic relation, and if that relation is abstracted into "ideality" instead of rooted in "material-ity," the argument goes, then data and code are one and the same. Adorno would be quick to warn us that such yearnings for ideality preclude the critical reception of material expressions within cultural frameworks, where they operate in more pedestrian guise, rather like gods in mortal form in Greek mythology.[9]

My concept of "ideality" is derived from Husserl's discussion of the origin of geometry. The original geometer, he suggests, was able to ap-prehend *form* intellectually, outside of material expression.[10] Mathemat-ical forms, he goes on to say, become apparent to human sentience—but are not dependent upon it (by contrast, the "form" of the story of Emma Bovary is dependent on human authorship even if it can live as a con-struct outside of the text). Husserl even suggests that the peculiar speci-ficity of geometric forms is that, although they become conventionalized within representational systems, the original condition of their existence is independent of human constructs. Because mathematical forms have a claim to objective, universal status, even if their authority varies in cul-tural circumstances, Husserl's decision to focus on geometry makes his discussion appropriate to current mythologies in which the cultural au-thority of mathesis is supported.

If, following Husserl, geometric forms exist independent of human perception and are not changed by that perception from their ideal form, then does that ideality necessarily fall into the category of "self-identity" or "unity" of form? The idea of self-identity is anathema to Adorno, who argues that when empirical or positivist logic invades culture to such an extent that representation appears to present a unitary truth, there can be little or no room for the critical agency essential to any political action.

These two positions provide the poles of reference on which I examine the premises by which mathesis functions in current conceptions of digi-tal data. I suggest that there is an underlying, at times overt, ideological bias in the way the myth of digital code is conceived in the public imagi-

nation. Because mathematical forms of knowledge are presumed to lie outside of ideology, this conception validates digital representation in a way that forecloses interrogation. My double agenda is to disclose the ideological assumptions in the way the ontological identity of the digital image is posed and to suggest that graphesis (information embodied in material, and thus ambiguous, formats) can challenge mathesis. In other words, the instantiation of form in material can be usefully opposed to the concept of image/form and code storage as a unitary truth or, to use Husserl's term, "ideality." My argument bears on digital media in its basic operation and use, not merely in what it represents. I suggest that the possibility of critical cultural agency is linked to the assertion that the real materiality of code should replace the imagined ideality of code.

Digital photography presents a useful starting point. Many questions about the truth, fiction, or simulacral identity of digital imagery were prompted in the 1980s and early 1990s by its presumed distinction from traditional darkroom photography. Images by photographer and early adopter Peter Campus, for instance, provoked critical discussion around matters of ethics and illusion. Such work and its reception offers a useful comparison with the fictions produced by those early-twentieth-century adolescents, Frances Griffiths and her cousin Elise Wright.[11] The pair created paper cutouts of fairies, expertly photographed by them in a garden setting, that appeared sufficiently real to elicit great debates. *Alice and the Fairies* (1917) shows one of the girls in a garden setting, a "fairy" close at hand. In this image, deceit seems inconceivable, as much due to cultural expectations about the innocence of adolescent girls as to the plausibility of fairies' existence in English gardens. That it was a hoax is now readily obvious. That anyone believed in the image based on its use of photographic codes seems less credible. By contrast, Peter Campus's digitally manipulated *Wild Leaves* (1995) was more simulacral than fictional (its impact comes from the way a surface can create a reality effect, rather than from narrative credibility), but a mere half step separates the photographic antics of Griffiths and Wright from those of Campus.[12] Any number of critics have pointed out that there is much more continuity than discontinuity in the shift from darkroom to digital.[13] The notion of photographic truth based on a pure, unmediated representation of a "real" referent was illusory even before Griffiths and Wright's confabulations; multiple exposures, multiple negatives, and blatant reworkings of both plate and print were all tools of the photographer's trade almost from its origin in the early nineteenth century.

Critic Hubertus Amelunxen contrasts two types of mimesis, both

defined by Plato: eikon/likeness and semblance/simulacrum.[14] The difference between these terms supports distinctions between features of the photographic imitation of light and the presentation of an image of life as truth. Likeness privileges the indexical traces of actual light and the codes of verisimilitude that dominate our ideas of what truth "looks like." But in a world of digital special effects, the ability to produce virtual and hallucinatory reality is continually evolving. Market forces and competition, as well as habits of viewing, all favor novelty and invention. The skills through which the entertainment industry successfully deceives (some) of the senses raise philosophically charged questions.[15] But my argument is focused on the simpler, more fundamental question of assumptions about the truth value assigned to digital images as code.

Unlike traditional photographic "truth," the truth of the digital image is not, I would argue, posed as an index to the instant of exposure or as encoding the experience of "natural" visual perception. The digital image, photographic or not, is removed from those mechanics of production in which the metaphysics of light is linked via a moment of revelation to reality. Nonetheless, the digital image is (popularly and fundamentally) conceived as another kind of truth, premised on a deep conviction about a rational link between mathematics and form that is supposed to be irrefutably present in digital code. This premise is the foundation of a digital ontology. It promotes the idea that mathematical code is self-identical, irrespective of its material embodiment. This is a potent myth.

For the sake of argument, I want to approach the representation of thought as form along another trajectory, in which truth and form are put into a relation of identity. In the first decade of the twentieth century, the psychic Annie Besant produced a series of drawings of "thought forms."[16] Though her work, conceived within a late-nineteenth-century sensibility that embraced telepathy, magnetism, and the role of the medium, has a distinct naïveté, it also has a striking purity because of her conviction that thought *is* form and thus be manifested directly in visual images. Unlike Husserl's first geometer, however, Besant suggests that the representation of thought must be situated within a human context to be intelligible. She classed her images through a typology of universals: radiating affection, animal, grasping affection, watchful anger, jealous anger. These categories are typical of her time, a legacy of a theory of types and forms combined with a vocabulary of late-nineteenth-century psychology.[17]

By virtue of their schematic abstraction, Besant's visual forms have a formal resonance with a number of early computer-generated graphics,

such as those produced by Jack P. Citron in the 1970s.[18] In their minimal, skeletal appearance, Citron's graphics have a pristine innocence. The mathematics and logic of thought that created both algorithms and their manifestations were conceived of as thought beyond the philosophical frame of human subjectivity. *Geometric Digital Graphic from a Curve,* for instance, might be said to stand in relation to the algorithm that preceded it as the Copy does to Idea (eidolon) in a Platonic scheme. The image might even be consigned to the more debased category of Phantasm, a copy of a copy. But such a hierarchy presumes that Idea (and, by extension, algorithm) has a stable, fixed existence. Is Besant's original "thought," which her "form" presumably expresses, also such an algorithm? Do these artists create forms whose graphic identity, because it presumes to manifest an ideal form, shares a common belief about ideality?

As a digitally produced and manipulated entity, Citron's algorithm is also stored in material—in silicon—through a sequence of instructions and address codes. But here is the crux of the matter: like the ideality of Husserl's geometric forms, these algorithms seem to be capable of appearing to sentience, of being apprehended, outside of a material form—as thought.

Curiously, Citron's work is thematically engaged with these questions as well. He made several works that use algorithms to express and then distort a form. The images trace a process of deformation from the mathematical ideal of a geometric form through its distortion—by manipulation of its stored formula or code. This was a common theme in works by "digital artists" in the early 1970s, almost as if the problems of form as mathematical ideal and form as instantiation were paradigmatic issues for computer graphics. George Nees's *Random Number Generator Causes Swaying* maps the distortion in a regular pattern caused by introducing a random element, and the Japanese CTG group's 1971 *Return to Square* is almost a poster image for the comfortable fit between the ideality of the square as order and the process of debasement by which it is transformed into a (material) image.[19] If we imagine that the algorithmic representation of the geometry is the pure code, the ideality, then the material graphic representation will always be cast as the degradation, affirming the Platonic hierarchy of Idea, Copy, and Phantasm.

This opposition of algorithm and graphic manifestation, or of geometric idea and encoded algorithmic equivalent, entails a fundamental flaw. And this flaw, bound to the myth of the "immateriality" of digital artifacts, informs all celebration of "codework" as autonomous and transcendent.[20] The manifestation into substance, the instantiation of form

into matter, is what allows some thing, any thing, to be available to sentience. Ideas are apprehended through expressions (the illusory transparency of language as a means of expression often renders this invisible in common perception). This is true for the ideal form of a square, as well as for the analytic visualizations made by scientists using computer-generated images. An image of a complex molecule, for instance, purportedly showing detail at the atomic level, may in fact be a visualization expressing a mathematical model. The presumed ideality of the molecular structure, here made apparent as an image, serves as a convenient fiction through which we can gain access to the mathematical "truth" of the image, or even of the model it expresses.

But a digital image of something that is fully simulacral, such as the hyperreal renderings common in early music videos (as an example, the monster from Peter Gabriel's video *Mindblender*), refutes any easy link between an ideal algorithm and visualized reality as a fundamental unity. The existence of the image depends on the display, the coming into matter in the form of pixels on a screen. If, in one instance, the graphic display is manipulated by an algorithm, then, in other instances, the display becomes the site for manipulation of the algorithm. After all, the image on the screen is not even identical to itself. Not only are no two pixels alike, but the material expression of any algorithm varies from screen to screen, from moment to moment, from viewer to viewer. Embodied materiality is always distinct from the code it expresses. Conditions of use and perception enter into the production of an image in a very real sense, since forms are neither immaterial nor transcendent.

This brings me to the heart of my argument. What are we to imagine constitutes the "information" invoked or suggested in any of these various expressions? The algorithm? An ideal form (geometric or not)? An imagined molecule modeled mathematically? A simulacral monster whose algorithmic reality, its code-based model or identity, follows from the manipulation of data as visualized on the screen? In the visual practice of information design, in which graphic artists create schematic versions of the history of philosophy using as motifs an imagined solar system, or map thermal conductivity with fine, schematic precision, the assumption is that the information precedes the representation, that the information is other than the image and can be revealed by it. But we see from these examples that form is constitutive of information, not its transparent presentation. And no constituted expression exists independent of the circumstances of its production and reception.

Perhaps the most compelling, chilling image that I have come across

in thinking about these issues is a computer-generated graphic by a very early experimenter in this field, artist-scientist Melvin Prueitt.[21] It is a nocturnal image of a field of snow, unbroken and undisturbed. To my mind this is a terrifying image of the ideal of digital purity, the pristine visual manifestation of code. Nothing human or circumstantial disturbs its form. But it certainly is not pure, any more than any other image output by a plotting pen, laser jet, or Giclée printer. Any act of production and inscription, the scribing of lines that create the specificity of an image, demonstrates that an expressed form is different from the underlying code. Whatever the "ideality" of code may be, even if it were available to sentience in some unmediated way, the encounter of expression and matter produces thought as form. Any interpretive act returns to this initial inscription through its own productive and generative process, reinscribing a work as product within a specific situation of viewing.

In a very real sense, code lurks behind Prueitt's image of snow. In saying "behind" I mean deliberately to invoke an ontological and chronological anteriority. But this code can't be conceived as "pure" in the sense of being independent from a material substrate or instantiation into material. Code is itself always embodied, instantiated in material.

The digital encoding of form as information, as data, as patterns of binary code might be used to assert that our understanding of what a "form" is should shift toward the realm of mathesis. That tradition of logic, envisioned by Leibniz, still drives a quest for cognitive, epistemological, and technical certainty that seeks to reduce all formal, even material, expressions to a "higher" logical order of existence. But the ideality that Husserl envisioned for mathematical forms is generalized and reductive, a mere category and placeholder within human expression (even if assumed to exist in some ontological sense outside cognition). His geometries are not replete and specific forms capable of showing that the world is understood through experience and perception. Thus, we can define graphesis as knowledge manifest in visual and graphic form, and insist that it is based on understanding of form as replete, instantiated, embodied, discrete, and particular.

In Karl Fredrich Schinkel's eighteenth-century, neoclassical rendering *The Invention of Drawing,* the act of form-giving is depicted within the tensions between the lived and the ideal. Schinkel's image inverts Pliny's tale of Dibutades, in which the daughter of the potter traces the outline of her departed lover, changing the genders, so that female beauty is objectified as an ideal within a male gaze. This painting suggests that aesthetic form-giving is always an inadequate copy, a lesser truth than

the real. By contrast, in a late-1990s advertisement for Johnny Walker Red Scotch, a young man sits in khakis and topsiders on a deck, beachside, with his laptop computer open in front of him. On its screen is a wireframe graphic image of a dolphin, and beyond the man, leaping up and out of the Johnny Walker Red sea, we see the beast itself. The image of the dolphin on the screen does not match the image of the dolphin leaping from the ocean. Their direction, temporal moment, and other details are out of synch. But which is bringing the other into being? The visual image confuses the hierarchies of original and copy. The computer graphic seems to generate reality or, at the very least, to function on an equal, autonomous level as a form-producing environment. In *The Vision Machine*, Paul Virilio raises the specter of a sightless visuality, one in which images exist only as signals in the electronic currents of a closed system, readable by machines but neither visible nor legible to humans.[22] In such a situation, "form" is nothing other than code, still material but accessible only to some other sentience than the human. The case demonstrates even more fundamentally the link between the materiality of code storage and formal expression, since the networks cannot grasp ideality, only pulse and flow within their circuitry.

What is at stake in asserting the authority of graphesis—the material expression of form as the condition of its existence—is not the viability of code that has no graphic manifestation, but the fact that it is stored materially. Code is not an immaterial ideal. This in itself calls the mythic status of the digital as the realization of mathesis into question.

Such realizations have implications for the transformation of form from traditional media and representational systems into digital formats. They suggest that decisions about what aspects of material forms to encode, and how, have to engage with broader conceptions of information. When "form" is conceived in mathematical terms, it can be absorbed into an absolute unity of essence and representation. But when it is conceived in terms of graphesis, it resists this unity, in part through the specificity imparted by material embodiment.[23] Materiality cannot be fully absorbed into ideality, nor can it be understood as a mechanical, self-evident literal identity. Something is always lost when, for instance, a text is translated into ASCII format. Digital media have their own materiality (and material history to be sure), but in the distinction between mathesis and graphesis the resistance to the totalizing drive of the digital can be articulated. This is the beginning of the place from which an argument about the ideology of code can be created, but also the place from which a literal approach to materiality can be critiqued.

I return, for a final moment, to Melvin Prueitt's digital snow-field, in which, as Amelunxen says of such work, the gap between the algorithmic-numerical image and its origin is so slight that it seems to cast "no shadow." But the gap does exist. The distinction can be made just as surely as in any conceptual work. There is always a space between expressed idea and expression of an idea. The ideas that drive conceptual projects are not immaterial—they are usually expressed as language, as coded procedures capable of generating any number of material instantiations. But even as procedural statements, they are already both code and matter. Unless we revert to the mystical concept of ether, the base materiality of all human expressions will need to be accounted for in any analysis of objects and artifacts, forms and ideas, that are part of human experience.

Thus the crisis introduced into aesthetic discussions by digital media is not, as commonly reported, a crisis of the copy, of originality, or of authenticity or truth. What is at stake is more poignant, since it depends upon the possibility of reinscribing form into matter as part of a human, cultural, and social system. If code is ideal form, it resists inflection, cannot register subjectivity in its production or interpretation. But the specific, particular character of materiality always registers the circumstances of production, expression, interpretation.

This argument against the immateriality of code fosters critical consideration of the ways it actually participates in and helps replicate cultural mythologies. It dispels the idea of code as either self-identical or transcendent, or as constituting a truth. The easy interchange of image into code and back into image becomes loaded with a myth of technosuperiority, as if the independence of code from matter were so fundamental it could never questioned. In a system premised on mathesis, code is presumed self-identical, unavailable to critical interrogation, and everything else is reduced to data and equivalents. When this claim is extended to the cultural realm of representation, its hubris needs to be challenged. Graphesis is always premised on the distinction between the form of information and information as form-in-material. It insists on recognition of the specificity and particularity that resists self-identicality.

Most important, this argument cannot be reduced to a distinction between digital and analog. Whether an artifact exists as print, code, digital file, or physical image, its material expressions are always undergoing changes, aging, crumbling, acquiring or resisting wear. All forms of expression are ontologically incapable of self-identicality. Graphesis is premised on the irreducibility of material to code as a system of ex-

change and equivalents without acknowledgment of its specific instantiation. The materiality of graphesis constitutes a system in which there is loss and gain in any transformation that occurs as a part of the processing of information. In that process, space to register subjective inflection creates a place within which Adorno's critical reason can operate and in which humanity, such as it is, can be expressed. Digital media are no different than traditional media in this regard, but the claims and mythologies they sustain have allowed aesthetic work to be used to justify a cultural authority in which logic and its formalisms trump other, experiential, forms of knowledge. Or try to. Digital media are not Prueitt's dead zone of insubstantial rendering, in which neither experience nor perception, human subjectivity nor or social experience register. This realization presents a far more optimistic outlook than if the code world were a realm of intangible remoteness, absolute and transcendent.

3.2 Intimations of (Im)materiality: Text as Code in the Electronic Environment

Analog graphical artifacts challenge the formal and logical basis of digital information. The specificity and particularity of their material inscription have an inherent ambiguity that is not readily translated. But it would be a mistake to imagine that only analog artifacts confound the authority of digital media, or that the challenge to formal logic is solely a property of traditional media and their materials. Texts in an electronic format align themselves with code in a deceptively simple way, as ASCII text that translates into a string of binary digits, as if the text were in fact equivalent to that code. But this presumes that *what a text is* is a linear sequences of marks or signs. A text, of course, is more than this.

Debates about the nature of materiality with respect to writing in digital formats are often premised on a false binarism: print artifacts are considered material, electronic formats immaterial. Attention to the actual characteristics of digital texts, from the level of the letter to more complex aesthetic expressions and organizations, reveals the fallacy of such a binarism.

As discussed in chapter 1.1, the appearance of "electric language" initially generated a utopian buzz among theorists. Electronic environments seemed to promise

the realization of hypertextual potentials latent in print formats. Traditional linearity seemed poised for an explosive expansion, and the term "rhizomatic," much overused, turned up everywhere, as if performing its own meaning.[1]

A few decades of word processors and Web browsers later, the sense of continuity between traditional and electronic formats has become as apparent as the sense of rupture introduced by new technologies. We have come to see that many features of hypertext, hypercard stacks, and the threads linking one Web node to another have antecedents in print formats. The structure and form of traditional print media, once spuriously characterized as linear, have been newly scrutinized for their generative and dynamic properties. Stasis, it is worth repeating, is a *relative* property of the material conditions of inscription, not a characteristic of texts. Current textual studies have brought attention to the ways various nonlinguistic aspects of that materiality (type, paper, book structure, layout) participate in the production of semantic meaning.

Still, the notion of the "immaterial" text has become fixed in popular and even critical imagination. Why? Though digital information is far more fungible than physical inscription, the codes on which electronic texts are based are themselves material. More to the point, however, the graphical and dynamic organization of texts continues to function as textual information in the electronic format.

At the most basic level of textual matter, we might ask, what is the link between a letter and the binary codes of electronic storage?[2] What constitutes the identity of a letter as an information form? Is the essence of an *A* its graphical shape? Or is a letter merely an element in a finite system that is sufficiently distinct from all the other elements (e.g., an *A* is not a *B*) to allow the system to function as a graphical code? What is the basic relation between form and information in letters? Does the letter have a body? Does it need a material form in order to register to perception or to function as signification (two different issues, to be sure, one rooted in human communication and the other in semiotic systems)?

If we assume that the letter innately possesses a body, then its identity is bound up in some essential way with that form. If the letter merely *needs* a body, then the implication is that the letter could function through difference. The first concept of identity suggests an inherent essence. The shape of an *A* is substantive information that would be irrevocably lost if the letterform were altered past all recognition (as in fact occurs when a letter is stored electronically). The second concept is more clearly semiotic, since it requires only that letters remain distinct from one an-

other (as, indeed, the electronic code for an *A* differs from that for a *B*). In that case, the identity is functional or operational, not graphical or visual, and any notion of formal essence can be discounted. The question of whether graphic form is substantive information cannot, of course, be answered with a simple yes or no. The answer depends on the circumstances and what information is being gleaned. In questions about the history of printing, writing, textual production and transmission, and other such matters, visual form is clearly substantive. Losing such information through electronic encoding registers as a substantive loss. The question of what constitutes substantive textual information replays at every level of electronic production. One thing, however, is clear: the stripping away of material information when a document is stored in a binary form is not a move from material to immaterial form, but from one material condition to another. The format and graphical design that are part of the presentation of information in every area of communication (including poetic expression) contribute substantively to the text.

Electronic media push the examination of form-as-matter to what seems like its limit because of the inherent character of binary code. But when information is stored as code, is it really pared down to its essential identity? Is data an ontologically pure condition for information or merely a convenient format for management and administration? What is the ontology of a text in "code storage" if the graphic features of the preexisting text are eliminated by the process of encoding? Such questions open a rift between form and associative meaning, between a letter and its graphical identity, between a text and its configured format—relations that seemed inextricably intertwined in print media. In the electronic environment, by contrast, it possible to imagine and even to encounter a letter or text that seems to exist independent of any specific embodied form. Such encounters lead one to believe that a text need not be inscribed in a material substrate. A document can be stored electronically, then output through a variety of devices. A text file can be used to generate musical notes, patterns of light, graphic forms, or letters on a page. This uncoupling of the relation between material form of input and material form of output is what makes information in electronic media fungible and creates the illusion of immateriality. But in fact the mutable condition of "code storage" is endemic to all textual transmission. The time lag between when a text is read and when it was typed, or set by hand in a composing stick, is also a gap in which the fungible quality of textual information can be registered.

Thus the electronic condition introduces a new self-consciousness

about writing's past functions, dependencies, and relations to material-ity. Code scintillates between material conditions only long enough to ask us what the substantive content of each material inscription might be. Any text is materially instantiated; the degree of stability in the re-lation of inscription to material varies. In physical, graphic media, it is high, in electronic media, far lower. But if the material information of a text—at the level of the letter, document, or artifact—is an integral part of textual information, then how does storage as code and the mutability that entails transform or undermine the content of electronic texts?

The curious history of language in relation to electronic media enters the picture here. That history involves a split between the logical and formal language used to integrate human communication with machine function and the analysis and interpretation of "natural," data-rich lan-guage by the machine. In each case, the concept of what constitutes in-formation is subject to particular constraints and limitations, and meets with different problems in machine processing. The development of programming languages in the course of the twentieth century spawned a veritable babel of dialects. But such languages are as much mathemati-cal writing as they are linguistics. Highly constrained and specific, they work on the principle of eliminating or avoiding ambiguity, nuance, or variable interpretations.

Natural language processing reached certain impasses in the first decades of serious computing, and early-1960s optimism about the pos-sibility of parsing natural grammar into machine-readable (or machine-producible) forms foundered on the complexities of context depen-dence and the need for a cognitive frame of lived experience outside the language system. In the history of debates from artificial intelligence to cognitive studies, belief systems split between top-down, rule-governed programming and bottom-up, experience-based learning. These debates struggled to decide whether a logical or a data-rich system of representa-tion more accurately mirrors human learning processes, and thus which might more productively be modeled in computational environments where language processing is to take place. But neither position took into account the elements of *configured* language—that is, the format, graphical organization, and structural relations that contribute substan-tively to textuality in traditional and electronic formats.

The properties of configured language are not those of an algorithmi-cally programmable statement based on formal logic, nor are they the same as those of the context-dependent utterances of natural language. Configured meaning is an aesthetic, rhetorical, and substantive part of

linguistic expression. Configuration constitutes meaning. Taking into account configuration revives the inquiry into the relation of sense and form, idea and expression, within human communication systems and mediated exchanges. The letter is a good point of departure for thinking about the value of configured meaning and the way the apparently immaterial text of electronic environments reveals the fallacy of conceiving of code as an ideal form outside of material instantiation.

The process by which any text can be stripped of its apparent materiality as it enters the electronic environment is familiar. But imagine the dilemma of the archivist or librarian deciding on the appropriate means of migrating a handwritten or printed document into digital format. Many such documents contain at least as much visual information as textual. Saving the document as an ASCII file, a sequence of strokes on a keyboard, records a bare record of linguistic information. Or the document could be saved as page images, preserving the rich visual information, even if the verbal content is not available for electronic searching and processing. For scholars intent on attending to the material properties of textual production, such matters are crucial. The Renaissance typographer, designer, and metaphysical philosopher Geofrey Tory, for example, designed his letter *Y* as a study in Pythagorean morals, contrasting the fat stroke of easy indulgence, hung with hams and other pleasures from which one drops into a flaming hell, with the thorny, thin stroke, the path to virtue plagued with wolves and other difficulties. The absurdity of rendering Tory's *Y* with a keystroke is obvious, but this exceptional example makes obvious what is less evident, and sometimes less pertinent, in other cases: that the graphical characteristics of letters are information.

In the late 1970s and early 1980s, mathematician Donald Knuth attempted to make a program that would describe the letters of the alphabet so that he could overcome certain technical difficulties in typesetting his work.[3] This brought him to the heart of the question of whether any algorithm could describe any and every instance of a letter. In other words, does a letter have a single identity, an essential configuration in which it is always expressed, albeit with varying degrees of deviation from the norm. The idea that a letter could be described by a formula that always and only resulted in that letter turned out to be a chimera. As Douglas Hofstadter observed, the individual letters do not constitute a closed set.[4] Any and every instance of a letterform adds to the set without distorting or destroying its delimiting parameters, just as every chair—regardless of height, material, number (or absence) of legs—adds

to the category of chairs. The functional life of letters is obviously different from that of chairs, if only because letters' significance depends on their being recognized. To commonsense perception, the essence of an *A* seems incontrovertible. But in actuality, the conventions by which we perceive, read, and process these complex forms are system- and context-dependent. As with chairs, they cannot be defined in a fixed, formal description.

Knuth's dilemma becomes all the more clear when the problems of generating letterforms are contrasted with those of recognizing letterforms. Programs for optical character recognition have become increasingly sophisticated. But the assessment of symbol codes according to primary characteristics (what to look for in the elements of crossbars, downstrokes, x-height, descenders or ascenders) is always calibrated in relation to the fixed set of letters that are to be distinguished as the alphanumeric code. If a letter were simply and fundamentally algorithmic, ideal, and, in current parlance, immaterial, then essential shape and distinctive features could be prescribed as variations on a single formula. In scalable, multisize fonts, letters are described either as vectors, as bit maps, or as complex objects whose internal proportions must to be altered as the scale changes. These letters may be stored in various ways: as sets of instructions about the coordinates that determine the shape of strokes and curves, as records of ductal movements or gestures, as patterns of start and stop points in a raster display, or as pixel patterns in a tapestry grid. The object can be treated in different ways depending on its code identity—sloped, thickened, stretched, resized, and reproportioned—without losing the shape that is essential to communicating its form. Nonetheless, the identity of letters, Knuth found out, cannot be described in an essential or prescriptive algorithm capable of generating any and every instance of that letterform. Mathematical code can accommodate elegant description—information about pathways, vectors, and shapes— but cannot encompass the identity of the letter as a form.

The specific materiality of letterforms, as it turns out, links these particular ways of describing them mathematically to larger traditions. Most have been created in the context of particular belief systems—cosmological, semiotic, or stylistic—and can be described as either constructed, gestural, pictorial, or decorative. *Constructed* letters are based on ideal forms and follow the most precise mathematical prescriptions for proportions—though almost always with some slight variation, to create more dynamism than a perfect mathematical form allows. The algorithm for their creation may be precise except for these slight, and

oh, so critical, adjustments, which take into account use and perception. *Gestural* forms are ductal, their stroke patterns described as vectors rather than as a set of fixed geometrical elements, but here again the specific properties of material expression involve the swell and pressure of a brush or pen as the hand varies in its path. And again, the materiality is difficult to recover. *Pictorial* and historiated initials, with moralizing vignettes painted within the counters of majuscules or biblical scenes depicted in the strokes, can best be rendered in digital form as bit maps, but such renderings are perversely distant from the rich content of the image. *Decorative* letters, whose stylishness can be described in terms of component parts, might be coded as units and modules for combinatoric purposes. Granting a value to each piece of a letter by virtue, for instance, of its proportion of curved to straight form in order to calculate its place with a scheme of feminine and masculine principles, could be effectively coded into a mathematical formula. But within any of these conceptions, analysis of what a letter is requires apprehension of the expression within a material instantiation—since that is where its properties become apparent. The properties of letterforms are not inherent, nor are they transcendent, and the material structures within which they are expressed as elements of belief bear on them as they are migrated into digital form.[5]

In the early days of low-resolution monitors and crude output devices, the technical limitations of display pushed the question of the essence of letters as shapes. An alphabet like Wim Crouwell's machine-friendly "New Alphabet," designed in 1967, put as much emphasis on criteria of differentiation among letters as it did on essential form. One has only to isolate a few letters from that alphabet and try to read them on their own to realize how much legibility and recognition depend on context within a sequence of characters. As letter designers have taken advantage of the permissive potential of electronic environments to do things that no calligraphic, print, or photographic medium could do, three-dimensional type designs, rendered fonts that challenge legibility, and other challenges to convention have enjoyed their vogue and vanished. But a mystical belief in essences, with all its kabbalistic undertones, never fully vanishes from the scene. The notion of letters as cosmic elements has great allure, and the idea of code as the key to this universe of signs is too seductive to be put aside completely. These activities all revive the question of materiality with renewed vigor, since it is the inscription of letters in forms and shapes that accord with the whim and styles of a historical cultural moment that allows them to realize the affective

potential of their formal expression. The extent to which graphical and visual properties inflect a text with a meaning that is inseparable from its linguistic content is always a feature of its materiality. What the code encodes is always an instantiation, and the transmission from one state of inscription to another merely iterates material conditions, it does not eliminate them.

If this is true with regard to letters, marks, and even the white spaces that constitute a textual field, it is also true of configured texts at the secondary and tertiary levels of organization—as text (composition) and document (artifact). Formats are information, rhetorical and semiotic structures that offer instructions for the production of a text through reading. Outline forms and diagrammatic textual structures are prime examples of texts in which configuration carries semantic value, and understanding the ideological force of schematic forms is an essential critical tool for reading the material codes of information design. Elaborately configured texts use a graphical scaffolding in their organization and layout that carries semantic value: hierarchy, relations of dependence and inheritance, metaphors of branching, various modes of grouping elements, proximity, and so on. These features of the graphical space are integral to the textual field, even if they are completely nonlinguistic.

Classification systems are clearly content rich and ideologically complex. Outline formats, for instance, encode striking numbers of reading clues in their organizational structure. The treatment of headings, subheads, and sub-subheads, their diminishing size, degree of boldness, capitalization, or degree of indentation, are all graphic indicators of the importance of the information within the structure as a whole. In the magnificently elaborate schemes of late medieval cosmologies, Aristotelian rhetorical structures that were pervasive among the Schoolmen, these systems embodied an argument about a worldview.[6] Such schemes blossomed again in the hands of ambitious polymath scholars of the Renaissance, who were intent on describing the order of all things in a manner that could, in the tradition of mathesis, be mapped into a linguistic order. As one of the preliminaries essential for creating the much-sought-after grail of a universal and philosophical language, the rather dauntingly determined Bishop John Wilkins made a full outline of the natural, cultural, spiritual world. His *Essay towards a Real Character and Philosophical Language,* completed in 1668, includes that scheme in all its detail.[7]

Wilkins's obsessive energies may distinguish him from his peers, but his project was neither idiosyncratic nor anomalous. Others pursued

similar outlines with the same goal of creating a language that was iso-morphic to the order of the world, and thus able to encode knowledge within its formal, logical order and its inscriptional notation system. The similarity between these undertakings and those of later figures such as George Boole and Gottlob Frege is rooted in their shared quest for a comprehensive algebra of thought. For inspiration, these figures drew on the notes of René Descartes and Leibniz's plan for a rational calculus.[8] The work of the young Ludwig Wittgenstein and the attempts made by Noam Chomsky to show the rational order of language are further ex-tensions of this tradition.[9] But the graphical ordering of relations finds less explicit attention among such practitioners than these comprehen-sive schematic orderings of entities. The elements of syntax are absorbed into structures that mimic the formulas of mathematics or formal logic, where order and notations are graphically inscribed and *semantic,* but vi-sual *rhetoric* is rarely analyzed.

A glance at the organization of Wilkins's scheme, familiar in its outline form, shows clearly how the configured visualizations not only order the information in their systems but *are* themselves information. The won-der of Wilkins's outline is that it adapted the outmoded late medieval diagrammatic tendency to a new purpose—a modern system of classifi-cation and typologies. His hierarchies and divisions order the world into clusters and zones that rehearse binarisms between heavenly and earthly, animate and inanimate, vegetable and mineral elements. These divisions are forged in the format as much as the nomenclature, and the branch-ings of the organizational armature contribute their specific semantic value within the larger whole. Much more needs to be said about the visual rhetoric of diagrammatic forms and the force of visual structures as interpretations, but that is another project altogether.[10] Having made the point that structures are semantic, my emphasis in this context is on features of materiality within electronic texts.

These observations are applicable to texts in any format, but in an elec-tronic environment, where formal relations can be abstracted into a tem-plate (through the simple Save As function) or encoded as metastructures that model texts (the Document Type Definition and XML schemas are most familiar), the self-consciousness that attends to their organization as formal systems can be readily apprehended in their graphic expression. But taking these relational, structural features literally, finding a lexicon of values for each organizational form, would replicate a mechanistic and reductive approach to the analysis of materiality. While relations of hi-erarchy can be read for their value, and it is demonstrably true that basic

graphical features perform with somewhat predictable effect (following, for instance, the principles outlined in a gestalt analysis of graphics), the findings of cognitive approaches go beyond literal, mechanistic materiality and replace it with a generative, probabilistic understanding. Mary Carruthers's important corrective to earlier studies of memory theaters provides a dramatically useful example of this shift in approach.[11] Memory theaters, devised in antiquity and perfected in conceptual terms in Renaissance revivals, provide a striking instance of meaning structured in spatialized relations. Frances Yates's well-known study showed that in these structures, space was used in metaphoric and schematic modes simultaneously.[12] Place had value, as did the "contents" exhibited in any location. But in analyzing medieval structures and their role in encoding systems of thought as representations, Carruthers found that the elaborate spatial schemes were experienced as part of a cognitive process in which one cue after another was encountered in the spatial organization. These cues prompted thinking, or action, in a performative mode, not simply a mechanical repetition of memorized information.

The distinction between provocation to interpretation and the older idea of a fixed structure is crucial to the shift between mechanical understandings of materiality and probabilistic ones. The analysis of graphical organizations as material forms gives rise to a basic set of critical insights. Outline forms impose hierarchy, tree diagrams suggest organic models based in genealogy, graphs order their information in relation to axes that usually make use of standard and uniform metrics, and grid structures, like graphs, bear within them the stamp of rationalized, bureaucratic approaches to information and representation. French semiologist Jacques Bertin created a list of seven graphic variables (size, scale, position/placement, spatial arrangement, orientation, shape, and color) that is extremely useful for description and design.[13] To these we can now add the rate of change and refresh cycles, perceived and programmed movement, and other dynamic features that are components of the design or analysis of time-based electronic media. Similarly, the principles of composition that have long governed design of visual communication are amplified by navigational factors in an electronic medium (flow, continuity or rupture, etc.).

But the *reading* of any text and its graphical structure is always an interpretive act, an intervention in a field that is coded to constrain the possibilities of reading but works through provocation, not mechanical transmission. In an electronic environment, the organized structures of graphical space are extended by the multidimensional possibilities of

hyperlinked architecture or arrays and protocols for calling the elements of any data set into play. The configurations of Wilkins's cosmological scheme hold the elements in relation to each other so that the reading articulates their value through terms of proximity, derivation, or other features. The importance of analyzing the way such structures and protocols model information and the conditions for its use is paramount in understanding the ways electronic texts function within the cognitive processes that Carruthers describes for medieval architecture. The difference is that the iterative capability that distinguishes information structures from those of the built environment operates much more rapidly and thus perceptibly than that at work in the transformation of a stone building through its relations of codependence and use.

Backtracking for a moment, recollect the way debates about the value of literal materiality came into focus early in the implementation of HyperText Markup Language. In the mid-1990s, as Web browser became capable of generating graphical displays, the question of what should be encoded as information in a text came into focus. Was the typeface, style, or format of a text to be encoded or only the alphanumeric sequence? The initial HTML tag set suggested that graphical information was irrelevant. Headers were organized by importance and size but little else, and features of display were rendered generically. Graphic expression was primitive, and typography (much to the dismay of designers) was simply deemed not to be information. If a text were to be able to be displayed on any platform and in any browser/monitor situation, then, for practical reasons, such nuances as Garamond or Baskerville couldn't be stipulated as part of the display. In the late 1990s, the insistence that HTML should be capable of registering design features—that design was in fact part of the information—coincided with the development of style sheets. Increasing bandwidth, diminished anxiety about file size, and other technological changes were accompanied by the development of fonts and display forms made for the electronic environment. But the earlier omission had already drawn attention to the significance of material information in type and format decisions, whether these were developed in the electronic environment or merely stored there.

The idea that lurks in the study of electronic textuality is that binary code reduces information to an essential condition, and that this condition, with its insistent logic, matches Descartes's original idea of mathesis. The idea of understanding configured texts as logical forms, and code storage as their essence, misses the point that a multiplicity of materialities enter into the production of any text, even in advance of the reader's

probabilistic intervention. The dynamic mutability and flexibility of display modes is a constant demonstration that the "essence" of code storage has no self-identical hold on the semantic value of a text. Files are constantly reconfigured in reading and display, and in each instance and iteration, material form and structure contributes substantively to the configured meaning. A text rendered in a skinny column of six-point type with carefully chosen line breaks is not the same as one that screams across the monitor in a stream of blinking, six-inch-tall, neon pink letters. Sharing an alphabetic sequence of letters as stored code does not make these two texts the same at all. The chimera of a code that would register the immaterial trace of pure difference (binarism at its most hubristic)— and thus fulfill Leibniz's dream—is pure fantasy. Code storage is neither immaterial nor self-identical, any more than any other inscriptional or notational format. The iterative display of electronic texts shows off the limits of reading within a frame of literal materiality (and thus the need for critical analysis of these features) rather than the probabilistic materiality in which we conceive of texts as products of interpretative acts.

Charles Bernstein's *Veil,* first published in print form and then in electronic format, offers a useful contrast in two modes of materiality.[14] The printed *Veil* is based on a typewriter poem in which Bernstein overprinted line after line of letters. This created a scrim or screen effect that rendered the language of the text almost illegible. But this illegibility is the point of the text, the porousness of which permits scraps of meaning to surface through the dense field of letters, the fine mesh of its own self-produced screen thus veiling the linguistic transparency of language. The materiality of print form is inherent in the visual and verbal value of the work. In a dialogic synthesis, the two aspects of writing, visual and verbal, play equal parts in the production of the whole.

In transposing the work into an electronic format, Bernstein modified the text and visual production. The letters in the printed *Veil* are always fully present, each layer sitting on the next in an irrefutable maximization of information. In the electronic version, however, the letters and blocks merge. For each point on the screen a single value is assigned to the pixel (one can say the same for the printed version, a photographic reproduction of the overprinting in the original typescript, though the photograph retains some of the material information of the original). This single value averages the overlapping rather than registering several values simultaneously. Unusual effects are produced that are not present in the print artifact. Some letters lighten the dark field of overlap, rather than invariably increasing its darkness.

In some ways the electronic *Veil* has more transparency than the printed version, but the texts in the electronic version no longer retain any degree of autonomy. Even if they couldn't be recovered and read from the print version, the individual text layers remained evident. In the electronic version, the history of placement, displacement, and layering simply can't be discerned.The production history might be saved in any number of file formats, but in the flattened display, the material trace of the early medium is lost, a new material expression in its place. The new *Veil* is thus a screen between production and display, erasing the history of production and erasing traces of its encoding. The poem has gone from being a text-as-image-of-its-production to being a graphical display showing the end result of now absent manipulations. In the digital condition it lacks—or appears to lack—a recoverable history of its own production. The electronic text has become a configured pattern, a palimpsest both real and illusory. Is the essence of its language the inherent but unreadable semantic value or the newly configured form of visual effect? Neither, of course, and both, as well as the many other visible and invisible features of its production and reinscription in any and every reading.

Obviously any notion that "pure code" is immaterial is false. Matt Kirschenbaum has described the apparent paradox between the "phenomenological materiality" of a text and the "ontological immateriality" of its existence.[15] We perceive the visual form of a letter on the screen or on a page in all its replete material existence (font, scale, color, etc.), even though the "letter" exists as a stored sequence of binary code with no tactile, material apparency. But the electronic current, hardware, support systems, and substrate for such code are materially complex. Even at its most basic level, as Kirschenbaum knows full well, code is not immaterial.[16] It functions as a temporarily fixed and infinitely mutable sequence that always refers to a place within the structure of the machine. As a binary sequence, code is always constituted as substantive difference, not simply metaphysical *différance,* and is part of the topographic structure of the computer's configured spaces and mapped territory. As computer historian René Moreau has said, "No item of information can have any existence in the machine unless there is some device in which its physical representation can be held."[17] Code is material, and its materiality has implications at every level of inscription and display, as well as for its role in accounting for configuration as information.

So long as we eschew metaphysics, code cannot be read as transcendent, as ideal, or as comprising a universal set of independent and auton-

omous symbols (any more than the alphabet should be read as comprising the fundamental elements of the cosmos). The configured meaning within code formations should be read as part of the material world, in variously layered interpretations: from the coming-into-being-as-form that can be grasped as sense (the originary inscription) to a level where form is interpreted within any of the many complexities of iconography, symbolic imagery, textual dimensions, aesthetic inflections, and their attendant historical and cultural engagements with discourses of power and the social conditions of production in all their individual and collective dimensions.

Treating meaning as transparent and materiality as insignificant renders these ideological values unavailable. The "immaterial" gap of transformation—that moment in the movement of a text from one condition of inscription to another—whether in the typesetter's head at the case, the typist's mind, eye, and fingers at the keyboard, the electronic generation of display from a stored file, or transmission to another file format—precipitates back into material expression unless the text is lost in the ether. Language is never an ideal form, always a phenomenal form. The configured features of language in electronic formats are as substantive and significant as in printed artifacts. Reading these literal features of materiality reveals the rhetorical force of specific properties even as every individual interpretation of texts produces them anew from the probabilistic field.

Coda: The Quantum Leap from Literal to Probabilistic Studies of Materiality

The distinction between mechanistic or literal approaches to the study of materiality and the probabilistic or quantum approach, though it is not only a feature of electronic texts, merits further comment. One crucial move, highly relevant in the context of digital code and reading practices, is the shift from a concept of *entity* (textual, graphical, or other representational element) to that of a *constitutive condition* (a field of codependent relations within which an apparent entity or element emerges).[18]

We can take typeface, page size, headers and footers, and column width in any electronic or printed textual artifact as points of departure. These apparently self-evident graphical features of any textual work, whatever the material format, tend to go largely unnoticed unless they interfere with reading or otherwise call attention to themselves. Works by book artists and designers cleverly may exploit these codes to defeat

or trick expectations provoked by familiar conventions.[19] The irreverence of a mismatch between elaborate stone-carved majuscles and the "OMG" or "LOL" of a text message can be obvious and funny. The practice of reading such material codes, what I call literal or mechanistic analysis of materiality, is indisputably valuable.

Most style choices are made to please the eye, make a text legible and presentable, or produce an "aesthetic" design—not as studies in historical understanding. But with just a little background in type history, a reader can register striking paradoxes. The realization that typographic descendants of the rational seventeenth-century Romain du Roi are pressed into service for personal ads or crass commercialism could be disturbing to the eminent design committee commissioned by the French king, were they around to see it. A distinctly ahistorical medievalism runs rampant in video and online games. The typographic construction of a pseudomedieval setting (and its association with "gothic" themes of vampirism, dark magic, and undead forces) offers prime material for cultural study. But it is only a single, conspicuous version of more familiar blindnesses. Only the most rarified typophilic readers, for instance, inflect their morning reading of the *New York Times* with reflections on the fate of Stanley Morison's judicious design expertise. Nor do many casual observers note the debased uses of once elite fonts like Baskerville or Park Avenue. And very few viewers pause to read the IBM logo, designed by Paul Rand, as the essence of modern corporate systematicity and global imperialism. The typographic codes are at once too familiar to be read and their origins too obscure to be available without special knowledge. Fewer yet will puzzle through the cultural implications of the genealogical relation between such designers, their training, and the transformation of the communicative sphere. Every material artifact embodies such aesthetics in its formal properties and history, carrying the legacy of its use and reuse. Too much attention to these graphical properties quickly becomes reductive, as if a dictionary of equivalents existed in which Neuland + Ezra Pound + wide spacing = fascism.[20] If it did, it would embody literal, mechanistic materiality *in extremis*.

Still, the discussion of the "meaning value" or "expressivity" of visual means, though unfamiliar in particulars, finds more or less ready acceptance as a general idea. With just a little prompting most readers will admit a begrudging preference for one font or another or admit to the inflecting effect of graphic styles on semantic value. A sample display of posters, type samples, or graphic instances makes clear that such graphical codes affect our reading. Early-twentieth-century journals, for in-

stance, display marked differences meant to signal appeal to different audiences: The unbroken, measured columns of serious news journals were aimed at a masculine sensibility. For the female reader, imagined to suffer from a deficient attention span, chunks of type were interspersed with graphics, encouraging her wandering eye to fall at random on ads for domestic labor-saving devices, corsets, and pickling equipment. Exchanging *Wall Street Journal* headlines with those in the *Weekly World News* provides a similarly dramatic demonstration. "Bond Markets See Rates Drop by Slight Margin" takes on a screaming impact as a banner headline set in white sans serif type atop a lurid photo, and "Woman Gives Birth to Angel" tones down considerably once modestly set in the greyest and least exclamatory of formats.

Meaning is produced, after all, not exhumed, and such exercises are dramatic demonstrations of this principle. Most literate people are fully ready to believe that the massage of meaning goes beyond surface effects even if many of these same readers, including textual-studies and lit-crit scholars, tend to shrug off these observations as trivial. Most literary types (and common readers) are closet transcendentalists, harboring a not-so-secret belief that, after all, it is "sense" that really matters. (The use of the word "matters" here is notably perverse. What could *matter* more than material? But more on this in a moment.) We could likely agree, however, without too much dispute, that any instance of graphic or typographic form can be read as an index of historical and cultural disposition. Attention to the "character of characters" is laudable, maybe even useful, and similar observations could be made with regard to other elements of layout and design.

Typographic expertise used to be an esoteric art, the province of trained professionals. Desktop publishing changed this and broadened sensitivity to design as a set of familiar variables. The features of graphical expression, when enumerated and described, comprise a set of entities that are now listed in the menu bars of Word, Quark, InDesign, and other text- and page-description programs. The user is offered a set of choices for transforming font, format, point size, leading, alignment, tab settings, and so forth. If these graphic elements of a text's appearance are not specified, the default ("normal") settings kick in: twelve-point Times, single-spaced, unjustified, set in a single, 5.5-inch column with standard margins, word spacing, and letter fit. But this approach, like the discussion of the historical analysis of style, is premised on assumptions that limit the scope of a larger inquiry into graphical aesthetics. Why?

Manipulation of each of these graphical components assumes that it

is an entity with ontological autonomy and self-evident completeness. This is misleading. Interested as I am in material histories, the crux of my argument is that the very conception of these elements as discrete entities is problematic. The menu of options extends an attitude I call "literal materiality"—a sense that a graphical entity is simply *there* and thus available to a rich, descriptive discussion of its self-evident characteristics. Getting nondesigners to pay attention to the material properties of graphical elements is difficult enough. Undoing the assumptions that support the idea of literal materiality is even harder. Consider the palette and toolbar categories of graphic entities, for instance. These menus reinforce the idea that the appearances of graphical entities are chosen from a finite list of named, discrete elements. The problem is that graphical elements, like anything else material, are defined circumstantially, in relation to the other elements with which they are juxtaposed or surrounded. Even in the seemingly simplest case—black type on a white ground—the letters aren't self-identical things that have the same weight, look, and effect of legibility no matter what. Rather, each assumes a character according to its use. One senses this vividly when working with a line of hand-set lead, fine-tuning placement, juxtaposition, leading, and surrounding space until its weight can be felt most effectively. But it is less tangible in a digital context.

The fallacy of regarding any graphical element as an entity is dramatically demonstrated when we try to name and discuss *the ground*—the page, the material support, or the base—essential to a graphic work, whether in traditional or electronic format. Each of these terms (page etc.) again tends to imply that the ground is a thing to be selected from an inventory and used. Terms like "ground" and "support" also reinforce a hierarchy in which the base is subservient to the presumably more substantive text and graphical elements that will be placed "on" it. I doubt I would have much difficulty convincing readers with the argument I sketched earlier—the value of understanding graphical features in their historical dimensions. But I've set myself a different task here, to dispel the notion of design elements as graphic "entities" and to dislodge the presumptions that carries. I want to rework the conventional approach to the idea of the "page" as an a priori space for graphical construction. In its place, I want to propose an understanding of all graphical elements as dynamic entities in the "quantum field" of a probabilistic system.[21]

Not only are graphical codes the very site and substance of historical meaning, rich and redolent with genealogical traces of origin and use, trailing their vestiges of experience in the counters and serifs of their

fine faces. Not only are conventions for the organization of text into textual apparatus and paratextual appendices themselves a set of codes that predispose us to read according to the instructions embedded therein. And not only are both physical materials and the graphically expressive arrangement of verbal materials integral parts of the semantic value of any text. These elements all deserve specific, descriptively analytic attention for the contribution they make to our processes of interpretation. But we also have to understand that the very possibility of interpretive acts occurs within this "quantum system." This field is not a preexisting literal, physical, metrical "space" that underlies the graphical presentation of a text, but a relational, dynamic, dialectically potential *espace* that constitutes it.

To reiterate, I'm suggesting that the specific properties of evident and obvious graphical elements, though frequently unnoticed, make an important contribution to the production of semantic meaning—that the expressivity of these "inflections" is more than superficial, and can and should be understood as integral to textuality. But that only gets us part of the way, and is still within the horizon of an analysis based in literal materiality. I term this mechanistic because it is still premised on the concept of discrete, apparently autonomous, entities. But a radical reconsideration of the process by which these "appearances" are constituted brings about a shift toward a probabilistic approach.

Studying the white space in a page of William Morris's Kelmscott *Canterbury Tales* offers an exemplary opportunity for such a reconsideration. The unprinted area here is not a given, inert and neutral space, but an *espace*, or field, in which forces among mutually constitutive elements make themselves available to be read.[22] The same observation applies to the garden-variety encounters of daily reading. Any page or screen is divided into text blocks and margins, with line space, letterspace, space between page number and margin, and so on. Areas of white space each have their own quality or character, as if they marked variations in atmospheric pressure in different parts of a graphic microclimate.[23] "White" space is thus visually inflected, given a tonal value through relations rather than according to some intrinsic property.

White spaces can be divided into three basic categories depending on their behavior and character: graphic, pictorial, or textual. I define these as follows: (1) graphic—providing framing and structural organization to the supposed ground, with no figural or semantic referent; (2) pictorial—part of an identifiable image or visual meaning in shape or pattern; and (3) textual—keeping characters, lines, and blocks discrete, consistent

with organizational convention. On any given page, each area takes on a particular graphic value. By this I mean a tone, or color acquired in relation to the density of other graphic elements in proximity, and also a signifying (if not quite semantic) value.

Typographic elements depend upon the use of white space to sustain the careful articulation that gives them their stylistic specificity. Letterforms are as much an effect of the way the spaces breathe through the lines of type as they are of the character of the strokes. The white space plays a primary role as a supporting medium in guaranteeing the typography its stylistic identity. We see evidence of this in the way the space holds open the counters of letters keeping them to specific degrees of curvature or slant (textual). The incredibly obvious and yet utterly essential space between image and text lines often divides the elements of the graphic universe into word and picture, separating the verbal heavens from the visual earth. This fundamental vocabulary can be subdivided almost indefinitely into the spaces between lines, between the text block and the background, and other distinct margins within the area of the text, each of which has a place within the visual hierarchy that organizes our reading. Similarly, the space around text blocks creates the measured pace for reading while referencing the specific histories of book design and format features (textual). Lower margins keep the text block from slipping off the page while also giving an indication of textual continuity or termination. All of these distinctions could be refined even further, to a surprisingly high degree of granularity and specificity.

The conceptual leap required to move beyond a literal, mechanistic understanding of graphic elements should be easy. We no longer think of the atom as a Tinkertoy model with balls and sticks and rings of wire constraining electrons in fixed orbits. That notion, so charmingly modular, has the scientific validity of Ptolemaic models of the structure of the solar system—or of Newtonian, rather than quantum, physics. Atoms, molecules—the mechanistic understanding of these "entities" were dispelled in the early twentieth century by a theoretical frame that replaced entities with forces and introduced the principle of uncertainty into the account of atomic physics. In quantum physics a phenomenon is produced by the intersection of a set of possibilities and an act of perceptual intervention. At the level of granularity we are used to experiencing, matter appears to operate with a certain consistency according to Newton's laws. But at the atomic and subatomic level, these consistencies dissolve into probabilities, providing contingent, rather than absolute, identities. We should think of letters, words, typefaces, and graphic forms in

the same way. Think of the page or screen as a force field, a set of tensions in relation, which assumes a form when intervened in through the productive act of reading. Peculiar? Not really, just unfamiliar as a way to think about "things" as experienced. A slight vertigo can be induced by considering a page as a set of elements in contingent relation, a set of instructions for a potential event. But every reading reinvents a text, and that is a notion we have long felt comfortable invoking. I'm merely shifting our attention from the "produced" nature of signified meaning to the "productive" character of the signifying field.

In historiographic perspective, this approach draws from three areas: (1) work on typography, printing, and graphic design; (2) texts on visual representation, printmaking, and literary, critical, and cultural studies; and (3) speculative work in the realm of documents, cognitive studies, and systems theory.[24] All contribute to the significant shift from a *literal* to an *emergent*, codependent conception of materiality. As literary scholars and design critics engage with graphical aesthetics and material properties of text, I suggest we should not limit ourselves to a literal reading of materiality but consider instead a probabilistic approach to materiality in textual and visual studies. In a digital encounter, the constitutive character of code and expression are all the more compelling because of the generative, iterative, and interactive aspects of display.

3.3 Modeling Functionality: From Codex to e-Book

The material properties of textual artifacts can be modeled, as we've seen, in markup and metadata. They can be described and attended to within mechanistic as well as more probabilistic or constitutive approaches. But considerations of the ways material features are understood should also include attention to their functionality, not just their formal qualities. The peculiar history of the "e-book" shows the ways in which a too-literal misapprehension of what constitute the distinctive features of a material form can give rise to a misconceived model of what it should be when redesigned in another media environment.

The brief career of the e-book has been plagued with fits and starts. In the short time in which personal computers and hand-held devices have come into widespread use, a whole host of surrogates for traditional books has been trotted out with great fanfare and high expectations. In almost every case, these novelties have been accompanied by comparisons between familiar forms and their reinvented electronic shape. That pattern can be discerned in nearly every descriptive title: the expanded book, the superbook, the hyperbook, "the book emulator" (my personal favorite for its touch-

ing, underdog sensibility). Such nomenclature seems charged by a need to acknowledge the historical priority of books and to invoke a link with their established cultural identity.

The rhetoric that accompanies these hybrids tends to suggest that all of the advantages are on the electronic side. The copy written in support of them, as new products bidding for market share, contains conspicuous promises of improvement. The idea that electronic "books" will "supercede the limitations" and overcome the "drawbacks" of their paper-based forebears features largely in such promotional claims. Such rhetoric presumes that traditional books are static, fixed, finite forms that can be vastly improved through the addition of so-called interactive features. Testing those claims against the gadgets themselves, however, one encounters a field fraught with contradictions. Electronic presentations often mimic the kitschiest elements of book iconography, while potentially useful features of electronic functionality are excluded. So we see simulacral page drape but little that indicates the capacity for such specifically electronic abilities as rapid refresh, time-stamped updates, or collaborative and aggregated work. E-book "interactivity" has been largely a matter of multiple options within fixed link-and-node hyperstructures.[1]

That e-books have been limited no one doubts. But their limitations have stemmed in part from a flawed understanding of what traditional books are. There has been too much emphasis on formal replication of layout, graphic, and physical features and too little analysis of how those features affect the book's function. Rather than thinking about simulating the way a book *looks,* then, designers might do well to consider extending the ways a book *works.*

A glance at the literature on electronic books shows the persistence of hyperbolic claims spanning more than a decade. Bob Stein's early experiment, Voyager, was adventurous and visionary.[2] Anticipating the design of online formats for hypertext and other new media presentations of experimental works, his company launched its "Expanded Book" in the early 1990s, before the Web was in operation, using CDs and other storage devices. Earlier forms, particularly CDs and the alternative reading practices of hypertext story structures, have not found the large followings their advocates anticipated. Hypertext fiction and the chimera of interactive film have had their vogue and faded. Attempts to develop new reading formats would appear to have reached an impasse if we judge by continuing addictions to traditional fictional forms, or by the persistence of online reading by scrolling through a single text. But during the

same decade that hypertext fiction went the way of Kohoutek, the Net has become a fixture in contemporary life. Links and hyperlinks abound, and using these networked structures has become as familiar as turning the pages of a print newspaper. The vision of a reconfigured reading environment has been realized. Geographically dispersed textual, visual, graphic, navigational, and multimedia artifacts can now be aggregated in a single space for study and use, manipulated in ways that traditional means of access don't permit. The telecommunications aspect of new media allows creation of an intersubjective social space—arguably an extension of the social space of traditional scholarly or communicative exchange distinguished mainly by the change in rate, the immediacy, and the capacity to engage simultaneously in shared tasks or common projects.

But what of e-books? The slowness with which new formats have arisen is as much the result of conceptual obstacles as technical ones. The absence of an e-book with the brand-recognition of Kleenex or Xerox isn't due only to the fact that the phrase "electronic document management and information display systems and spaces for intersubjective and associative hyperlinked communication using aggregation, real-time authoring, and participatory editing" doesn't trip off the tongue. The real difficulty is in understanding which aspects of the familiar book have relevance for the design and use of information in an electronic environment. Are they the features that researchers such as IBM's Harold Henke refer to when they identify "metaphors" of book structure?[3] What metaphors does he mean? What does the malleable electronic display of data whose outstanding characteristic is its mutability have to do with the material object familiar to us as the codex book? What, in short, do we mean by the "idea of a book"?

A look at the designs of graphical interfaces for e-books gives some indication of the way conventional answers to this question lead to a conceptual impasse. Ex-libris, Voyager's expanded book, and other "superbook" and "hyperbook" formats have all attempted to simulate in flat-screen space certain obvious physical characteristics of traditional books. IBM's research suggested that readers "prefer features in electronic books that emulate paper book functions." But functions are not the same as formal features. The activity of page turning is not the same as the binary structure of the two-page opening or the recto-verso relations of paper pages. Nonetheless, electronic books have relied heavily on fairly literal simulations of formal features, offering, for instance, a kitschy imitation of page drape from a central gutter. This serves ab-

solutely no purpose, like preserving a coachman's seat on a motor vehicle. Icons that imitate paper clips or book marks, by contrast, allow the reader to place milestones within a large electronic document. As in paper formats, these not only serve navigational purposes but call attention to significant passages. The replacement of pages and volumes with a slider that indicates one's position within the whole reinforces the need to understand information in a gestalt, rather than experiencing it piecemeal. Finally, the reader's urge to annotate, to write into the text with responsive immediacy, has been accommodated as note-taking capabilities for producing e-marginalia have been introduced.

The list of "drawbacks" of traditional books that electronic ones purport to overcome is easy to ridicule. Features like bookmarks, search capabilities, navigation, and spaces for annotation and comments by the author are already fully present in a traditional codex. Indeed, it is very difficult in another medium to simulate their time-tested efficiency. But other features of electronic space do add functionality—live links and real-time or frequent refresh of information. These are unique to digital media; even if linking merely extends the traditional reference function of bibliography or footnotes, it does so in a manner that is radically different. Links don't just indicate a reference route. They either retrieve material or take the reader to that material. And the ideas of rapid refresh, date stamping, and annotating the history of editions materially change the encoded information that constitutes a text in any state. The capacity to materially alter electronic surrogates, customizing actual artifacts, or, at the very least, specifying particular relations among them, presents compelling and unique opportunities.

So what possible function, beyond a nostalgic clue to the reader, do features like gutter and page drape serve in electronic space? The icon of the "book" that casts its long shadow over the production of new electronic instruments is a grotesquely distorted and reductive idea of the codex as a material object. The cover of the book within the video game *Myst* that contains links and clues is a perfect example of the pseudo-gothic, book-as-repository-of-secret-knowledge clichés that abound in the use of the codex as an icon in popular culture.

Let us return to the design of electronic books for one more moment, however. If we ask what is meant by a "metaphor" in Henke's discussion and look at examples of e-book design, we see familiar formats, text/image relations, visual cues that allude to traditional books, and other navigation devices meant to facilitate use by novices. The assumption that familiar forms translate into ease of use may be correct in the first it-

eration of electronic book-type presentations. But when we look at a table of contents, or an index, or even headers/footers or page numbers—or any of the other structuring elements of book design—it's difficult to imagine how we can consider these metaphors in Henke's sense. These format elements aren't figures of meaning, or presentations of an idea in an unfamiliar form. Quite the contrary, these are instruction sets for cognitive performance.[4] I would argue that as long as visual cues suggest a literal book, our expectations will continue to be constrained by the idea that books are communication devices whose form is static and formal, rather than active and functional. But if we shift our approach we can begin to abstract that functional activity from the familiar iconic presentation. One place to begin this inquiry is by paying attention to the conceptual and intellectual motivations that led to these format features. From there we can extrapolate the design implications that follow for new media.

Instead of reading a book as a formal structure, then, we should understand it in terms of what is known in the architecture profession as a "program," that is, as constituted by the activities that arise from a response to the formal structures. Rather than relying on a literal reading of book "metaphors" grounded in a formal iconography of the codex, we should instead look to scholarly and artistic practices for insight into ways the programmatic function of the traditional codex has been realized. Many aspects of traditional codex books are relevant to the conception and design of virtual books. These depend on the idea of the book as a performative space for the production of reading. This virtual space is created through the dynamic relations that arise from the activity that formal structures make possible. I suggest that the traditional book also produces a virtual space, but this fact tends to be obscured by attention to its iconic and formal properties. The literal has a way with us, its graspable and tractable rhetoric is readily consumed. But concrete conceptions of the performative approach also exist. I shall turn my attention to these in order to sketch a little more fully this idea of the program of the codex.

We should also keep in mind that the traditional codex is as fully engaged with this virtual space as electronic works are. For instance, think of the contrast between the *literal* book—that familiar icon of bound pages in finite, fixed sequence—and the *phenomenal* book—the complex production of meaning and effect that arises from dynamic interaction with the literal work. Here, as elsewhere in my discussion, I base my model of the phenomenal codex on cognitive science, critical theory,

and applied aesthetics. The first two set some of the basic parameters for my discussion. Invoking cognitive models suggests that a work is created through interaction with a reader/viewer in a codependent manner. A book (whether thought of as a text or a physical object), is not an inert thing that exists in advance of interaction, but rather is produced anew by the activity of each reading. This idea comports well with the critical legacy of poststructuralism's emphasis on performativity. We make a work through our interaction with it, we don't "receive" a book as a formal structure. Poststructuralist performativity is distinguished from its more constrained meaning in work like that of John Austin, for whom performative language is defined by its instrumental effect. Performativity in a contemporary sense borrows from cognitive science and systems theory, in which entities and actions have codependent relations rather than existing as discrete entities. Performance invokes the kind of constitutive action within a field of constrained possibilities referred to through my argument. Thus, in thinking of a book, whether literal or virtual, we should paraphrase Heinz von Foerster, one of the founding figures of cognitive science, and ask *how a book does* its particular actions, rather than *what a book is.*

With these reference frames in mind, I return to my original question: What features of traditional codex books are relevant to the conception and design of virtual books? My approach can be outlined as follows: (1) start by analyzing how a book works rather than describing what we think it is; (2) describe the program that arises from a book's formal structures; and (3) discard the idea of iconic metaphors of book structure in favor of understanding the way these forms serve as constrained parameters for performance. The literal space of the book thus serves as a field of possibilities, waiting to be "intervened" by a reader. The *espace* of the page arises as a virtual program, interactive, dialogic, dynamic in the fullest sense. Once we see the broader outlines of this program, we can extend it through an understanding of the specific functions that are part of electronic space.

Roger Chartier, tracking the development of book culture, notes several crucial technological and cultural milestones.[5] The shift from scroll to codex in the second to fourth centuries and the invention of printing in the fifteenth century are possibly the two most significant transformations in the technology of book production. Other substantive changes, famously noted by medievalist Malcolm Parkes, came as reading habits were transformed, and when monastic approaches were replaced by scholastic attitudes toward texts in the twelfth through fourteenth centuries,

bringing about dramatic changes in format.[6] In earlier usage, books were the basis for linear, silent reading of sacred texts, punctuated by periods of contemplative prayer. These habits gave way to the study and creation of argument as the influence of Aristotle on medieval thought brought about increased attention to rhetoric and the structure of knowledge. Readers began to see the necessity to create metatextual structures for purposes of analysis. To facilitate the creation of arguments, heads and subheads appeared to mark the divisions of a text. Marginal commentary not only added a gloss, an authorial indication of how to read the text, but also outlined and summarized points visually buried in the linear text. Contents pages provided a condensed argument, calling attention to themes and structures and their order within the volume as a whole. The graphic devices that became conventions in this period are aspects of functional activity. They allow for arguments to be abstracted so they can be used, discussed, refuted. These elements are devices for engaging with texts in a manner radically different from that of reflection and prayer. Argument, not reading, is the purpose to which such works are put, and their formal features are designed to provide a reader with both a schematic overview and the means to use the work in rhetorical activity.

Using a book for prayer is clearly an active engagement with the text. But the linear, sequential reading style did not require any extra apparatus as a guide. The development of graphical features that abstract the book's contents thus reflect a radical change in attitudes toward knowledge. Ordered, hierarchical, with an analytical synthesis of contents, the artifact that arose as the instrument of scholastic *lectio* was a new type of book. Readers came to rely on multiple points of access and the search capabilities offered by metatextual apparatus.

The important point here is not just that format features have their origin within specific reading practices but that they are functional, not merely formal. The significant principle is relevant to all reading practices: that the visual hierarchy and use of space and color don't simply reference or reflect an existing hierarchy in a text, they make it, producing the structure through the graphical performance. Such approaches seem self-evident because they are so familiar to us as conventions. But conceptualizing the book in terms of its paratextual apparatus required a leap from literal, linear reading to the spatialized abstraction of an analytic metastructure. Differentiating and identifying various parts of a codex went hand in hand with the recognition of separate functions for these elements. Function gives rise to form, and form sustains functional activity as a program that arises from its structure.

We have inherited that scholastic model but are frequently oblivious to the dynamic agency of its graphic elements. We may find headers a delightful feature on a page, chapter breaks and subheads convenient for our reading in reference materials, but rarely do we step back and recognize them as coded instructions for use. The lines in a modern table of contents, and the accompanying page numbers, function as cognitive cues, pointers into the volume. The information space of a book appears as the structure of its layout. And the analytic synopses in the index and contents are organized to show something in their own right as well as to enable specialized reading tasks.

Various statistical analyses of content appeared as paratextual apparatuses in medieval manuscripts and even their classical predecessors, sometimes motivated by the need to estimate fees (counting of lines) rather than more studious purposes. The habit of creating commentary through marginal notes established a space for conversation within a single page. The palimpsestic nature of such conversations has a particularly rich lineage in commentaries upon sacred texts; an interwoven cultural document like the Talmud is in effect a record of directives for reading. The interpretive gloss is designed to instruct and guide, disposing the reader toward a particular understanding. By contrast, as Anthony Grafton points out, the footnote makes a demonstration of the sources on which a text has been constructed.[7] Justification and verification are the primary purpose of mustering a scholarly bibliography to support one's own work. Thus footnotes may occupy a humbler place, set in smaller type at the bottom of a page or transformed into endnotes at the finish of a section or work, whereas marginalia must be ready to hand, allowing the eye to take in their presence as a visual adjunct if they are to be digested in tandem with the flow of the original text.[8]

The familiarity of conventions causes them to become invisible, and obscures their origin within activity. The figured presentation of meaning in the codex is a condensation of an argument, specific to that form, an argument made in material and graphical structure as well as through textual or visual matter. Recovering the dynamic principles that gave rise to those formats reminds us that graphical elements are not arbitrary or decorative, but serve as functional cognitive guides.

This brief glance at the historical origins of familiar conventions for layout and design should also underscore the fundamental distinction between scroll and codex. The seemingly unified, emphatically linear scroll format, in which navigation depended on markers (protruding ribbons or strips) and a capacity to gauge the volume of the roll on its

handle, is striking in contrast to the codex format. When the paratextual features are added, the codex becomes a dynamic knowledge system, organized and structured to allow various routes of access. The replication of such features in electronic space, however, is based on the false premise that they function as well in simulacral form as in their familiar physical instantiation. In thinking toward a design of electronic textual instruments, we would do well to reflect on the *function* that every graphical feature can serve, as well as the informational reference it contains as part of its production or reception history.

Media do matter. The specific properties of electronic technology and digital conditions allow for the continual transformation of artifacts at the most fundamental level of their materiality—their code. The data file of an electronic document can be continually reconfigured. And each intervening act, operating on the field of potentialities, brings a work into being. In digital files we can take advantage of the capacity of electronic instruments to mark such changes rather than merely registering them within the space of interpretation. In addition, two other functions mentioned above are given specific extension within electronic space: the aggregation of documents (as documents and as data) and the creation of an intersubjective exchange. The calling of surrogates through a "portal" in electronic space (as pointed out by Joseph Esposito) allows materials from dispersed collections to be put into proximity for study and analysis.[9] But beyond this, the ability to resize, rescale, alter, or manipulate these documents provides possibilities that traditional paper-based documents simply don't possess. (Looking at a manuscript scanned in raked light, enlarging it until the fibers of the paper show, is a different experience from handling an autographic work in most special collections.) The electronic space engages these technological mediations of the information in a surrogate. But electronic space serves as a site of collaboration and exchange, of generative communication in an intersubjective community that is integral to knowledge production. Information, as Paul Duguid and John Seely Brown have so clearly pointed out, gains its value through social use, not through inherent or abstract properties.[10] The virtual *espace* we envision takes all of these features, themselves present in many aspects of the traditional codex, but often difficult to grasp clearly, and makes them evident. All those traces of reading, of exchange, or of new arrangements and relations of documents, expressions of the shared and social conditions in which a text is produced, altered, and received, can be made visible within an electronic space. These very real and specific features of virtual space can be featured in a graphical inter-

face that acknowledges the codex and traditional document formats as a point of reference but conceives of this new format as quite distinct.

The functions that digital technology accommodates more readily than print media are those of accretion (and processing) of data, aggregation (pulling things together in virtual space that are either separated in physical space or don't exist in physical space), real-time and time-based work, and community interactions in multiauthored environments. But the iterative aspect of digital work fostered by multiple-author environments is also a crucially distinctive feature. Developing a graphical code for representing these functions in an analytic and legible semiotics of new media will still take some time. Ivanhoe is one attempt in this direction, because it is meant to abstract and schematize information in diagrammatic form. Other information visualizations lie ahead, and the conventions for linking functionality and format are emerging.

Writing persists, to this day, with its intimacy and immediacy, while print forms and other mass-production technologies continue to carve up the ecology of communication systems according to an ever more complex division of specialized niches. Books of the future depend very much on how we meet the challenge to understand what a book is and has been.

Frequently, the idea of "the book" guiding design of e-books has been a reductive and unproductive example of inadequate modeling. The multiplicity of physical structures and graphic conventions are manifestations of activity, returned to book form as conventions because of their efficacy in guiding use. An element like a table of contents is not a metaphor, we must recognize, but a program, a set of instructions for performance. By looking to scholarly work for specific understanding of attitudes toward the book as literal space and virtual *espace,* and to artists and poets for evidence of the way the spaces of a book work, we realize that the traditional codex is also, in an important and suggestive way, already virtual. But also, that the format features of virtual spaces of e-space, electronic space, have yet to encode conventions of use within their graphical forms. As that happens, we will witness the conceptual form of virtual spaces for reading, writing, and exchange take shape in the formats that figure their functions in layout and design.

3.4 Aesthetics and New Media

The aesthetics of new media has generated discussion from various perspectives. Some have focused on the specificity of electronic and digital modes, mapping the networked, algorithmic, and procedural character of digital media. Others focus on the rates of transformation, rapid refresh, or mutability of digital media, or its code base and electronic infrastructure. The social immediacy and networked transformation of economies of communication, capital, and currency also come into consideration.[1] All are useful approaches. The resulting insights are accurate and to the point, as are analyses of the "forensics" of new media, the embodied subjects who engage with its practice, and database aesthetics.[2] Other approaches have attempted to frame new media aesthetics in paradigms from the disciplines of literature, film, or semiotics—as a "language" or "montage," or as an extension of narrative or textual practice. These attempts sometimes entail an awkward fit between the conceptual model and terminology derived from older media.

But what happens when instead of pursuing an aesthetics *of* new media, we consider the relation of aesthetics *and* new media? The purpose of this shift would

be to bring digital art into dialogue with other artistic practices that are part of a contemporary landscape of imaginative and creative work. Work in new media would then be included among the practices on which contemporary aesthetics is to be based, rather than kept apart as a special case. This puts the fate of *aesthetics* in an era of new media under consideration.

The dialogue between critical theory and aesthetics that descends from modernism was rooted in notions of formalism and autonomy, as well as the innovations and strategic antagonisms of the avant-garde. In the work of Theodor Adorno, this was expressed as an attachment to resistance and its negative capabilities (see chapter 3.5). In a high modern mode, the work of Clement Greenberg, with its emphasis upon media and their specificity, or the literary approaches of new criticism, reinforced the tendency to see works of art as bounded, finite expressions, self-evident and complete. Their highest achievement was to embody a self-referential engagement with the characteristics of their media. In the visual arts, this meant an approach to painting that famously embraced flatness, eschewing illusion and representation, figuration, or literary allusion. High modernism was a last-gasp attempt to salvage utopian beliefs in the face of fascism's rise, the coming of the culture industries as a recognized force, and the period of the Second World War and its chilly aftermath. That modern aesthetic has lost most of its grip. But an attachment to critical negativity still dogs our artistic steps, largely for lack of a better belief system within which to conceptualize art in the current world. If concepts of the avant-garde seem outmoded, so do notions of a language of art.

At the point when high modernism held sway, another approach to media was articulated by Marshall McLuhan.[3] Beginning in the early 1960s his theoretical writings put forward a set of principles that addressed modern media as message and massage. McLuhan and the passing of high modernism shared not only a historical moment but certain assumptions, evident in the ways they defined their objects of study. McLuhan's intensely wrought discussions of the specificity of media as artifacts, modes, and social practices shared high modernism's attachment to formal attributes as essential identities. His intellectual range and his roots in literary criticism and semiotics, as well as the later moment of his intellectual maturity, enriched his approach to media with techniques from cultural and critical studies. And his work became, of course, a defining discourse of mass media as a sphere of activity that could further aesthetic investigation, not be bracketed out of it.

By the 1970s, postmodernism displaced notions of modern auton- omy with a model of contingency (and here McLuhan's approach forms another bridge, in part through his connection with Harold Innis and is- sues of empire, power, and history).[4] Whether inspired by the poststruc- turalist play of *différance* in it deconstructed mode, or by the theoretical formulations of postcolonial theory and its emphasis on critiques of he- gemony and discourses of power, the critical shift in postmodernism was marked by attention to reading works as texts produced across social practices and signs. The writings of Roland Barthes, usually read along- side those of Jean-Francois Lyotard, Jean Baudrillard, and other justly renowned figures of French theory, can also be read in tandem with the shockwaves introduced by McLuhan.

Taken together, these many intellectual frameworks have provided useful descriptive and analytic methods for an aesthetics of digital me- dia, as well as for a rethinking of aesthetics in relation to new media. For the first task, the formal analysis of media specificity remains a valuable and compelling tool. The ontological properties of digital and electronic instruments are key to their material identity and the meanings they thus enable and produce. Critical theory and cultural studies offer use- ful frames for reading digital works at the macro level of media systems, social practices, and cultural networks of value and control.

But to conceptualize contemporary aesthetics, we have to confront the ways new media push artistic practice into a systems-based, code- pendent relation with their conditions of *use* and *discourse*, not merely their formal properties or their capacity to function as social signs in a semiotic mode. Aesthetics is transformed, hybridized, by the challenges of *mediation* as a central feature of artistic work. The very situatedness and codependent character of mediation calls forth a host of other terms apt for describing the aesthetic properties of digital media works: em- bodied, complicit, experiential, participatory. Mediation, as a space be- tween, is registered in digital expressions as an ephemeral but material trace, a time-based inscription, transiently configured, and constituted by and as an experiential field.

To anchor this discussion in concrete examples, I will draw on two artworks: Janet Zweig's *The Medium* and Jim Campbell's *5th Avenue Cut- away*, both from 2002. Zweig's piece models mediation at a fine, micro level of granularity. She tightens our focus, showing us the basic activi- ties through which digital media function within cultural practice. The very concepts of communicative mediation that inform our exchanges within the social sphere, and the practices of representation through

which they are embodied, are brought into view in this piece. By contrast, Campbell's work extends the horizon of postmodernity by returning to that quintessential modern figure, the *flâneur,* and bringing it into the paradoxes and ironies of contemporary existence. Zweig's piece is emblematic of the current condition of aesthetic work—its integration into media systems as a fundamental feature of their representational capacity. Campbell's connects to the longer historical axis through which the role and function of the image of contemporary life is figured—and links to our conception of aesthetic practice now. Neither of these pieces can be accommodated within the critical legacy of modernism, postmodernism, or the various didacticisms left over from earlier paradigms.

In *The Medium,* two people sit facing each other in a small alcove, an intimate conversation space carved out of a large, public hall.[5] A screen between them interrupts their direct view. Cameras are installed on each side, and the image of each person is displayed to the other on the screen. Each sees the other, more or less life-size, in what appears to be real time, thus creating a subtle comment on face-to-face communication as pure or unmediated experience. The screen, like the familiar television monitor, offers a talking head. But the programmed algorithms slowly alter the digital video feed. Haloes appear, ghost outlines of the face fade slowly, the image switches from color to black and white, becomes posterized, or is inverted into a stark negative. Occasionally the display shows the viewer's own face, up close, life-size. Less distant than a mirror, the visages are more highly mediated for being recorded live and fed. The time lag between lived and perceived moments is so brief that it barely registers. From time to time a floating frame inserts one image into the other so that the persons see themselves. When both cameras enact this effect, the images form an infinite regress.

Elegant and engaging, *The Medium* reifies its sitters and their interactions, objectifying their presence through representation. The conversational exchange takes place through and as their images. No matter how "natural" those images appear, they are undeniably the product of digital processing, images of mediation. The in-between space of exchange is an entity, and it is precisely that fact that is revealed by this work of art. Without a conversation, *The Medium* doesn't function; it is made anew in every instant and instance. The digital intervention in the conversational exchange embodies and consolidates the intangible and ephemeral trace of face-to-face talk while exposing the embodied materials of digital media as site and instrument of such mediation.

The installation thus embodies several tropes of displacement. We

imagine, for instance, that the authentic *real* is always just behind or beyond the screen, where we believe the "actual" person exists. But the screen, cameras, and processors create a relation between the two sitters that is mediated through a "technological imaginary." A space is constituted through mediation and then represented as the work. The deftness of this piece lies in is its conflation of a real place of conversation—the two people are in the physical proximity required for an exchange—and a mediated intervention through a highly technological device, simultaneously an object and an instrument, that both obscures and calls attention to its own existence. This overlap of actual and mediated activity reinforces Zweig's extension of McLuhan's observation that electronic media have subtly pervaded all aspects of our existence. We now *telecommunicate* even in proximity, and all communication falls into a space of "betweenness." The medium is the situation—the ephemeral circumstance, the technological device, and the cultural context of its creation and use as an aesthetic object, one that has no use value except to provoke an experience of wonder, slight strangeness, and awareness.

As a work of art, *The Medium* familiarizes and calls attention to complex networks of technological intermediation that now process communications to an unprecedented degree. McLuhan was not, though he is often misrepresented as such, a technodeterminist. New media don't cause transformations of conception, they participate in them. Technology is opportunistic, not deterministic. New forms of technological infrastructure and media emerge where they can, and thus become the foundation of opportunities and possibilities that they enable. We are better off thinking in terms of an ecology of media than a technology. The imaginary, that place in which we conceive of the world as representation, acts on and receives cultural forms of knowledge and experience. In this age and in response to the technologies of image production that mediate our "imaginary" relation to lived experience, aesthetics has a role in explaining such relations.

The exceptional character of Zweig's piece is that it is less an object than a circumstance for experience. The work constructs conditions of use through which it is in turn constituted. This is a remarkable feature of new media projects. They are not simply experienced, but require participation as a premise of their existence. Understanding the distinctions between Zweig's constructed circumstance of viewing and that of, for instance, a home entertainment system or an arcade is significant. We have to have some grounds on which to distinguish the aesthetic object or experience, ways of knowing how it is marked or defined.

If we refer back, again, to the modern period, we recall that the categories of "the literary" and "visual art" were linked to the differences between the mass production of the culture industries and the practices of high art. Such distinctions depend more on institutional settings and frames rather than on the inherent character of objects. Marcel Duchamp's readymades and Andy Warhol's oeuvre make this very clear indeed. Though brand identity and cultural institutions can still be identified in a digital world—and still carry a validating and legitimating authority—all material appears on the same screen. Digital addresses do not have the same character as Fifth Avenue or Park Avenue ones; .edu or .gov brands something as authoritative in a different way than .com. But the inherent properties of screen display are the same in each case. The quality of a digital image can be just as high in an independent site as in a corporate or institutional one, though information architecture and computational power divide the independent from the powerful.

The distinction between high art and cultural product is increasingly in the value or character of ideas, not the material identity of their expression. Pinning down the "art" status of a digital work depends upon the framework in which it is encountered (UbuWeb vs. Microsoft), but this realization already shows that the strategic position of a work within various cultural categories is part of its identity. Aesthetic objects create a space for reflection, thought, experience. They break the unity of object as product and thing as self-identical that are the hallmarks of a consumerist culture. They do this through their conceptual structure and execution, in the play between idea and expression. An aesthetic object may be simple or complex, but it inserts itself into a historical continuum of ideas in such a way as to register. Aesthetic objects make an argument about the nature of art as expression and experience. They perform that argument about what art is and can be, and what can be expressed and in what ways, at any given moment.[6]

These questions about new media are related to questions about the function of aestheticization in a broader sense. At the end of the 1960s, the cultural authority of information received a boost from important exhibitions like *Information, Software,* and *Cybernetic Serendipity* held in New York and London.[7] These helped familiarize and glamorize new technology. Works of digital art were one of the instruments that helped publicize information and software concepts so that they could circulate outside technical communities. This was long before equipment or software for individual use had been designed, and the advanced wing of information art served more to legitimate the cultural work of compu-

tational activity in nonart fields than to shift the realm of art production toward electronic means. Experimentation among early adopters such as Roy Ascott, Melvin Prueitt, and researchers at Bell Labs was often done in the context of scientific or industry sponsorship. Digital productions were regarded as novelties for the most part, even as conceptual art absorbed many of their instruction-based principles for wider dissemination and use.

Both lines of inquiry—the cultural function of aestheticization and the character of contemporary aesthetics—have generated discussion for several decades. Secular literary and artistic traditions have drawn on aleatory and combinatoric practices and an algorithmic or procedural sensibility. Others have engaged mechanistic means of production within programmed constraints, exposing the rule-bound character of art making. Oulipo, the Workshop of Potential Literature, founded by French writer Raymond Queneau in 1960, sought working methods based on constraints that would resist the highly romantic subjectivity of Surrealist automatism. Using mathematics or procedural methods to derive their forms, Oulipian writers worked contemporaneously with the popularization of the concept of "information" within 1960s culture.

A larger procedural turn permeated literary, artistic, and musical production throughout the 1960s. Sol LeWitt articulated this sensibility succinctly: "The idea becomes a machine that makes the art." In the context of 1960s procedural conceptualism, the explicit expression of a (somewhat mechanistic) generative aesthetics was not surprising.

Physicist and poet Max Bense, mentioned in chapter 2.2, put forth a program of what he termed "generative aesthetics" in the early 1960s. His was a fairly literal concept of how such programming would be conceived. Algorithmically generated computations would give rise to data sets capable of being expressed in visual or other output displays. Does such work have the crucial capacity to become emergent at a level beyond the looping processes of its original conception? Or is it limited because in focusing on calculation rather than the symbolic properties of computing it remains mechanistic in conception and execution. Reconceptualizing the mathematical premises of combinatoric and permuatational processes so they work at the level of the symbolic, even the semantic and expressive, is a central tenet of the extension of generative aesthetics to include critical reflection on the role of aesthetic artifacts within an ideological frame.[8]

The mass-culture and material conditions of the development of digital art brought other challenges. Minimalist and fabricated work had

established the idea of an industrially produced artwork. Here again the problem arose: How was digital art to be distinguished from other industrial products such as games or information design? The characteristic differences had to reside in some identifiable feature of the work. Works of digital art had to operate with an aesthetic defined as a category of knowledge based in sensory experience. The question remains as to whether aestheticizing information technology and computational activity merely absorbs fine art practice, or whether aesthetic work offers an alternative to instrumentalization and efficient functionality. The answer hinges on the extent to which these works can be shown to resist the smooth functioning, efficient operation, and totalized claims of mathesis.[9]

Digital "things" are highly formalized, obviously, since they exist as data. As I argued in chapter 3.1 and 3.2, the material/immaterial binarism that is so often mindlessly used to distinguish traditional and digital artifacts is simply wrong. The conceptual artists of the 1960s struggled to dematerialize art. In the process they made us aware of a very fundamental principle of art making—the distinction between the idea or algorithmic procedure that instigates a work and the manifestation or execution of a specific iteration. What was clear from that point onward was that the disconnect between provocation and instantiation contributes to the non–self-identicality of all of these elements and to the work of art as a whole. But without a material expression of some kind—an instruction, an utterance, a performance—even the most conceptual of conceptual works did not exist. Every iteration of a digital work is inscribed in the memory trace of the computational system in a highly explicit expression. Aesthetics is a property of experience and knowledge provoked by works structured or situated to maximize that provocation. The mediated character of experience becomes intensified in digital work.

In the 1990s, as digital media came out of the margins and into mainstream galleries and museums, hybridity was a topic that broached identity and border politics and, combined with tropes of genetic mutation, cyborg imaginings and other morphological mutations. The cultural politics surrounding the term "hybridity" deserve their own discussion; the concept was used simultaneously within debates about challenges posed to the fixed categories governing lived conditions and within an artistic domain, where it indicated formal challenges to the traditions of media and classical form-giving. Morphing, figurative distortion, surfaces hinting of impossible combinations of flesh, flora, fauna, and

mechanico-robotic engineered organisms proliferated in art even as Monsanto and other major industries branded their own genetic modifications and *Time* magazine flaunted the face of America's future in a Photoshopped blend of racial characteristics whose percentages matched the demographics of our new melting pot.[10]

These thematic concerns, I suggest, all related to a deeper issue. In that moment it seemed that an *aesthetics of hybridity* might acknowledge the broad-based cultural anxiety about the blurring of the category "human."[11] Discussions of hybridity, as well as the popularization of the idea of *posthuman,* risk serving the same normalizing interests. The function of criticism and artistic activity in such a situation is to familiarize the novel concept, rendering it comfortable and acceptable within the cultural sphere. But whose interests were served by a discourse of hybridity? And what administrative decisions can be engineered and authorized on the basis of the category "posthuman," whatever its value in raising critical concerns? The answers to these questions are as complex as our current cultural systems, in which information flows across networks linking very different users. Are we ready to abandon humanness—or the project of humanistic inquiry and beliefs?

The concept of a *hybrid aesthetic* seemed more attractive, since it reflected upon a philosophical tradition and its capacity to address the current cultural condition. The aesthetics bequeathed to us from classical tradition focuses on matters of form, specificity of media, and particulars of expression. In the eighteenth century, aesthetics became concerned with matters of taste and questions of judgment, thus reflecting the shift from objective criteria of value to individual perception, knowledge, and experience. In the twentieth century, concerns with ideology, and anxiety about the role and function of art within the culture, claimed greater attention. But a hybrid aesthetics drawing together various strains of critical and theoretical disciplines is a different concept entirely. These traditions of aesthetic and critical thought might be hybridized in order to address a work like *The Medium.*[12]

Obviously, at the micro level, digital work exists materially as code. At the macro level, we can analyze the repurposing of information by tapping its fungible character, unlocking input and output identities. We can address issues of truth and authority, shifting grounds of cultural power, claims for visual epistemology and for the use of digital media in production of subjectivity, collectivity, and identity. But ultimately, digital artifacts function in relation to contemporary culture. Their properties cannot be discerned through simple analogy to "language" or to a

discrete or formalized ontology of "new media." Hybrid aesthetics, unlike an aesthetics of hybridity, induces a self-consciousness into the very practice of critical thought that shifts its ground toward the subjective and nontotalizing. The aesthetics of hybridity, of posthuman and cyborg conditions, especially when posed as *the* language of new media, merely extended the premises of system-building thought. Speculative aesthetics resists this, and the ideas of the post-Cartesian and the metahuman as countermodels.

The ideology of the virtual factors in here, and it appears that we have to do away with yet another false binarism. The distinction between truth and imitation that comes directly from classical thought is still regularly introduced to frame the discussion of simulation. Encounters in virtual worlds, now common in such environments as Second Life, are so many removes from "truth" as to be indicted for aesthetic violations in any Socratic court. Platonic hierarchies, and their negative stigmatization of images as imitations of illusions, are famously entrenched in Western thought. But the ethics of the avatar and the question of whether social rules obtain in a virtual world have brought the symbolic character of lived experience to new levels of discussion.[13] No simple distinction between real and imagined worlds makes sense at the level of symbolic exchange. Physical life exists outside "the machine," but what of emotional, intellectual, and social life? As Zweig's *Medium* makes clear, the line between virtual and its other is unsustainable.

I suggest that the term *metahuman* might be used to more accurately describe this condition. For what such circumstances and artifacts offer is an insight into the nature of our humanity, not a chance to opt out of it or a condition surpassing or rendering it obsolete. The idea of the *metahuman* takes up the tenets of the post-Cartesian sketched in chapter 1.2. Why should we frame our consideration of the virtual as one in which the image must either be a thing-in-itself, with ontological status as a first-order imitation, or a debased mimetic form further removed from those Ideas whose truth we attempt to ascertain? We are not Platonists. The purpose of such an intellectual framework was to create a structure of moral values within a fixed hierarchy. Such approaches reject the positive aspects of creative and imaginative thought. They assume a world in which art and artifice are debased from the outset—as hubris, as deception, as indulgence. Platonic philosophy and its legacy is hardly the place to look for an aesthetic understanding of artifacts of elaborate production.

We might draw on another classical tradition as a foundation for

studying the specificity of media, even though the condition of hybridity in artistic practice poses all manner of challenges to its assumptions. Aristotle's poetics lays out the basis for a hierarchical authority of formal structures. Concerned with how things are made, not just how "truthful" they are, Aristotle articulated four causes in works of poetic expression: final, formal, material, and efficient. Aristotelian inquiry sought the properties of each object that are particular to its medium. The "proper" character for poetry, then, is opposed to—or at least distinct from—that of visual forms. These principles were central to the development of modern aesthetics and remain useful, even though "new media" challenge such boundaries.[14] In the late 1960s, for instance, the experimental Computer Technology Group created a painting machine triggered by sensors that responded to a dancer's movements; its 1968 installation-performance thus challenged age-old ideas about the purity of media and specificity of expression. They were hardly alone, and the practices of conceptual art and electronic experimentation in the 1960s share much common ground.[15] Metatechnologies and the intermedia sensibility in art world practices combined conceptual, procedural, and computational practices.

The search for a basis for contemporary aesthetics, however much it may borrow from those discussions of specificity of media, has more to gain from engagement with subjective experience than with objectified forms. Subjectivity must be understood in a contemporary, post-Cartesian mode. In the vernacular, it is understood as the unique experience of a self-identical, intact subject who *has* experience, customized, unique, and consumerist. But the concept of subjectivity that advances contemporary aesthetics is modeled differently, as a codependent configuration. This is a "subject" in the poststructuralist sense, positioned and constituted within discursive and sensorial networks. The concept of subjectivity that arises from this model allows the elaboration of a notion of aesthetics as a particular kind of knowledge formation—partial, situated, experiential, emergent—to be built on its foundation.

High modern and classical approaches to aesthetics, no matter how different in other ways, share one common characteristic: they are *descriptive* systems. Whether concerned with hierarchical, empirical, or formal values, they conceived of their task as the apprehension of an *object* by a perceiving *subject.* Even the eighteenth-century turn to taste and judgment kept these distinctions intact.[16] Note Alexander Baumgarten's statements that the object of aesthetics is "to analyse the faculty of knowledge" or " to investigate the kind of perfection proper to percep-

tion which is a lower level of cognition but autonomous and possessed of its own laws."[17]

Because the approaches bequeathed to us by tradition are descriptive, they assume form exists prior to the act of apprehension, that artifacts stand outside the experience of awareness. They assume that stable, static forms of knowledge representation are equally available for perception no matter how hybrid their methods or concerns. By contrast—and the difference is radical, going straight to the ways we conceive the ontology of media—the foundations of new media are not only procedural, generative, iterative, and intersubjective but situated, embodied, and participatory. Though the concept of generative aesthetics provided a crucial turn in consideration of contemporary work because it was conceived very differently from that of formal, rational, empirical, or classical aesthetics, it offered only part of what was necessary. To get beyond the mechanistic aesthetics of earlier models, I turn to a second work of art.

In Jim Campbell's work *5th Avenue Cutaway* (2002), a grid of illuminated spots recalling halftone dots swell and shrink on a video screen, forming fleeting images. Fascinating illusions, the sense they create is of images more nuanced, more detailed than the grid that displays them, as if the granularity of vision and that of the display device were in dialogue. The banal image, produced from a video feed, of a street with figures walking resonates with the memory of the Baudelairian flâneur, whose presence announces modernity. Campbell's screen snatches at modern life with full cognizance of the futility of the attempt, the image is always already gone, mutated and morphed through movement in an illusory continuum. I am seduced by the hypnotic repetition of the work, drawn to its red light tapestry, as if by staring I might recover the lost presence of a past nostalgic for this particular future. Modernity, a modern past, one self-consciously remembering its peculiar relation to temporality and imagery. Digital technology. Beautiful imagery. The modern scene, present and absent, is elusive and passing. Campbell's screen produces a remote relation, in a contemporary mode, to the city of modern life. Its method of display reifies the street in a rendering that is both too crude and too refined for our perceptual apparatus, alien and seductive. In the aesthetics of its display a dialogue between media and culture and traditions of fine art—the red and the black, print modes and reproductive technology, the readout and printout frame of a realistic illusion—all are in play. From autonomy to contingency to complicity and the embedded, entangled condition of all knowledge production, visual or other,

Campbell's work is neither a window on the world nor a mirror. But a produced mediation of the symbolic image of the once real. Integration and streaming virtuality, it can be read as a Virilian vision machine whose subject is production without humanity. Or has it moved beyond such a nihilistic point of view? Is it an argument for recognition of the metahuman, mediated and extended, situated condition of experience I have posited? Campbell's piece embodies a struggle, a compromised optimism. It appears to preserve a humanist striving, trying to recover a purpose for its works of signification and to cover the aporia of "meaning" with a continual stream of information, a pattern of bits passing into aesthetic form through a compromising filter.

If Campbell's work extends the humanistic struggles of modernity into a metacondition, it is because of its contrast to the "cool" antihumanistic relation to form production that characterizes much electronic work made from data display.[18] The difference is striking. Campbell's window on the world, the digital flâneur rooted in individual subjectivity, and—at least the illusion of—a telecommunicated intersubjectivity is not simply information processed by Web crawlers and put up on the screen as a visual pattern. In antihumanist work, information visualization creates form for its own sake in an image no more charged with value than the stars in the night sky. Which is to say, such visualizations are full of potential for meaning—any incidentally produced configuration may be apprehended, rendered meaningful—but they do not display a human intention to communicate. Short of embracing a fully antihumanistic aesthetics, an approach with many advocates in our time, we have to preserve the place of communicative effects within human mediation and our codependent relation to each other and these mediating systems. The distinction is not only in the objects but in the critical conception of aesthetic experience.

Campell's piece embodies an irresolvable distinction between information feed and human perceiver. It comments constantly on the process of mediation. It shows the desperate impossibility of unmediated perception while rendering the activity of looking and seeing within a reification of process and image. Both are figured. The medium is made palpable, perceptible, its production of display inseparable from the message. They are mutually embodied and the viewer's experience of decoding is rendered through a situated engagement, complicit by necessity with the human and electronic mechanisms of contemporary processing and display.

Zweig and Campbell both use dynamic, real-time screen space. The im-

ages they make are contingent, circumstantial—embodied and situated but also open-ended. In each instantiation, the images are different, even as the procedures through which they are generated remain the same. Can images produced through such highly "engineered" technological means ever move beyond the mathematics that prescribe them? Can digital representations enable ways of thinking beyond instrumentality?

Aesthetics is the self-conscious attention to that condition of knowledge that returns the knowing mind to its own awareness. But the term *hybrid* aesthetics seems as problematic as that of *generative* aesthetics. Both carry overtones of genetic engineering and rationality. I prefer *speculative* aesthetics, grounded in the language of computational method, but with a recognition that imaginatively stimulated reinvention plays a part in any aesthetic understanding, and that conditions, not objects, are the focus of our investigation.

As human beings, we have the ability to process sensorily and physically. If physical labor and tasks return to greater popularity, then a manual/tactile interface to knowledge can be created that reintegrates what our bodies know more completely into the symbolic processing we are so engaged with. We have to think using a worldview that is sustainable, not just globally but individually. Neither technology and applied knowledge nor capital were partners in the social contract of the Enlightenment. The nonanthropocentric aspect of the world should give us pause and humility, as well as inspiring awe and a need for decisions about responsibility and limits. Human imagination may still preserve and foster a space for human things to be said and for experience to flourish outside the programmatic life of the monoculture and the drives of technocapital. That is the task for imagination expressed in the form of aesthetic works. The machines will not do this for us. Why would they?

3.5 Digital Aesthetics and Critical Opposition

At the turn of the twentieth-first century, discussions of aesthetics are bound to questions of ideology. Artists and critics seem to feel that the task of fine art and imagination is a political one, and so the consideration of how electronic artifacts engage questions of aesthetic opposition arises.

The sheer power ascribed to the idea of digital media gives it an extra potency in our culture. But does the capacity of electronic media to absorb all forms of human expression and experience into data-formats create an inevitability that is ideological as well as technological? In his discussions of aesthetics and ideology, Theodor Adorno continually reiterated the caveat that when positivist logic invades culture to an extreme degreee, representation appears to present a "unitary" truth, a totalizing model of thought which leaves little room for critical action or agency.[1] Pulling this unity apart is essential to critical rationality (as distinct from instrumental rationality) in its struggle to maintain a gap between data and idea, form and experience, the absolute and the lived. In the hybrid condition of the digital the separation necessary to sustain the distinctions between the instrumental and the critical appears to be

precluded. The "absolute" nature of the mathematical underpinnings of all digital activity threatens to collapse concept and materiality into a state of identity with an encoded file. As the popular idea of technological truth continues to function as an instrumental force in the increasing rationalization of culture, artwork that renders such "truths" consumable perform in what Adorno would term a reconciliatory manner. Such work seems profoundly insidious—unless it can be qualified within a critique of its assumptions, claims, and premises.

Contemporary technological innovation pushes the boundaries of once discrete areas of cultural activity, subjecting an ever-increasing number of arenas to the managerial bureaucracy of data processing. As it does so, the opposition between two traditions that had been markedly distinct in the visual arts becomes more difficult to sustain—in part because each depends upon identification with contradictory concepts of the role of Reason. The first is the antilyrical, antisubjective, rational tradition of art that aspires to the condition of science. The second is a humanistic, lyrical, subjective romanticism that has opposed emotional, natural, and chaotic forces to those of technologically driven progress.

Hybridity of mechanical and organic entities is a current condition, undermining old oppositions. The machine is now flesh, the body technological, and nature is culture. The cyborg *may* be the sign and actualization of the current lived condition of humanity. Certainly the arts have helped familiarize and legitimate many of these once unthinkable ideas. But the idea that aesthetics regulates boundaries between rational and irrational regimes of technology is limited. As mentioned in chapter 3.4, the notion of a post-Cartesian metahumanism may provide a way to think beyond such oppositions, by shifting the terms of the discussion. *Posthuman*, N. Katherine Hayles's term, suggests that we have passed beyond a condition that fits with humanistic traditions and concerns, even though she frames the term within a synthetic, cyborg sensibility, not a binaristic opposition. But have we? At stake in this conception and its application is nothing short of a commitment to remodel our image of self and world in relation to technology. *Metahumanism* suggests, as McLuhan did, that media are extensions, not negations, of humanity. This concept returns responsibility as well as priority to the culture conceived as a humanistic endeavor. As in any other arena of human endeavor, the long history of the Enlightenment reads as the aggressive attempt to bring nature under control, but the contract that defines humanity is only as strong as the terms on which limits and distinctions are defined. Whether technology has a will and life of its own, like capital, hardly matters, since the process

of human beings' defining their own identity as a sentient species begins precisely in our articulation of how to address what is under (however illusory) our control. Metahumanism reengages that enterprise with full recognition of the always mediated and now technologically and digitally extended apparatus of human activity.

These themes could be examined in many areas of contemporary art activity: the imagery of mutation, sculpture and installation work that merges new technology with conventional media, work that extends the human body through technological prostheses or otherwise toys with machine aesthetics in new, synthetic ways.[2] All are interesting manifestations of a profound transformation. But the implications of this change can be brought into focus through a narrower and perhaps more fundamental avenue: an inquiry into the identity of digital technology.

As art's dialogue with technology extends into the digital arena, the political implications of such activity come to the fore. As a touchstone in such debates, the work of Adorno, particularly his conception of aesthetics as potentially resistant (no longer liberatory, given his profound pessimism), provides a starting point and still-relevant reference. At midcentury, Adorno struggled to articulate the capacity of aesthetics to resist the forces and tropes of instrumental reason informing an increasingly commodified and administered consumer society. All cultural production (and reception), he suggested, had come to mirror the processes of capitalism, with their mind-dulling repetitions and formulas, while the capacity of what passed for Reason to perform with destructive force had been made all too vividly clear by the events of the Second World War. Aesthetics could only effectively resist such processes through a refusal of utility and systematicity. Adorno placed considerable weight on formal strategies of artistic production as a means to achieving this goal. These can be identified by the terms *determinate irreconcilability, dissonance,* and *nonidentity.*[3] Are these concepts sustainable within the context of the digital production of works of art? Or does the qualified role of materiality in the digital environment fundamentally alter the way an artwork's identity and self-identity can be conceived?

As we have seen, the notion that an image can be "reduced to" or rendered "equivalent to" a data file, algorithm, program, or any mathematical, quantifiable identity gives rise to a notion of digital identity as absolute and certain. Leibniz's dream is Adorno's nightmare—Adorno and Max Horkheimer were quite clear on this point in *Dialectics of Enlightenment,* when they suggested that Kant's aesthetics of purposelessness is the necessary (and only) antidote and means of resistance to the enslave-

ment of all sections of society and culture by the deceptive forces of mass-culture capitalism (read as an extension of rationalized modes of production into the cultural sphere). In considering how such a technorationality infuses itself into cultural practice, Horkheimer and Adorno take issue with the ways perceptions of representation are themselves subjected to a positivist logic. This occurs, Horkheimer and Adorno suggest, in the approach to language/image in which a literalist, positivist interpretation forces representation into a collusion/elision with the "real" such that one takes the "word for the thing," the "image for the real," the "representation for the referent."[4]

This collapse of the discrete structures of representation into a perceived unity makes it virtually (in the technical sense of the word) impossible to insert any critical distance into an understanding of representation and its social function. The distance between Leibniz and Adorno maps the temporal span that encompasses cultural modernity. What was for Leibniz the glimpsed possibilibity of all-encompassing descriptive and analytic Reason has become for Adorno (and Horkheimer and others) the nightmare image of totalizing control effected by instrumental Rationality. And commodification, it turns out, is the most potent means through which this social and cultural transformation is effected. Capital, as Jean-Francois Lyotard points out in *The Postmodern Condition*, did not sit down at the table at which the terms of the Enlightenment were established.

Artistic engagement with modernity as a phenomenon rapidly transformed every area of cultural production, communication, and administration. Modernity attached a wide range of valences to rationality and technology. A keen awareness of the effects of the radical changes wrought on lived experience produced celebratory as well as critical responses. The utopianism of avant-gardes was premised on the belief that progress promised liberation from oppressive labor and its social constraints, while the nihilistic negation of technorationality attacked these premises and the entire tradition of positivist thought.[5] There was also a tension between the idea that an escape from reason was the means to salvation for the human spirit and a position that invoked rationality as an antidote to injustice and social inequities.

Many reformist and counterculture movements of the late nineteenth century expressed incipient opposition to an unchecked and unquestioned concept of "progress" as the automatic gloss on any feature of modern technology or its effects. By the early twentieth century, aesthetic engagement with the technological manifestations of rationality

(and later the irrational manifestations of supposed Reason) covered a considerable range of more sharply defined positions. These included the enthusiastic production of a machine aesthetic—as in Robert Delaunay's renowned paintings of the Eiffel Tower, Fernand Leger's machine motifs, and Futurist works (and rhetoric) in praise of motorcars, trains, and industrially produced objects. The inorganic and technological was clearly privileged over and against the holistic, humanistic, and organic. An ironic retort came in the work of Dada poets and painters, conspicuously nuanced in the oeuvre of Marcel Duchamp. The embrace of chance operations and resolutely asystematic negations of the very premises of rationality eschewed any nostalgic return to the lyrical, personal, or artisanal, which had been held out as antidotes to industrialization and modernity in earlier decades in the Arts and Crafts movement, in Symbolist aesthetics, and among the Pre-Raphaelites.

But mathematical logic, and not a machine aesthetic, is the basis of digital work's relation to the technological as a concept and as a practice. Both the fine arts and the humanities experienced aspirations to the disciplinary rigor of the hard sciences at the turn of the twentieth century. Thus the "machine aesthetic" can be read as a link between the industrial machinery of overproduction and the need to provoke consumption while familiarizing industrial motifs and artifacts. Such aestheticization was also a response to the cultural malaise provoked by increased industrialization, as iconically signaled in Charlie Chaplin's film *Modern Times*.[6] This malaise may not have resulted in a full-blown critically articulated opposition, though sporadic and organized resistances have arisen throughout industrialized nations practically from the moment of the inception of industrial methods of manufacture. The point is not that machines are negatively stigmatized or positively depicted but that their coming causes a radical reconfiguring of attitudes toward work, the body, and aesthetic experience.

Mid-twentieth-century developments in the dialogue of logic and art were as varied as those of the earlier decades, and were tempered considerably by post–World War II reflections on the destructive character of technorationality. Information science, which flourished within the adminstrative and military industries of the war years, expanded out of the restricted domains of esoteric application, extending its reach ever more broadly, until, toward the end of the twentieth century, it had penetrated every aspect of contemporary culture. The rational surfaces of modernist grids, replayed in the minimalist canvases and structures of system-generated art, give ample evidence of the persistence and aesthetic

potency of this aesthetic. As mentioned in the preceding chapter, Sol LeWitt's famous dictum "The idea becomes a machine that makes the art" sutures the machinic and rational within his aesthetic—no matter how qualified each of these terms must be in actually assessing his projects.

Computers began to find their way into art projects in the 1950s and 1960s, usually in elaborately conceived works whose conceptual parameters required a considerable amount of input for a relatively piddling material output. The burden of production was such that this work has a high coefficient of conceptualization in proportion to the quality of final product. But such work established the basic paradigm, distinguishing input from output and idea (algorithm, program) from material (print-out, template, form)—so that the "stuff" of a piece is data to be manipulated through process. Fundamental to conceptual art as well as computer-generated work, this paradigm signals a radical break within the aesthetic underpinnning of the fine arts since it renders overt the terms on which idea and material are distinguished—or cease to be distinguishable, depending on the extent to which the identity of a work of digital art is posited to reside within its digital file.

Many works from the 1960s onward, within conceptual art narrowly defined and art broadly understood, take the paradigmatic premises of this distinction between idea as program and form as (incidental) output as their basis. There is a corollary to be drawn between the classical sense of "essence" and "accident" here: the digital file is regarded as having an immutable identity, while individual outputs, though unique, are seen as ever so slightly debased and individuated instances of that original. The question, much discussed in these pages, is whether the essence of the digital work is in fact its file, encoded and encrypted and clearly mathematical, or in a fulfilled, material expression of that file.

Here it seems useful to come back to a framework provided by Adorno: "The Same, which the artworks mean as their what, becomes through how they mean it, an Other."[7] Adorno's aesthetic agenda depends on a separation between subject and object, on a persistent and irremediable difference at all levels of artistic production that allows criticality to function. This "difference" takes the form of keeping idea separate from material—the "same," which is idea or content or thematic problem, is made into an "other" through extrusion into and embodiment in a materiality. The inability of these two to be identical can be maximized in works that promote a dissonant, nonunified, nonunifiable condition in their formal realization. Such work, by its own form and by its disruptive place in the cultural landscape of otherwise too easily

consumable objects, serves to keep the critical function alive. Dissonance without closure, difficulty without reconciliation ("determinate irreconcilability")—these functions keep the rational from dominating the material, keep reason from turning nature into its perfect image as some mere imitative form.

William Latham's *Evolution of Form* (1990) consists of algorithmically generated forms that grow, mutate, and adapt within the parameters of an also mutating program. Its operation translates the problems of evolution into a program—the forms evolve according to the various solutions. The images are organic in appearance—tiny units of pale fleshy tissue emerging like some kind of mutant growth. They look more like brains, ovaries, or internal organs than self-sufficient organisms—like clusters of cells organizing in order to perform a specialized rather than an autonomous function. As forms, their identity is entirely linked to—is even, on some conceptual level, isomorphic to—the files generated through the mathematical operation of the algorithms evolving and acting on each other. But though the image cannot exist without the file—except in secondary format as photograph, printout, or other hard-copy manifestation—it *is* in every sense in its material manifestation. The "how" and the "what" of Latham's work are distinct entities—and also merely two aspects of a single, non–self-identical entity. They evolve simultaneously.

To frame it another way, in a paraphrase of the Adorno quote: in certain instances the *how* of the digital environment is never quite precisely the same as the *what*. The means and matter of expression—form/content, idea/expression, essence/accident—only appear to be indissolubly unified in the mathetic condition of digital storage. Difference and distinction remain inscribed within the material expressions of aesthetic artifacts, and with them the possibilities of critical insight. We cannot ask that fine art, or digital aesthetics, answer the need for critical opposition within the sphere of contemporary culture. But we can assert that a theory of knowledge grounded in aesthetic precepts has the possibility of changing the conditions on which cultural authority is ascribed to knowledge. Metahumanism suggests that a language to describe our condition can emerge from our encounter with the extremes of a rationalized instrumentalism. Cognitive studies of codependence and emergence have shifted the foundations of knowledge beyond the mechanistic binarisms on which restrictive thought was instrumentalized and legitimated. The challenge is to foster the awareness to design and imagine alternatives.

Lessons of SpecLab

Many specific insights came out of our project-based activities at Spec-
Lab and the theoretical and critical investigations that ran in parallel,
and sometimes dialogue, with them. Those have been covered in preced-
ing chapters; I won't repeat or elaborately summarize them here. But if
any single lesson stands out, for me it would be the value of design as
an instrument of humanities work. I mean design in the literal sense, as
the task of giving functional form to a project, but also in the most pro-
found sense, as the charge to conceive of the way intellectual undertak-
ings work.

Design is not the usual term used to describe the outline of arguments
or research in the humanities, but the meta level of conceptualization
and description required for the creation of electronic environments or
digital tools is not, I think, different in kind from that required to write a
book or structure a scholarly argument. But the tasks focus on attention
to models of knowledge and function, rather than on what is being said
or presented.

In the more literal sense, the design activity in digital humanities (and

for the purpose of these remarks, I include all of our speculative activities under that larger rubric) has followed that in the larger history of graphic design. In an initial phase, problems of display and communication ordered the design of artifacts and determined the rules implemented to achieve these ends. In the world of writing and print, conventions for display, including compositional principles, hierarchies, and orderings, have a history centuries long. In the digital environment, the era in which design was limited to display was relatively short, as issues of navigation soon brought with them requirements to think more systematically about relations among elements (pages, nodes, links, levels). The navigational devices of print culture, combined with the montage sensibility of film and other time-based media, have provided the essential vocabulary for navigational design. The kinds of functionalities built into the codex book, for instance, have found an equivalent standardization within the sidebars, menu bars, and other now familiar features of Web design.

As the Web has matured, the phases of its development can be demarcated as Web 1.0 (static display and navigation), Web.2.0 (interactivity within structured sites), and Web 3.0 (collaborative content development by users, aggregation in real time, and on-the-fly analysis). Web 4.0 will increasingly emphasize the customization of Web resources and require intensified attention to the design of conditions of use.

What will this mean for the future of the humanities and for digital practices that serve scholarship, pedagogy, and professional lie? The design of authoring and editing environments that allow the functionality of peer-review and professional standards is already well under way. The creation of modes of scholarship based on an economy of plenitude and availability of original source materials will continue to foster interpretative innovation. The use of tools for the study of aggregated materials, analysis of patterns of production, distribution, and use, will make use of visualizations and other instruments that work on large bodies of texts and metadata.

But the future of digital scholarship and pedagogy is a social future as much as a technological one. Along with my colleagues in these undertakings and the broader community of digital practitioners, I have said and no doubt will continue to say that the migration of our cultural legacy into digital formats makes this as radical a historical moment as the coming of print. In spite of my aversion to hyperbole, I think this is true, and that the issues of access, preservation, and use will depend upon the way we model and design that legacy. The deepest error is to imagine

that the task ahead is a technical one, not an intellectual and cultural one. The theoretical questions that will set the direction for that design are rooted in basic concerns with the interpretative power of models in the creation of any cultural resource.

The other lessons of SpecLab are intellectual points, arguments about the way we were led to an understanding of aesthesis as a foundation for situated, subjective, and partial knowledge through a synthesis of theoretical and critical traditions brought into focus by specific projects and their design. Perhaps, more than anything else, the experiences of Spec-Lab have provided a way to integrate imagination and intellect, design and theory, individual vision and collaborative work within a variety of professional and institutional settings, into production in ways that demonstrate the rich, possible future for interdisciplinary work within the requirements of digital environments. These projects and their lessons are baby steps in what will turn out to have been the incunabula period of the development of future digital projects. Some of those, I hope, will be inspired by the sensibility that infused our experiments at SpecLab.

Introduction

1. For an introduction to digital humanities, see Susan Schreibman, Ray Siemens, and John Unsworth, eds., *A Companion to Digital Humanities* (Oxford: Blackwell, 2004). Jerome McGann's *Radiant Textuality* (New York: Palgrave, 2001) offers critical reflections that trace the development of the field from one perspective. For a philosopher's view on the field of humanities computing, as it is called in a British context, see Willard McCarty's *Humanities Computing* (Hampshire: Palgrave, 2005).

2. For documentation of the field, see the publications of the Association for Literary and Linguistic Computing and the Association for Computers and the Humanities, including *Research in Humanities Computing: Selected Papers from the ALLC/ACH Conferences,* published annually beginning in 1991, and *Literary & Linguistic Computing,* an electronic journal published by ALLC. The online archive of the Institute for Advanced Technology in the Humanities gives a vivid picture of the range of experiments undertaken at Virginia beginning in the 1990s. See the home page for IATH projects: http://www.iath.virginia .edu/IathProjects/projects/homepage.

3. My interests in this area go back to the early 1980s, when digital technology and its mythologies were being introduced at Berkeley, where I was a graduate student. The impact of digital tools on artistic production of print artifacts was particularly striking. In the early 1990s, I served as guest editor for an issue of *Art Journal* that addressed the topic of digital media and arts, at a moment when such activity was still marginal and the community

of theorists and practitioners still relatively small. "Digital Reflections: The Dialogue of Art and Technology" (*Art Journal*, Fall 1997) included articles by Simon Penny, Janet Zweig, Deborah Haynes, Paul Zelevansky, Eduardo Kac, Dew Harrison, Jonathan Harris, and Jon Ippolito.

4. Monroe Beardsley, *Aesthetics from Classical Greece to the Present: A Short History* (Tuscaloosa: University of Alabama Press, 1975), provides a useful introduction to this field. The best reference text is Michael Kelly, ed., *Encyclopedia of Aesthetics* (Oxford: Oxford University Press, 1998).

5. Theories of subjectivity are crucial to this discussion. Mine come from structural linguistics, psychoanalysis, film theory, feminist theory, and cultural studies. Lessons from Claude Levi-Strauss, Ferdinand de Saussure, Sigmund Freud, Jacques Lacan, Julia Kristeva, and Gerard Genette are, for me, foundational. See also the applied and synthetic work of Rosalind Coward and John Ellis (*Language and Materialism: Developments in Semiology and the Theory of the Subject* [London: Routledge and Paul, 1977]), Paul Smith, Jacqueline Rose, Christian Metz, Jean-Louis Comolli, Bertand Augst, Stephen Heath, Elizabeth Grosz, Lisa Tickner, Peter Wollen, Laura Mulvey, Mary Kelly, and other writers in *Screen, Tel Quel, Camera Obscura, Representations,* and *Discourse.*

6. The concept of performativity, derived from the work of John L. Austin (*How to Do Things with Words* [Cambridge: Harvard University Press, 1967]), has spread across disciplines and fields, resulting in many variations, but the fundamental concept remains the same: that a word, action, or behavior effects change, rather than simply stating, describing, or representing an idea, thought, feeling, or expression.

7. This observation was informed by my background in book arts, printing, letterpress, design, and studio production in the graphic and visual arts, my ongoing work as a practicing artist, and my experience in the 1990s teaching visual art, graphic design history, and theory of visuality and representation.

8. The use of graphs, charts, maps, timelines, and other graphical conventions adopted from statistics are all based in shared assumptions about the transparency of graphical forms. Such premises were apparent in many of the IATH projects created over the years (see URL in note 2 above). The most renowned practitioner in this field is Edward Tufte, whose biases derive from engineering and statistical methods, and whose influence has been enormous even while his assumptions go unexamined. Edward Tufte, *The Visual Display of Quantiative Information* (Chesire, CT: Graphic Press, 1983) and other titles.

9. For an extreme example, see McGann, *Radiant Textuality,* and his thorough discussion of the Rossetti Archive design.

10. TEI Consortium, *Guidelines for Electronic Text Encoding and Interchange* (Humanities Computing Unit, University of Oxford, 2002), http://www.tei-c.org/Guidelines/index.xml.

11. Traditional semiotics and other descriptive methods of analysis point out the difference between the nature of linguistic codes, particularly the double articulation of language, and those of graphical media. No equivalent to the morpheme as a signifying unit exists in graphical systems. Roland Barthes, *Image/Music/Text* (New York: Hill and Wang, 1977); Nelson Goodman, *Languages of Art: An Approach to a Theory of Symbols* (Indianapolis: Bobbs-Merrill, 1968).

12. Rossetti Archive, http://www.rossettiarchive.org; Valley of the Shadow, http://valley.vcdh.virginia.edu.

13. Janet Abbate, *Inventing the Internet* (Cambridge: MIT Press, 1999); Margot Lovejoy, *Postmodern Currents: Art and Artists in the Age of Electronic Media* (Ann Arbor:

UMI Research Press, 1989); Timothy Druckrey, *Iterations* (New York: Institute for Contemporary Photography, 1993) and *Ars Electronica* (Cambridge: MIT Press, 1999); Tom Corby, *Network Art* (New York: Routledge, 2006); Frank Popper, *From Technological to Virtual Art* (Cambridge: MIT Press, 2007); Lynn Hershman-Leeson, *Clicking In: Hot Links to a Digital Culture* (Seattle: Bay Press, 1996); and many articles in *Leonardo* (which has focused in a serious way on art and computers), for a start.

14. For documentation and an introduction to the MOO culture, see http://www .hayseed.net/MOO/, http://ebbs.english.vt.edu/mudmoo.clients.html, and http:// personal.georgiasouthern.edu/~jwalker/MOO/index.html to get started (all last accessed August 15, 2007). For a print resource, see Cynthia Haynes and Jan Rune Holmevik, eds., *High Wired: On the Design, Use, and Theory of Educational MOOs* (Ann Arbor: University of Michigan Press, 1998).

15. Daniel Dennett, *Brainchildren* (Cambridge: MIT Press, 1998); "Can Silicon Based Life Exist?" http://www.cmste.uncc.edu/new/papers; Clarence W. De Silva, *Intelligent Machines: Myths and Realities* (Boca Raton: CRC Press, 2000); Robert Reynolds and Thomas Zummer, eds., *CRASH: Nostalgia for the Absence of Cyberspace* (New York: Thread Waxing Space, 1994); Ray Kurzweil, *The Age of Intelligent Machines* (Cambridge: MIT Press, 1990).

16. For detailed and technical debates about electronic scholarship, see Susan Hockey, *Electronic Texts in the Humanities* (Oxford: Oxford University Press, 2000), and Kathryn Sutherland, ed., *Electronic Text* (Oxford: Clarendon Press, 1997). For analysis of the culture of digital technology and critical insight into its workings on the broader contemporary imagination, read Alan Liu, *The Laws of Cool: Knowledge Work and the Culture of Information* (Chicago: University of Chicago Press, 2004). For critical discussions of aesthetics, the concept of control, or matters of textuality, see Mark Hansen, *New Philosophy for New Media* (Cambridge: MIT Press, 2004); Lev Manovich, *The Language of New Media* (Cambridge: MIT Press, 2001); N. Katherine Hayles, *How We Became Posthuman* (Chicago: University of Chicago Press, 1999); Wendy Chun, *Control and Freedom* (Cambridge: MIT Press, 2006); Rita Raley, "Reveal Codes: Hypertext and Performance," http://www.iath.virginia.edu/pmc/text-only/issue.901/12.1raley. txt; and Matthew Kirschenbaum, home page (http://www.otal.umd.edu/~mgk/blog/) and *Mechanisms: New Media and the Forensic Imagination* (Cambridge: MIT Press, 2008). (All URLs last accessed August 15, 2007.)

1.1

1. See the publications of the Association for Computational Linguistics (http:// www.aclweb.org). Pioneering projects include the William Blake Archive (http:// www.blakearchive.org/blake/main.html), Perseus Digital Library (http://www .perseus.tufts.edu/hopper/), the Rossetti Archive, http://www.rossettiarchive.org, the Canterbury Tales Project (http://www.canterburytalesproject.org/CTPresources .html), the Piers Plowman Electronic Archive (http://www.iath.virginia.edu/piers), and the Brown University Women Writers Project and other work of the Scholarly Technology Group (http://www.stg.brown.edu).

2. Sutherland, *Electronic Text*.

3. See, for instance, William J. Mitchell, *City of Bits: Space, Place, and the Infobahn* (Cambridge: MIT Press, 1995).

4. Bertrand Russell, Alfred North Whitehead, young Ludwig Wittgenstein, Rudolf Carnap, Gottlub Frege, and W. V. Quine are the outstanding figures in this tradition. See Robert J. Stainton, *Philosophical Perspectives on Language* (Peterborough, Ontario:

Broadview Press, 1996); W. G. Lycan, *Philosophy of Language: A Contemporary Introduction*. (New York: Routledge, 2000).

5. Edmund C. Berkeley, *Giant Brains: Or Machines That Think* (New York: Wiley, 1950), is a classic in this genre.

6. For some of the early systematic thinking, see Marvin Minsky, *The Society of Mind* (New York: Simon and Schuster, 1986); Minsky with Seymour Papert, *Artificial Intelligence* (Eugene: Oregon State System of Higher Education, 1973); Herbert Simon, *Representation and Meaning: Experiments with Information Processing Systems* (Englewood Cliffs, NJ: Prentice Hall, 1972); Terry Winograd, *Artificial Intelligence and Language Comprehension* (Washington, DC: U.S. Department of Health, Education, and Welfare, National Institute of Education, 1976); Hubert Dreyfus, *What Computers Can't Do* (New York: Harper and Row, 1979); and even Richard Powers, *Galatea 2.2* (New York: Farrar, Straus, and Giroux, 1995). Daniel Crevier, *AI: The Tumultuous History of the Search for Artificial Intelligence* (New York: Basic Books, 1993), is still a useful introduction to the emergence of crucial fault lines in this area.

7. For a range of imaginings on this topic, see Philip K. Dick, *Do Androids Dream of Electric Sheep* (Garden City, NY: Doubleday, 1968); Rudy Rucker, *Software* (New York: Eos/HarperCollins, 1987); Bill Joy, "Why the Future Doesn't Need Us," http://www.wired.com/wired/archive/8.04/joy.html; Donna Haraway, *Simians, Cyborgs, and Women* (New York: Routledge, 1991); and Chris Habels Gray and Steven Mentor, *The Cyborg Handbook* (New York: Routledge, 1995).

8. For an extreme view, see Arthur Kroker, *Digital Delirium* (New York: St. Martin's Press, 1997); Chun, *Control and Freedom*, offers a more tempered assessment. The writings of Critical Art Ensemble, at http://www.critical-art.net, synthesize critical philosophy and digital culture studies.

9. See Howard Besser's published works and online references, including "Digital Libraries, Standards, Metadata, and Longevity Activities," http://besser.tsoa.nyu.edu/howard/#standards.

10. For an overview of the field from varying perspectives, see Schreibman, Siemens, and Unsworth, *Companion to Digital Humanities*.

11. The EText Center at University of Virginia is a useful example: http://etext.virginia.edu.

12. Barbara Stafford, *Good Looking* (Cambridge: MIT Press, 1996), provides a striking demonstration of the extent to which logocentrism prevails in academic work. Her arguments, from the point of view of artists, art historians, or practitioners of visual knowledge production, seem so obvious as to be unnecessary, and yet, for textual scholars, they seemed to challenge basic assumptions, at least in some quarters. See also Franco Moretti, "Graphs, Maps, and Trees," *New Left Review*, no. 24, November–December 2003 (first of three articles, http://www.newleftreview.net/Issue24.asp?Article=05).

13. On codework, see the exchanges between Rita Raley and John Cayley in Raley, "Interferences: [Net.Writing] and the Practice of Codework" (http://www.electronicbookreview.com/thread/electropoetics/net.writing), and the discussions of digital poetry at http://www.poemsthatgo.com/ideas.htm.

14. Michael Heim, *Electric Language* (New Haven: Yale University Press, 1987); George Landow, *Hypertext* (Baltimore: Johns Hopkins University Press, 1992); J. David Bolter, *Writing Space* (Matwah, NJ: L. Erlbaum Associates, 1991).

15. Hockey, *Electronic Texts*, is an extremely useful, objective introduction to the

field and its history. In addition see: Schreibman, Siemens, and Unsworth, *Companion to Digital Humanities;* McCarty, *Humanities Computing* (Hampshire: Palgrave, 2005); and Elizabeth Bergmann Loizeaux and Neil Fraistat, *Reimagining Textuality* (Madison: University of Wisconsin Press, 2002).

16. For information on metadata standards, see http://dublincore.org; http://www.tei-c.org.

17. Jerome McGann, "Texts in N-Dimensions and Interpretation in a New Key," expands this list in a broader discussion that summarizes our work at SpecLab from his perspective (http://www.humanities.mcmaster.ca/~texttech/pdf/vol12_2_02.pdf).

18. Michael Day, "Metadata for Digital Preservation: A Review of Recent Developments" (http://www.ukoln.ac.uk/metadata/presentations/ecdl2001-day/paper.html), and the discussion of metadata at http://digitalarchive.oclc.org/da/ViewObjectMain.jsp provide useful starting points.

19. Henry Kucera and Nelson Francis of *Computational Analysis of Present-Day American English* in 1967 is considered a turning point for this field. For current work in this area, see *Studies in Corpus Linguistics,* Elena Tognini-Bonelli, general editor, and the professional journal publications *Corpora,* and *Studies in Corpus Linguistics.*

20. Adam Mathes, "Folksonomies—Cooperative Classification and Communication through Shared Metadata," http://www.adammathes.com/academic/computer-mediated-communication/folksonomies.html; overview of search engines, http://jamesthornton.com/search-engine-research; updates on data mining, http://dataminingresearch.blogspot.com.

21. This distinction, more than any other, differentiates natural and formal languages and, not surprisingly, demarcates work in the fields of artificial intelligence from that in cognitive studies, for instance. The shift in the attitudes with which Ludwig Wittgenstein approached the study of language in his *Tractatus* and, later, in *Philosophical Investigations* registers the recognition that the project of totalized, objectified, formalistic approaches to language was a failure and the subsequent realization that only use, situated and specific, could provide insight into the signifying capabilities of language.

22. Jerome McGann, *The Critique of Modern Textual Criticism* (Chicago: University of Chicago Press, 1983) and *Black Riders: The Visible Language of Modernism* (Princeton: Princeton University Press, 1993); Randall McLeod, lectures on "Material Narratives" (http://www.sas.upenn.edu/~traister/pennsem.html); Steve McCaffery and bp nichol, *Rational Geomancy* (Vancouver: Talonbooks, 1992); Johanna Drucker, *The Visible Word: Experimental Typography and Modern Art, 1909–1923* (Chicago: University of Chicago Press, 1994); and essays by McLeod, Nick Frankel, Peter Robinson, Manuel Portela, et al. in *Marking the Text,* ed. Joe Bray, Miriam Handley, and Anne C. Henry (Aldershot: Ashgate, 2000).

23. Joëlle Despeyroux and Robert Harper, "Logical Frameworks and Metalanguages," *Journal of Functional Programming* 13 (2003): 257–60.

24. McGann, *Radiant Textuality,* esp. chap. 5, "Rethinking Textuality," 137–66.

25. Allen Renear, "Out of Praxis: Three (Meta)Theories of Textuality," in Sutherland, *Electronic Text,* 107–26; Allen Renear, Steve De Rose, David G. Durand, and Elli Mylonas, "What Is Text, Really?" *Journal of Computing in Higher Education* 2, no. 1 (Winter 1990): 3–26.

26. Probably the most significant critique of markup, Dino Buzzetti's paper "Text Representation and Textual Models" (http://www.iath.virginia.edu/ach-allc.99/

proceedings/buzzetti.html), brought much of that debate to a close by pointing out another important issue—that the insertion of tags directly into the text created a conflict between the text as a representation at the level of discourse (to use the classic terms of structuralist linguistics) and at the level of reference. Putting content markers into the plane of discourse (a tag that identifies the semantic value of a text relies on reference, even though it is put directly into the character string) *as if* they are marking the plane of reference is a flawed practice. Markup, in its very basis, embodies a contradiction. It collapses two distinct orders of linguistic operation in a confused and messy way. Buzzetti's argument demonstrated that XML itself is built on this confused model of textuality. Thus the foundation of metatextual activity was itself the expression of a model, even as the metatexts embodied in markup schemes model the semantic content of text documents.

27. Holly Shulman, ed., Dolley Madison Digital Edition, University of Virginia Press, http://www.upress.virginia.edu/books/shulman.html.

1.2

1. Heinz von Foerster, *Observing Systems* (Salinas, CA: Intersystems Publications, 1981); Ernst von Glasersfeld, *Radical Constructivism: A Way of Knowing and Learning* (London: Falmer Press, 1995) and "An Introduction to Radical Constructivism," in *The Invented Reality: How Do We Know?*, ed. P. Watzlawick, 17–40 (New York: W. W. Norton, 1984); H. R. Maturana and F. J. Varela, *Autopoiesis and Cognition: The Realization of the Living* (Boston: D. Reidel, 1980).

2. Alan MacEachren, *How Maps Work* (New York: Guilford Press, 1995).

3. Alfred Jarry, *Exploits and Opinions of Dr. Faustroll, Pataphysician* (New York: Exact Change, 1996); Werner Heisenberg, *Philosophical Problems of Quantum Physics* (Woodbridge, CT: Ox Bow Press, 1979); William Charles Price, *The Uncertainty Principle and Foundations of Quantum Mechanics: A Fifty Years' Survey* (New York: Wiley, 1977); McGann, "Texts in N-Dimensions"; Erwin Schrödinger, *Science and Humanism: Physics in Our Time* (Cambridge: Cambridge University Press, 1951) and *My View of the World* (Cambridge: Cambridge University Press, 1964).

4. Mikhail Bakhtin, *The Dialogic Imagination* (Austin: University of Texas Press, 1981).

5. Jacques Bertin, *The Semiology of Graphics* (Madison: University of Wisconsin Press, 1973); Fernande Saint-Martin, *Semiotics of Visual Language* (Bloomington: University of Indiana Press, 1990); Paul Mijksenaar, *Visual Function* (Princeton: Princeton Architectural Press, 1987); Stephen Kosslyn, *Image and Mind* (Cambridge: Harvard University Press, 1980); Richard L. Gregory, *Eye and Brain* (Princeton: Princeton University Press, 1990); James Jerome Gibson, *The Ecological Approach to Visual Perception* (1979; Hillsdale, NJ: Lawrence Erlbaum Associates, 1986); Peter Galison, *Image and Logic: A Material Culture of Microphysics* (Chicago: University of Chicago Press, 1997); Martin Kemp, *Visualizations: The Nature Book of Art and Science* (Berkeley: University of California Press, 2000); Stephen Wilson, *Information Arts: Intersections of Art, Science, and Technology* (Cambridge: MIT Press, 2002); or David Freedberg, *Eye of the Lynx* (Chicago: University of Chicago Press, 2002); James Elkins, *The Domain of Images* (Ithaca: Cornell University Press, 1999); David Marr, *Vision: A Computational Investigation into the Human Representation and Processing of Visual Information* (San Francisco: W. H. Freeman, 1982).

6. Charles Peirce, *The Philosophical Writings of Charles Peirce*, ed. Justus Buchler (New

York: Dover, 1955); Ferdinand de Saussure, *Course in General Linguistics,* ed. Charles Bally and Albert Sechehaye (London: Duckworth, 1983).

7. Jerome McGann, *Dante Gabriel Rossetti and the Game That Must Be Lost* (New Haven: Yale University Press, 2000); Gérard Genette, *Nouveau discours du récit* (Paris: Editions du Seuil, 1983); Paul Smith, *Discerning the Subject* (Minneapolis: University of Minnesota Press, 1988); Emile Benveniste, *Problèmes de linguistique générale* (Paris: Gallimard, 1966–84).

8. *Research in Humanities Computing: Selected Papers from the ALLC/ACH Conference, Association for Literary and Linguistic Computing* (Oxford: Clarendon Press, ongoing from 1991), and Schreibman, Siemens, and Unsworth, *Companion to Digital Humanities,* are excellent starting points for the critical discourse of digital humanities over the last fifteen years.

9. Charles Babbage, *Charles Babbage and His Calculating Engines* (New York: Dover, 1961).

10. Claude Shannon, "A Mathematical Theory of Communication" (Bell Labs, 1947), http://cm.bell-labs.com/cm/ms/what/shannonday/paper.html.

11. Alan Turing, "On Computable Numbers, with an Application to the Entscheidungsproblem," *Proceedings of the London Mathematical Society,* series 2, vol. 42 (1936); Martin Davis, *Universal Computer* (New York: W. W. Norton, 2000).

12. John Comaromi, *Dewey Decimal Classification: History and Current Status* (New Delhi: Sterling, 1989). Wayne Weigand, "The 'Amherst Method': The Origins of the Dewey Decimal Classification Scheme," *Libraries & Culture* 33, no. 2 (Spring 1998), http://www.gslis.utexas.edu/~landc/fulltext/LandC_33_2_Wiegand.pdf; Fritz Machlup, *Information: Interdisciplinary Messages* (New York: Wiley and Sons, 1983).

13. Warren Weaver and Claude Shannon, *The Mathematical Theory of Communication* (Urbana: University of Illinois Press, 1949).

14. Works across disciplines have discussed the dialogue of formal reasoning and cultural issues in representation and knowledge, among them: Liu, *Laws of Cool;* McCarty, *Humanities Computing;* Manovich, *Language of New Media;* Wilson, *Information Arts;* and William J. Mitchell, *The Reconfigured Eye: Visual Truth in the Post-Photographic Era* (Cambridge: MIT Press, 1994). This initial list crosses disciplines.

15. Digital humanities draws heavily on the traditions of René Descartes, Gottfried Leibniz (*mathesis universalis*), and the nineteenth-century algebra of George Boole's tellingly named *Laws of Thought.* It has direct origins in the logical investigations of language in Gottlob Frege and Bertrand Russell, as well as the early Ludwig Wittgenstein (during his youthful, mathematical optimism), and the legacy of formalist approaches as extended to natural language by Noam Chomsky. Mind-as-computer models dominated early cybernetic thought; Norbert Weiner's feedback loops had the aim of making human behavior conform to the perceived perfection of a machine. Systems theory has since become considerably more sophisticated. AI debates have moved into the realms of cognitive studies, away from rule-based notions of programmable intelligence or even bottom-up, neural-net experiential modeling. But complexity theory and chaos models are often only higher-order formalisms, still advancing claims to totalizing explanations and descriptions, not refutations of formal logic's premises. Stephen Wolfram's totalizing explanation of a combinatoric and permutational system is only one extreme manifestation of a pervasive sensibility. Mathesis still undergirds a persistent belief shared by some humanities digerati with closet aspirations to control all knowledge-as-information.

16. Jarry, *Exploits and Opinions;* Warren Motte, *OuLiPo: A Primer of Potential Literature* (Normal, IL: Dalkey Archive Press, 1998); Harry Mathews, *Oulipo Compendium* (London: Atlas Press, 1998).

17. One undergraduate who worked with us created a project in Gnomic, a game that is entirely about rule making. http://www.gnomic.com (accessed September 26, 2006).

18. McGann, "Texts in N-Dimensions,"cites George Spencer-Brown, *The Laws of Form* (New York: Julian Press, 1972).

19. This is garden variety poststructuralism and deconstruction, drawing on Roland Barthes, *S/Z* (Paris: Editions du Seuil, 1970), *Mythologies* (Paris: Editions du Seuil, 1957), and *Image/Music/Text;* Jacques Derrida, *Of Grammatology* (Baltimore: Johns Hopkins University Press, 1976) and *Writing and Difference* (Chicago: University of Chicago Press, 1978); and Paul de Man, *Blindness and Insight* (New York: Oxford University Press, 1971) and *Allegories of Reading* (New Haven: Yale University Press, 1979).

20. Von Glasersfeld, *Radical Constructivism;* von Foerster, *Observing Systems;* Maturana and Varela, *Autopoiesis and Cognition;* Norbert Wiener, *Cybernetics of Control and Communication in the Animal and the Machine* (New York: Wiley, 1948).

21. Cultural theorists of media, from Harold Innis and James Carey through Kaja Silverman, Janice Radway, and Dick Hebdige stress the constitutive rather than instrumental function of mediating systems. James Carey, "Cultural Approach to Communication," chap. 1 in *Communication as Culture* (Boston: Unwin Hyman, 1989).

2.0

1. McGann, *Radiant Textuality*, chap. 9 and appendix (209–48), contains McGann's account of the first game and his moves.

2.1

1. Temporal Modeling is an Intel-sponsored research project of the Speculative Computing Lab and Media Studies at University of Virginia. Demonstrations, work in progress, and research reports are available at http://www.iath.virginia.edu/time.

2. This in fact is what Bruce Robertson's Temporal Markup Scheme attempts to do. The disadvantage is in the assumptions about parent-child relations and the difficulty of accommodating vague information, as well as the persistent difficulty of dealing with overlapping hierarchies within any XML-based scheme.

3. For an overview of some of these issues, see Stuart K. Card, Jock D. Mackinlay, and Ben Shneiderman, *Readings in Information Visualization: Using Vision to Think* (San Francisco: Morgan Kaufmann Publishers, 1999).

4. J. T. Fraser, *Time, the Familiar Stranger* (Cambridge: Massachusetts University Press, 1987); F. A. Schreiber, "Is Time a Real Time? An Overview of Time Ontology in Informatics," in *Real Time Computing*, ed. W. A. Halang and A. D. Stoyenko, 283–307 (Springer Verlag, 1992).

5. Schreiber, "Is Time a Real Time?"

6. Patterns of human activity, even belief systems grounded in cyclic progression toward enlightenment, prove on examination to be temporal arrows "wrapped" in circular loops.

7. J. F. Allen, "Time and Time Again: The Many Ways to Represent Time," *International Journal of Intelligent Systems* 6, no. 4 (July 1991): 341–55.

8. C. S. Jensen et al., "A Glossary of Temporal Database Concepts," *Proceedings of ACM SIGMOD International Conference on Management of Data* 23, no. 1 (March 1994).

9. M. Steedman, "The Productions of Time," draft tutorial notes 2.0, University of Edinburgh, ftp://ftp.cis.upenn.edu/pub/steedman/temporality/.

10. J. Burg, A. Boyle, and S.-D. Lang, "Using Constraint Logic Programming to Analyze the Chronology in *A Rose for Emily,*" *Computers and the Humanities* 34, no. 4 (December 2000): 377–92.

11. P. W. Jordan, "Determining the Temporal Ordering of Events in Discourse," master's thesis, Carnegie Mellon Computational Linguistics Program, 1994.

12. H. Bronstein, "Time Schemes, Order, and Chaos: Periodization and Ideology," in *Time, Order, Chaos: The Study of Time IX,* ed. J. T. Fraser, Marlene P. Soulsby, and Alexander J. Argyros (Madison, CT: International Universities Press, 1998).

13. Ira Bashow, Seminar Presentation, University of Virginia, June 2001.

14. H. Price, "The View from Nowhen," in *Time's Arrow and Archimedes' Point* (New York: Oxford University Press, 1996).

15. Teri Reynolds, "Spacetime and Imagetext," *Germanic Review* 73, no. 2 (Spring 1998): 161–74.

16. M. A. O'Toole, "The Theory of Serialism in *The Third Policeman,*" *Irish University Review* 18, no. 2 (1988): 215–25.

17. The resulting archive can be found at http://www.iath.virginia.edu/time/time.html.

18. Jerome McGann received a Mellon Lifetime Achievement award in 2002 that brought him a $1.5 million budget. This allowed Ivanhoe to be built but also, shifted the direction of SpecLab's ARP (Applied Research in Patacriticism) into development of Collex, Juxta, and NINES. While this was in every way a positive development, it marked a change in our activities from playful imaginings to serious software creation. My own interests shifted to ABsOnline and Subjective Meteorology, as well as other scholarly projects, and ARP went on under Jerry's direction. Bethany went back to work directly on the ARP projects as well, and our work shifted phase, but she had been the crucial partner in creating Temporal Modeling.

2.2

1. Temporal Modeling was designed to create XML output through a Flash interface. As a result, the kinds of hierarchies and standard metrics that obtain in a Cartesian coordinate system were built into the execution. We struggled over this, but given the budgetary limitations, we lacked the programming muscle to create a discontinuous and/or malleable spatial field. Our goal of making a primary space for creating data through visual means became more important than making sure all the specific characteristics of our design plan were realized, and rather than resort to an environment that would simply, as our doubting peers described it, "make a picture" of a subjective, interpretative space, we opted for making a workable XML platform for creating data on the fly.

2. Subsequent SpecLab projects—Collex (a digital collections tool), Juxta (a collation tool), and NINES, the Networked Infrastructure for Nineteenth-Century Electronic Scholarship—continued in this direction while I became involved in ABsOnline and Subjective Meteorology.

3. See McGann, *Radiant Textuality,* for another discussion of critical issues in their intersection with digital humanities.

4. Barthes, "From Work to Text," in *Image/Music/Text;* also at http://homepage
.newschool.edu/~quigleyt/vcs/barthes-wt.html.

5. Colleagues will protest this last assertion, no doubt, pointing to the volumes of
scholarly writing that engage seriously with deconstruction and its methods, but any-
one observing the daily practices of pedagogy knows all too well how persistently the
"mining for meaning" approach to reading continues to hold sway in the classroom.

6. Points and scoring are among the many features of the game that could be
toggled on and off. They seem largely unnecessary, though in the *Turn of the Screw,*
since we were testing a design with a particular game economy built into it, the points
were linked to "inkwells" needed for making moves, thus putting certain constraints
into play in the structure of the game.

7. Chandler Sansing's account of this version can be found in the Ivanhoe docu-
ments at http://www.speculativecomputing.org.

8. The first designs, as the figures will make clear, were worked out by me in
dialogue with Jerry, using what I had learned from storyboarding Temporal Modeling
and from talking with Louise Sandhaus and watching her teach her students at Cal
Arts, a revelation. Contributions from Bethany Nowviskie, Nathan Piazza, Ben Cum-
mings, Andrea Laue, Steve Ramsey, Worthy Martin, and John Unsworth in the initial
rounds transformed the project from an idea into a software development model. We
spent at least a year having Ivanhoe lunches during the period when Geoffrey Rock-
well and Rune Dalgaard were visiting us. Much of that activity was recorded in notes
and minutes, and thanks to Bethany's efforts these are archived on SpecLab. Another
major change occurred with the arrival of the Mellon funding and the hiring of Nick
Laicona, Lou Foster, Duane Gran, Erik Hatcher, and others who helped build Ivanhoe
and other ARP projects.

9. Ben Shneiderman and Catherine Plaisant, *Designing the User Interface: Strategies
for Effective Human-Computer Interaction* (Boston: Pearson/Addison Wesley, 2005);
Card, Mackinlay, and Shneiderman, *Information Visualization;* Aaron Marcus, Nick
Smilonich, and Lynne Thompson, *The Cross-GUI Handbook for Multiplatform User Inter-
face Design* (Boston: Addison-Wesley Longman, 1994). For a sensible introduction and
overview, see James Hobart, "Principles of Good GUI Design" (http://www.iie.org
.mx/Monitor/v01n03/ar_ihc2.htm), Antionio Drommi, Gregory W. Ulferts, and Dan
Shoemaker, "Interface Design: A Focus on Cognitive Science" (http://isedj.org/isecon/
2001/02a/ISECON.2001.Drommi.pdf), or Atta Badii and Sylvia Truman, "Cognitive
Factors in Interface Design: An E-Learning Environment for Memory Performance
and Retention Optimisation," Proceedings of the Eighth European Conference on
Information Technology Management: E-Content Management Stream (http://kmi
.open.ac.uk/people/sylvia/papers%20pdf/BadiiTruman%202001.pdf).

10. See Jakob Nielson, "Top Ten Web Design Mistakes," http://www.useit.com/
alertbox/990530.html; Jeff Johnson, *GUI Bloopers* (Morgan Kaufmann, 2000); Theo
Mandel, *The Elements of User Interface Design* (New York: Wiley and Sons, 1997);
and, for a collection of the worst errors in design and aesthetics, http://www
.webpagesthatsuck.com.

11. Elizabeth Würtz, "A Cross-Cultural Analysis of Websites from High-Context
Cultures and Low-Context Cultures," *Journal of Computer-Mediated Communication* 11,
no. 1, article 13, has an excellent bibliography (http://jcmc.indiana.edu/vol11/issue1/
wuertz.html).

12. Tufte, *Visual Display;* Richard Saul Wurman, *Information Architects* (New York:

Watson-Guptill, 1997); Robert E. Horn, *Visual Language* (Bainbridge Island, WA: Macrovu, 1991).

13. Erwin Panofsky, *Studies in Iconology* (New York: Harper and Row, 1972); Barthes, *Image/Music/Text;* Michel Foucault, *The Order of Things* (New York: Pantheon, 1970) and *The Archaeology of Knowledge* (New York: Harper & Row, 1972); Mieke Bal, *Looking In* (New York: Routledge, 2000); Norman Bryson, Michael Holly, and Keith Moxey, eds., *Visual Culture: Images and Interpretations* (Hanover, NH: University Press of New England, 1994); Laurie Adams, *The Methodologies of Art* (New York: Icon, 1996).

14. Staggeringly little material exists on the history, ideology, and semiotics of diagrams. See Martin Gardner, *Logic Machines and Diagrams* (Chicago: University of Chicago Press, 1982), and Moretti, "Graphs, Maps, and Trees." The study of cultural differences is, however, a major area of Web development now.

15. Graphic design history and theory has a substantial inventory of work at the intersection of critical, cultural studies and visual communication, such as that by Ellen Lupton, Lorraine Wild, Max Gallo, Roland Marchand, Stuart Ewen, Neil Harris, and Michelle Bogart.

16. Tufte is practically synonymous with this view of information.

17. See chapter 3.2, particularly the coda, on going beyond literal materialism.

18. Maturana and Varela, *The Tree of Knowledge* (Boston: Shambala, 1992); Francisco Varela, Evan Thompson, and Eleanor Rosch, *The Embodied Mind: Cognitive Science and Human Experience* (Cambridge: MIT Press, 1991).

19. MacEachren, *How Maps Work.*

20. See Michel Seuphor, *Abstract Painting* (New York: Abrams, 1962); Clement Greenberg, *Art and Culture* (Boston: Beacon, 1961); Theodor Adorno, *Aesthetic Theory* (Minneapolis: University of Minnesota Press, 1997); and my essay on modernism in Kelly, *Encyclopedia of Aesthetics.*

21. Charles Harrison and Paul Wood, eds., *Art in Theory* (Oxford: Blackwell, 1993).

22. Saussure, *Course in General Linguistics.* See also Umberto Eco, *Theory of Semiotics* (Bloomington: University of Indiana Press, 1976); Tveztan Todorov, *Theories of the Symbol* (Oxford: Blackwell, 1982); Louis Hjelmslev, *Prolegomena to a Theory of Language* (Madison: University of Wisconsin Press, 1963); and Thomas Sebeok, *Introduction to Semiotics* (London: Pinter, 1994).

23. Herschell Browning Chipp, *Theories of Modern Art* (Berkeley: University of California Press, 1968).

24. H. G. Wells, *World Brain: The Idea of a Permanent World Encyclopedia* (1937), https://sherlock.sims.berkeley.edu/wells/world_brain.html; J. C. Licklider, *Libraries of the Future* (Cambridge: MIT Press 1965).

25. Max Bense, "The Projects of Generative Aesthetics," in *Cybernetics, Art and Ideas,* ed. Jasia Reichardt, 57–60 (New York: Graphics Society, 1971).

26. Ted Nelson, "Project Xanadu: The Original Hypertext Project," http://www.xanadu.net; James M. Nyce and Paul Kahn, eds., *From Memex to Hypertext: Vannevar Bush and the Mind's Machine* (Boston: Academic Press, 1991).

27. Malcolm B. Parkes, "The Influence of the Concepts of *Ordinatio* and *Compilatio* on the Development of the Book," in *Medieval Learning and Literature,* ed. J. J. G. Alexander and M. T. Gibson, 115–41 (Oxford: Clarendon Press, 1976). See also L. Avrin, *Scribes, Scripts and Books* (Chicago: American Library Association; British Library, 1991); M. M. Smith, "The Design Relationship between the MSS. and the Incunable,"

in *A Millennium of the Book,* ed. R. Meyers and M. Harris (Winchester, England: St. Paul's, 1994); L. Febvre and H.-J. Martin, *The Coming of the Book* (London: Verso, 1997); Douglas McMurtrie, *The Book: The Story of Printing and Bookmaking* (New York: Dorset, 1943); and Robert Stillman, *The New Philosophy and Universal Languages in Seventeenth-Century England: Bacon, Hobbes, and Wilkins* (Lewisburg: Bucknell University Press, 1995).

28. Shneiderman and Plaisant, *Designing the User Interface.*

29. Frances Yates, *Lull and Bruno* (London: Routledge and Kegan Paul, 1982); Gershem Scholem, *Kabbalah* (New York: Meridian, 1978). See also the Oulipo references cited above.

30. See my essay "Graphesis," http://www.noraproject.org/reading.ph.

2.3

1. See Drucker, "Graphesis." See also Donald Ahrens, *Meteorology Today* (Belmont, CA: Thomson/Brooks/Cole, 2007), one of the standard texts in the field. Other works used for reference in this project include Calvin Schmid, *Handbook of Graphic Presentation* (New York: Ronald Press, 1954), and L. Hasse and F. Dobson, *Introductory Physics of the Atmosphere and Ocean* (Dordrecht: D. Reidel, 1986).

2. *Goodman, Languages of Art,* is still useful in describing allographic systems and distinguishing them from other notation forms.

3. *Jarry, Exploits and Opinions.*

4. Christian Bök, *Pataphysics: The Poetics of an Imaginary Science* (Evanston, IL: Northwestern University Press, 2002).

2.4

1. The design of the metadata for ABsOnline takes the form of a Document Type Description (DTD), which is used to generate the XML files that belong to each book/work.

2. Other projects at the University of Virginia use metadata to record the sequence of activities within a constrained space (the space of game play in Ivanhoe) or to enable controlled participation (Jerome McGann's NINES project as a discrete, bounded, but networked environment for academic publishing and scholarship). See http://www.speculativecomputing.org.

2.5

1. "Faustroll defined the universe as that which is the exception to oneself." Jarry, *Exploits and Opinions,* 98. See also Bök, *Pataphysics.*

3.0

1. Gardner, *Logic Machines;* Moretti, "Graphs, Maps, and Trees."

2. See Drucker, *Visible Word* and "Graphesis."

3. Beardsley, *Aesthetics;* Conrad Fiedler, *On Judging Works of Visual Art* (Berkeley: University of California Press, 1978); Clive Bell, *Art* (New York: Capricorn Books, 1958); Roger Fry, *Vision and Design* (Harmondsworth: Penguin, 1937); Michael Fried, *Art and Objecthood* (Chicago: University of Chicago Press, 1998); Greenberg, *Art and Culture;* Seuphor, *Abstract Painting;* Adorno, *Aesthetic Theory.*

4. Derrida, *Grammatology* and *Writing and Difference;* Foucault, *Order of Things* and *Archaeology of Knowledge;* Friedrich Nietzsche, *Beyond Good and Evil* (New York: Vin-

tage, 1966); Martin Heidegger, *Existence and Being* (London: Vision Press, 1956); Gilles Deleuze and Felix Guattari, *Anti-Oedipus: Capitalism and Schizophrenia* (New York: Viking, 1977) and *Rhizome: Introduction* (Paris: Editions de Minuit, 1976); Jean Baudrillard, *For a Critique of the Political Economy of the Sign* (St. Louis: Telos Press, 1981) and *Simulations* (New York: Semiotext(e), 1983).

5. Drucker, "Electronic Media and the Status of Writing," in *Figuring the Word* (New York: Granary Books, 1998), 232–36.

6. The *British Journal of Aesthetics*, I think.

7. Melvin Prueitt, *Art and the Computer* (New York: McGraw Hill, 1984); Roy Ascott, *Telematic Embrace* (Berkeley: University of California Press, 2003); Kenneth Knowlton as described in Jasia Reichardt, *Cybernetics, Art, and Ideas* (Greenwich, CT: New York Graphic Society, 1971) and *Cybernetic Serendipity* (New York: Praeger, 1968).

8. See Paul Binski, *Cambridge Illuminations: Ten Centuries of Book Production in the Medieval West* (London: Harvey Miller, 2005).

9. Druckrey, *Iterations;* Hershman-Leeson, *Clicking In;* Hansen, *New Philosophy;* Manovich, *Language of New Media*. Advocates of the value of code include Eduardo Kac, Alan Sondheim, and Loss Glazier.

10. Kirschenbaum, *Mechanisms,* is the most outstanding and insightful new text in this field.

11. Elkins, *Domain of Images;* Goodman, *Languages of Art*.

12. Roman Jakobson, *Six Lectures on Sound and Meaning* (Cambridge: MIT Press, 1978) and "Closing Statement: Linguistics and Poetics," in *Style in Language,* ed. T. A. Sebeok, 350–77 (New York: Wiley, 1960); Barthes, *Image/Music/Text;* Eco, *Theory of Semiotics;* Bal, *Looking In;* and Bryson, Holly, and Moxey, *Visual Culture*.

3.1

1. This piece took many forms: "Digital Ontologies: The Ideality of Form" (Digital Arts Conference, 1999), "Ontology of the Digital Image" (Wesleyan University, 1997), "Theoretical Informational Aesthetics" (Cal Arts, 1998), and various versions of "Code Storage" (keynote, Mixed Messages Conference, University of North Carolina, 1997; New York University, 1998). It was first published as "Digital Ontologies," *Leonardo* 34, no. 2 (2001): 141–45.

2. Martin Lister, ed., *The Photographic Image in Digital Culture* (London: Routledge, 1995). H. Amelunxen, S. Iglhaut, and F. Rötzer, eds., in collaboration with A. Cassel and N. G. Schneider, *Photography after Photography* (Basel, Switzerland: G&B Arts International, 1996); Mitchell, *Reconfigured Eye;* Druckrey, *Iterations;* Fred Ritchin, *In Our Own Image* (New York: Aperture, 1990).

3. Crevier, *AI*.

4. Jacques Derrida, *Edmund Husserl's Origin of Geometry: An Introduction,* trans. John P. Leavey Jr. (Lincoln: University of Nebraska Press, 1989).

5. Ritchin, *In Our Own Image;* Lister, *Photographic Image;* Mitchell, *Reconfigured Eye;* Kirschenbaum, *Mechanisms*.

6. See Amelunxen et al., *Photography after Photography,* for the specific characterization of the Platonic hierarchy relevant here.

7. Kirschenbaum, *Mechanisms*.

8. Peter Osborne, "Adorno and the Metaphysics of Modernism: The Problem of a Postmodern Art," 23–48, and Peter Dews, "Adorno, Poststructuralism, and the

Critique of Identity," 1–22, both in *The Problems of Modernity: Adorno and Benjamin*, ed. Andrew Benjamin (London: Routledge, 1989); H. Brunkhorst, "Irreconcilable Modernity: Adorno's Aesthetic Experimentalism and the Transgression Theorem," in *The Actuality of Adorno*, ed. M. Pensky (Albany: State Univ. of New York, 1997).

9. Brunkhorst, "Irreconcilable Modernity."

10. Derrida, *Husserl's Origin of Geometry*.

11. For a discussion of Griffiths and Wright, see *Faires: The Cottingley Photographs and their Sequel* (Theosophical Publishing House, 1966). On the ethics of digital manipulation, see http://www.astropix.com/HTML/J_DIGIT/ETHICS.HTM.

12. For Peter Campus images, see http://moma.org and http://www.gravus.net/

13. Lister, *Photographic Image*. Amelunxen et al., *Photography after Photography*.

14. Amelunxen et al., *Photography after Photography*.

15. For a useful resource on digital image manipulation, see http://www.media -awareness.ca/english/resources/educational/teachable_moments/photo_truth.cfm.

16. A. Besant and C. W. Leadbeater, *Thought Forms* (London: Theosophical Publishing Society, 1905).

17. I am thinking of the context in which Wilhelm Worringer's work was produced, for instance, or that of Wassily Kandinsky: that early twentieth-century investment in aesthetic systems of correspondence and universals that came out of late-nineteenth-century symbolism.

18. Herbert W. Franke, *Computer Graphics Computer Art* (New York: Phaidon, 1971).

19. Source for these is Jasia Reichart, *Cybernetic Sensibility* (New York: Praeger, 1968) and *The Computer in Art* (New York: Van Nostrand Reinhold; London: Studio Vista, 1971).

20. Alan Sondheim, *Disorders of the Real* (Barrytown, NY: Station Hill Press, 1988); Loss P. Glazier, *Digital Poetics: The Making of E-Poetries* (Tuscaloosa: University of Alabama Press, 2002); Brian Kim Stefans, *Fashionable Noise* (Berkeley, CA: Atelos, 2003). See online the previously cited Rita Raley references; Jim Rosenberg, essay (http://www.well.com/user/jer/NNHI.html) and poetry (http://www.eastgate.com/people/Rosenberg.html); John Cayley (http://homepage.mac.com/shadoof/net/in/inhome.html); and Jim Andrews, "Vispo, Langu(im)age" (http://www.vispo.com).

21. Prueitt, *Art and the Computer*.

22. Paul Virilio, *The Vision Machine* (Cambridge: MIT Press, 1995).

23. Kirschenbaum, *Mechanisms*, makes this point more strongly and clearly as the basis of a definition of forensic materiality. See chapter 1, "Every Contact Leaves a Trace."

3.2

1. Heim, *Electric Language*; Landow, *Hypertext*; Bolter, *Writing Space*.

2. We could quibble over taking the letter as a starting point. Some would favor an originary inscription of difference as the basis of signification, others a higher-order morphemic-word chunk.

3. Donald Knuth, *Tex and Metafont* (Bedford, MA: American Mathematical Society and Digital Press, 1979).

4. Douglas Hofstadter, *Metamagical Themas* (New York: Basic Books, 1985).

5. For further discussion, see Drucker, "What Is a Letter?" in *The Education of a Typographer*, ed. Steven Heller (New York: Allworth Press, 2004).

6. Walter Ong, *Ramus, Method, and the Decay of Dialogue* (Cambridge: Harvard University Press, 1958).

7. John Wilkins, *An Essay towards a Real Character and Philosophical Language* (London: Printed for Sa. Gellibrand, and for John Martyn, 1668).

8. Crevier, *AI*, provides a useful introduction and overview.

9. Gordon P. Baker, *Wittgenstein, Frege, and the Vienna Circle* (Oxford: Blackwell, 1988); Peter Lewis, *Wittgenstein, Aesthetics and Philosophy* (Burlington, VT: Ashgate, 2004); Noam Chomsky, *Cartesian Linguistics: A Chapter in the History of Rationalist Thought* (Christchurch, New Zealand: Cybereditions, 2002).

10. See Drucker, "Graphesis."

11. Mary J. Carruthers, *The Craft of Thought : Meditation, Rhetoric, and the Making of Images, 400–1200* (Cambridge: Cambridge University Press, 1998)

12. Frances Yates, *The Art of Memory* (Chicago: University of Chicago Press, 1966).

13. Bertin, *Semiology of Graphics.*

14. Charles Bernstein, *Veil* (LaFarge, WI: Xexoxial Editions, 1987).

15. Matthew Kirschenbaum, "Lines for a Virtual T[y/o]pography," http://www.iath.virginia.edu/~mgk3k/dissertation/title.html.

16. Kirschenbaum, *Mechanisms.*

17. René Moreau, *The Computer Comes of Age* (Cambridge: MIT Press, 1984).

18. See the discussion of systems theory, and related references, in chapter 1.2.

19. See, for example, Dick Higgins, *FOEW&OMBWHNW* (New York: Something Else Press, 1969)

20. James Mosely, *Romain du Roi* (Lyon: Musée de l'imprimerie, 2002); Stanley Morison, *Selected Essays on the History of Letter-Forms in Manuscript and Print* (Cambridge: Cambridge University Press, 1981); Jeremy Austen and Christopher Perfect, *The Complete Typographer* (Engelwood Cliffs, NJ: Prentice Hall, 1992); Paul Rand, *Thoughts on Design* (New York: Wittenborn and Company, 1947); Gerald Cinamon, *Rudolf Koch : Letterer, Type Designer, Teacher* (New Castle, DE: Oak Knoll Press, 2000)

21. McGann, "Texts in N-Dimensions."

22. William Morris, *The Works of Geoffrey Chaucer* (Kelmscott Press, 1896).

23. This paper was published in a different form as "Graphical Readings and the Visual Aesthetics of Textuality," *Text, Transactions of the Society for Textual Scholarship* 16 (2006): 267–76.

24. On printing: Daniel B. Updike, *Printing Types* (Cambridge: Harvard University Press/Belknap, 1961); Ellen Lupton and J. Abbott Miller, *Design Writing Research* (New York: Kiosk, 1996); David Pankow, *The Printer's Manual* (Rochester: Cary Graphic Arts Press, 2005); Michael Twyman, *Printing 1770–1970: An Illustrated History of Its Development and Uses in England* (London: British Library, 1998). On visual studies: John Berger, *Ways of Seeing* (New York: Penguin, 1972); Estelle Jussim, *Visual Communication and the Graphic Arts: Photographic Technologies in the Nineteenth Century* (New York: R. R. Bowker, 1974); Kemp, *Visualizations;* Wilson, *Information Arts;* Freedberg, *Eye of the Lynx;* Elkins, *Domain of Images.* William Ivins, *Art and Geometry* (New York: Dover, 1946), makes the point that geometrical figures can be understood and manipulated tangibly as well, and that many geometric proofs are elaborations of physical actions such as turning, layering, or placing shapes in relation to each other. On cultural studies, see von Glasersfeld, *Radical Constructivism;* Maturana and Varela, *Autopoiesis and Cognition;* and the work of Raymond Williams, Stuart Hall, John Tagg, and Francis Frascina.

3.3

1. The iterative aspects of digital processing have now begun to make themselves felt in tools that are genuinely interactive and intersubjective and result in material transformation of the text and knowledge produced through the activity they support. Two authoring and editing environments—Sophie, being prototyped by Bob Stein, and Collex, being developed by Bethany Nowviskie and Jerome McGann at SpecLab at the University of Virginia—are addressing some of the issues that hindered e-spaces from coming into their own. Sophie embodies certain echoes of book structure, particularly in the way it segments or modularizes its spaces and their sequencing, but it also incorporates features of time-based, animated multimedia alongside in software that is accessible enough for classroom use but multipurpose in its applications. Collex is conceived entirely within digital functionalities meant to support electronic publishing and scholarship (collecting, aggregating, making use of folksonomy technology and other networking capabilities). Its interface is strictly functional, with viewing areas for search, display, and notation features rather than a global view of activity. Both projects are so new that issues of scale and sustainability, patterns of use, and graphical navigation have yet to reveal themselves, but both are highly promising. Still, I would argue, these and other electronic environments for reading and authoring expose our indebtedness to print culture at the conceptual level. Understanding the way the basic spatiotemporal structure of the codex undergirds the conceptual organization of reading spaces remains important as we move forward with designing new environments for publication.

2. For discussions of the development of e-books, see Clifford Lynch, "The Battle to Define the Future of the Book in the Digital World," *First Monday* 6, no. 6 (2001), http://www.firstmonday.org/issues/issue6_6/lynch.

3. H. A. Henke, "The Global Impact of eBooks on ePublishing," *Proceedings of the 19th Annual International Conference on Computer Documentation*, 172–80 (New York: ACM, 2001), http://portal.acm.org/citation.cfm?id=501551.

4. One might instead think along the lines of medievalist Mary Carruthers's reassessment of memory theaters, which she views as designs for enacting a cognitive task rather than simply formal structures for information storage and retrieval. Carruthers, *Craft of Thought.*

5. Chartier, R. (1995). *Forms and meanings.* Philadelphia: University of Pennsylvania Press.

6. Parkes, "Influence of the Concepts of *Ordinatio* and *Compilatio.*" See also Avrin, *Scribes, Scripts and Books;* Smith, "Design Relationship"; Febvre and Martin, *Coming of the Book;* McMurtrie, *The Book.*

7. Anthony Grafton, *The Footnote* (Cambridge: Harvard University Press, 1997).

8. Other familiar features of the codex, such as page numbers, are linked to devices like the signature key and register list of first words on sheets. These originally functioned as instructions from printer to binder. The half-title is also an artifact of production history, having come into being with the printing press; sheets already finished, folded, and awaiting binding needed protection on their outer layer. Medieval manuscript scribes, keenly aware of the scarcity and preciousness of their vellum sheets, indicated the start of a text with a simple "Incipit" rather than waste an entire sheet on naming the work, author, or place of production.

9. Joseph Esposito, "The Processed Book," *First Monday* 8, no. 3 (2003), http://www.firstmonday.org/issues/issue8_3/esposito.

10. John Seeley Brown and Paul Duguid, *The Social Life of Information* (Cambridge: Harvard Business School Press, 2000).

3.4

1. Beth E. Kolko, Lisa Nakamura, and Gilbert B. Rodman, *Race in Cyberspace* (New York : Routledge, 2000); Anne Balsamo, *Technologies of the Gendered Body: Reading Cyborg Women* (Durham, NC: Duke University Press, 1996); Mary Flanagan, http://www.maryflanagan.com; Matthew Fuller, *Behind the Blip* (Brooklyn: Autonomedia, 2003)

2. Kirschenbaum, *Mechanisms;* Hansen, *New Philosophy;* Victoria Vesna, ed., *Database Aesthetics: Art in the Age of Information Overflow* (Minneapolis: University of Minnesota Press, 2008); Simon Penny, *Critical Issues in Electronic Media* (Albany: State University of New York Press, 1995); Jay David Bolter and Diane Gromala, *Windows and Mirrors: Experience Design, Digital Art and the Myth of Transparency* (Cambridge: MIT Press, 2005).

3. Marshall McLuhan, *The Medium Is the Massage* (New York: Bantam Books, 1967) and *Understanding Media* (New York: New American Library, 1964).

4. Harold Innis, *Empire and Communications* (Toronto: University of Toronto Press, 1972).

5. *The Medium* was slated for installation in fall 2002 as a permanent public art piece in Murphy Hall, at the School of Journalism and Mass Communication at the University of Minnesota.

6. Industrial and commercial objects often do the same within their own sphere, and the challenge of industrial design is to advance a class of objects through similar self-consciousness. What can a car be now? Or a house? Such questions are resolved not through formal solutions but through conceptual ones. Works of art insert themselves instead into the discourse of art making, an obvious but important difference. Art objects that do not acknowledge this fundamental condition are, in effect, merely well-made products, and are abundant in the art world.

7. *Information,* curated by Kynaston McShine, was held at the Museum of Modern Art in New York in 1970; *Software* was put together by Jack Burnham at the Jewish Museum in New York, also in 1970; and *Cybernetic Serendipity* was curated by Jasia Reichardt at the Institute of Contemporary Arts in London in 1968.

8. Here the key points of reference are not Baumgarten and Kant, Hegel and Arnold, Fry, Bell, and Adorno but the generative morphology of Leibniz, Babbage and Turing, Boole and Simon, Minsky, and the fifth-century-BC Sanskrit grammarian Panini—or the traditions of self-consciously procedural poetics and art: Lautréamont, Duchamp, Cage, Lewitt, Maciunas, Stockhausen, and so on.

9. See Kynaston McShine, *Information* (New York: Museum of Modern Art, 1970), and Reichardt, *Cybernetic Serendipity.*

10. See, for example, http://www.education.mcgill.ca/profs/cartwright/edpe300/mirabel.jpg and Exit Art, *Hybrid State* (New York: 1991). Artworks exemplifying hybridity include Ann Preston's *Twins* (1993), a small sculpture of a head with two faces; Jake and Dino Chapman's potato-headed figures; Alan Rath's machine-sensoria; and Alexis Rockman's fantasy worlds.

11. Hayles, *How We Became Posthuman.* Hayles's important contributions engaged digital technology with enthusiasm, coining this term and calling attention to its implications. But I wonder if, a decade later, we might be in a position to reflect and reconsider our critical agenda.

12. W. J. T. Mitchell, Timothy Druckrey, Hubertus Amelunxen, Fred Ritchin, Jasia

Reichardt, Margaret Morse, Martin Lister, Harold Robins, and more recently Lev Manovich and N. Katherine Hayles, among others, have helped establish some of the frames for description.

13. The classic case is the one reported by Julian Dibbell, "A Rape in Cyberspace," *Village Voice* 38, no. 51, December 21, 1993. Sociological studies abound in this area: Steve Jones, *CyberSociety 2.0: Revisiting Computer-Mediated Communication and Community* (Thousand Oaks: Sage Publications, 1998); Philip N. Howard, *Society Online: The Internet in Context* (Thousand Oaks: Sage Publications, 2004); and the work of Brenda Laurel and others.

14. In *Laocoön* (1766), Gotthold Lessing made distinctions among media that continue to serve as a foundation of disciplinary and critical activity to the present day. Boundaries are still surprisingly well policed. Painting, printmaking, and sculpture departments are frequently defined by media in more ways than one would imagine possible.

15. See my essay "Interactive, Algorithmic, Networked," in *At a Distance: Precursors to Art and Activism on the Internet*, ed. Annmarie Chandler and Norie Neumark (Cambridge: MIT Press, 2005), for an extended discussion and references.

16. As the discussion of taste came to the fore in the eighteenth century, subjective opinion came under scrutiny. The development, marked by contributions of the Earl of Shaftesbury, was well suited to an era of rational cultivation of sensibility; the discussion of taste and refinement builds on the idea of knowledge as expertise, connoisseurship of sorts, created through the systematic accumulation of experience through sampling and refining of sensation.

17. Beardsley, 157. Immanuel Kant's *Critique of Judgment* designated the function of aesthetics as the understanding of design, order, form—"purposiveness without purpose"—design outside of utility—knowledge seeking must be "free," disinterested, without end, aim, or goal. Among the three modes of consciousness, knowledge (governed by pure reason), and desire (subject to practical reason), Kant positioned aesthetics as the bridge between mind and sense, aligning it with feeling and judgment.

18. Lisa Jevbratt and Geri Wittig, "Mapping the Web Informe," http://jevbratt .com/projects.html.

3.5

1. Brunkhorst, "Irreconciable Modernity."

2. Examples include the work of Mark Pauline and Survival Research Lab, performance and robotic artist Stelarc, video artist Alan Rath, sculptor Janet Zweig, and collaborators Heather Schatz and Eric Chan.

3. Osborne, "Adorno and the Metaphysics of Modernism," and Dews, "Adorno, Poststructuralism, and the Critique of Identity," in Benjamin, *Problems of Modernity*.

4. Brunkhorst, "Irreconcilable Modernity," 52.

5. Stephan Bann, ed., *The Tradition of Constructivism* (New York: Da Capo, 1974); Richard Hollis, *Graphic Design: A Concise History* (London: Thames and Hudson, 1994).

6. Max Kozloff, *Cubism/Futurism*, (New York: Harper Icon, 1973) for a general overview of these artists and their work. Stephen Kern, *The Culture of Time and Space* (Cambridge: Harvard University Press, 1983).

7. Brunkhorst, "Irreconcilable Modernity," 52, citing Adorno, "Die Kunst und die Künste," 160.

BIBLIOGRAPHY

Abbate, Janet. *Inventing the Internet*. Cambridge: MIT Press, 1999.

Adams, Laurie. *The Methodologies of Art*. New York: Icon, 1996.

Adorno, Theodor. *Aesthetic Theory*. Minneapolis: University of Minnesota Press, 1997.

Ahrens, Donald. *Meteorology Today*. Belmont, CA : Thomson/ Brooks/Cole, 2007.

Allen, J. F. "Time and Time Again: The Many Ways to Represent Time." *International Journal of Intelligent Systems* 6, no. 4 (July 1991): 341–55.

Amelunxen, H. V., S. Iglhaut, and F. Rötzer, eds., in collaboration with A. Cassel and N. G. Schneider. *Photography after Photography*. Munich: G&B Arts, 1996.

Andrews, Jim. "Vispo, Langu(im)age." http://www.vispo.com

Ascott, Roy. *Telematic Embrace*. Berkeley: University of California Press, 2003.

Austen, Jeremy, and Christopher Perfect. *The Complete Typographer*. Engelwood Cliffs, NJ: Prentice Hall, 1992.

Austin, John L. *How to Do Things with Words*. Cambridge: Harvard University Press, 1967.

Avrin, Leila. *Scribes, Scripts and Books*. Chicago: American Library Association; London: British Library. 1991.

Babbage, Charles. *Charles Babbage and His Calculating Engines*. New York: Dover, 1961.

Baker, Gordon P. *Wittgenstein, Frege, and the Vienna Circle*. Oxford: Blackwell, 1988.

Bakhtin, Mikhail. *The Dialogic Imagination*. Austin: University of Texas Press, 1981.

Bal, Mieke. *Looking In.* New York: Routledge, 2000.

Balsamo, Anne. *Technologies of the Gendered Body: Reading Cyborg Women.* Durham, NC: Duke University Press, 1996.

Barthes, Roland. *S/Z.* Paris: Editions du Seuil, 1970.

———. *Image/Music/Text.* New York: Hill and Wang, 1977.

———. *Mythologies.* Paris: Editions du Seuil, 1957.

Baudrillard, Jean. *For a Critique of the Political Economy of the Sign.* St. Louis: Telos Press, 1981.

———. *Simulations.* New York: Semiotext(e), 1983.

Beardsley, Monroe. *Aesthetics from Classical Greece to the Present: A Short History.* Tuscaloosa: University of Alabama Press, 1966.

Bell, Clive. *Art.* New York: Capricorn Books, 1958.

Benjamin, Andrew, ed. *The Problems of Modernity: Adorno and Benjamin.* London: Routledge, 1989.

Bense, Max. "The Projects of Generative Aesthetics." In *Cybernetics, Art and Ideas,* ed. J. Reichardt, 57–60. New York: Graphics Society Limited, 1971.

Benveniste, Emile. *Problemes de linguistique générale.* Paris: Gallimard, 1966–84.

Berger, John. *Ways of Seeing.* New York: Penguin, 1972.

Bernstein, Charles. *Veil.* LaFarge, WI: Xexoxial Editions, 1987.

Bertin, Jacques. *The Semiology of Graphics.* Madison: University of Wisconsin Press, 1973.

Besser, Howard. "Digital Libraries, Standards, Metadata, and Longevity Activities." http://besser.tsoa.nyu.edu/howard/#standards

Binski, Paul. *Cambridge Illuminations: Ten Centuries of Book Production in the Medieval West.* London: Harvey Miller, 2005.

Bök, Christian. *Pataphysics: The Poetics of an Imaginary Science.* Evanston, IL: Northwestern University Press, 2002.

Bolter, J. David. *Writing Space.* Matwah, NJ: L. Erlbaum Associates, 1991.

Bolter, J. David, with Diane Gromala. *Windows and Mirrors: Experience Design, Digital Art and the Myth of Transparency.* Cambridge: MIT Press, 2005.

Bray, Joe, Miriam Handley, and Anne C. Henry, eds. *Marking the Text.* Aldershot: Ashgate, 2000.

Bronstein, H. "Time Schemes, Order, and Chaos: Periodization and Ideology." In *Time, Order, Chaos: The Study of Time IX,* ed. J. T. Fraser. Madison, CT: International Universities Press, 1998.

Brunkhorst, H. "Irreconcilable Modernity: Adorno's Aesthetic Experimentalism and the Transgression Theorem." In *The Actuality of Adorno,* ed. M. Pensky. Albany: State University of New York Press, 1997.

Bryson, Norman, Michael Holly, and Keith Moxey, eds. *Visual Culture: Images and Interpretations.* Hanover, NH: University Press of New England, 1994.

Burg, J., A. Boyle, and S.-D. Lang. "Using Constraint Logic Programming to Analyze the Chronology in *A Rose for Emily.*" *Computers and the Humanities* 34, no. 4 (December 2000): 377–92.

Buzzetti, Dino. "Text Representation and Textual Models." http://www.iath.virginia.edu/ach-allc.99/proceedings/buzzetti.html

Card, Stuart K., Jock D. Mackinlay, and Ben Shneiderman. *Readings in Information Visualization: Using Vision to Think.* San Francisco: Morgan Kaufmann Publishers, 1999.

Carruthers, Mary J. *The Craft of Thought: Meditation, Rhetoric, and the Making of Images, 400–1200.* Cambridge: Cambridge University Press, 1998.

Carey, James. *Communication as Culture.* Boston: Unwin Hyman, 1989.

Cayley, John. "Indra's Net or Hologography." http://homepage.mac.com/shadoof/net/in/inhome.html

Chipp, Herschell Browning. *Theories of Modern Art.* Berkeley: University of California Press, 1968.

Chomsky, Noam. *Cartesian Linguistics: A Chapter in the History of Rationalist Thought.* Christchurch, New Zealand: Cybereditions, 2002.

Chun, Wendy. *Control and Freedom.* Cambridge: MIT Press, 2006.

Comaromi, John. *Dewey Decimal Classification: History and Current Status.* New Delhi: Sterling, 1989.

Corby, Tom. *Network Art.* New York: Routledge, 2006.

Coward, Rosalind, and John Ellis. *Language and Materialism: Developments in Semiology and the Theory of the Subject.* London: Routledge and Paul, 1977.

Crevier, Daniel. *AI: The Tumultuous History of the Search for Artificial Intelligence.* New York: Basic Books, 1993.

Critical Art Ensemble. Home page. http://www.critical-art.net

Davis, Martin. *Universal Computer.* New York: W. W. Norton, 2000.

Day, Michael. "Metadata for Digital Preservation: A Review of Recent Developments." http://www.ukoln.ac.uk/metadata/presentations/ecdl2001-day/paper.html

Deleuze, Gilles, and Felix Guattari. *Rhizome: Introduction.* Paris: Les Editions de Minuit, 1976.

———. *Anti-Oedipus: Capitalism and Schizophrenia.* New York: Viking, 1977.

de Man, Paul. *Allegories of Reading.* New Haven: Yale University Press, 1979.

———. *Blindness and Insight.* New York: Oxford University Press, 1971.

Dennett, Daniel. *Brainchildren.* Cambridge: MIT Press, 1998.

De Silva, Clarence W. *Intelligent Machines: Myths and Realities.* Boca Raton: CRC Press, 2000.

Derrida, Jacques. *Edmund Husserl's Origin of Geometry: An Introduction.* Trans. John P. Leavey Jr. Lincoln: University of Nebraska Press, 1989.

———. *Of Grammatology.* Baltimore: Johns Hopkins University Press, 1976.

———. *Writing and Difference.* Chicago: University of Chicago Press, 1978.

Despeyroux, Joëlle, and Robert Harper. "Logical Frameworks and Metalanguages." *Journal of Functional Programming* 13 (2003):257–60.

Dibbell, Julian. "A Rape in Cyberspace." *Village Voice* 38, no. 51, December 21, 1993.

Dick, Philip K. *Do Androids Dream of Electric Sheep?* Garden City, NY: Doubleday, 1968.

Dreyfus, Hubert. *What Computers Can't Do.* New York: Harper and Row, 1979.

Drucker, Johanna. "Digital Ontologies." *Leonardo* 34, no. 2 (2001): 141–45.

———. *Figuring the Word* (New York: Granary Books, 1998).

———. "Graphesis." http://www.noraproject.org/reading.ph.

———. "Graphical Readings and the Visual Aesthetics of Textuality." *Text, Transactions of the Society for Textual Scholarship* 16 (2006): 267–76.

———. "Interactive, Algorithmic, Networked." In *At a Distance: Precursors to Art and Activism on the Internet*, ed. Annmarie Chandler and Norie Neumark, 34–59. Cambridge: MIT Press, 2005.

———. *The Visible Word: Experimental Typography and Modern Art, 1909–1923.* Chicago: University of Chicago Press, 1994.

———. "What Is a Letter?" In *The Education of a Typographer*, ed. Steven Heller, 78–90. New York: Allworth Press, 2004.

———, ed. "Digital Reflections: The Dialogue of Art and Technology." Comment introducing special issue of the same title. *Art Journal*, Fall 1997, 2.

Druckrey, Timothy. *Iterations*. New York: International Center of Photography; Cambridge: MIT Press, 1993.

———. *Ars Electronica*. Cambridge: MIT Press, 1999.

Duggan, Hoyt. "The Piers Plowman Electronic Archive." http://www.iath.virginia.edu/piers/

Dunn, D., ed. *Pioneers of Electronic Art*. Santa Fe: Ars Electronica and the Vasulkas, 1992.

Eco, Umberto. *Theory of Semiotics*. Bloomington: University of Indiana Press, 1976.

Elkins, James. *The Domain of Images*. Ithaca: Cornell University Press, 1999.

Esposito, Joseph. "The Processed Book." *First Monday* 8, no. 3 (2003). http://www.firstmonday.org/issues/issue8_3/esposito

Febvre, Lucien, and H.-J. Martin. *The Coming of the Book*. London: Verso, 1997.

Fiedler, Conrad. *On Judging Works of Visual Art*. Berkeley: University of California Press, 1978.

Foucault, Michel. *The Order of Things*. New York: Pantheon, 1970.

———. *The Achaeology of Knowledge*. New York: Harper & Row, 1972.

Franke, Herbert W. *Computer Graphics Computer Art*. New York: Phaidon, 1971.

Franke, Herbert W., and Horst S. Helbig. "Generative Mathematics: Mathematically Described and Calculated Visual Art." In *The Visual Mind*, ed. M. Emmer, 101–4. Cambridge: MIT Press, 1993.

Fraser, James T. "From Chaos to Conflict." In *Time, Order, Chaos: The Study of Time IX*, ed. J. T. Fraser, Marlene P. Soulsby, and Alexander J. Argyros, 3–19. Madison, CT: International Universities Press, 1998.

———. *Time, the Familiar Stranger*. Cambridge: Massachusetts University Press, 1987.

Freedberg, David. *Eye of the Lynx*. Chicago: University of Chicago Press, 2002.

Fried, Michael. *Art and Objecthood*. Chicago: University of Chicago Press, 1998.

Fry, Roger. *Vision and Design*. Harmondsworth: Penguin, 1937.

Fuller, Matthew. *Behind the Blip*. Brooklyn: Autonomedia, 2003.

Galison, Peter. *Image and Logic: A Material Culture of Microphysics*. Chicago: University of Chicago Press, 1997.

Gardner, Martin. *Logic Machines and Diagrams*. Chicago: University of Chicago Press, 1982.

Genette, Gérard. *Nouveau discours du récit*. Paris: Editions du Seuil, 1983.

Gibson, James Jerome. *The Ecological Approach to Visual Perception*. 1979; Hillsdale, NJ: Lawrence Erlbaum Associates, 1986.

Glazier, Loss P. *Digital Poetics: The Making of E-Poetries*. Tuscaloosa: University of Alabama Press, 2002.

Goodman, Nelson. *Languages of Art: An Approach to a Theory of Symbols*. Indianapolis: Bobbs-Merrill, 1968.

Grafton, Anthony. *The Footnote*. Cambridge: Harvard University Press, 1997.

Gray, Chris Habels, and Steven Mentor. *The Cyborg Handbook*. New York: Routledge, 1995.

Greenberg, Clement. *Art and Culture*. Boston: Beacon, 1961.

Gregory, Richard L. *Eye and Brain*. Princeton: Princeton University Press, 1990.

Hansen, Mark. *New Philosophy for New Media*. Cambridge: MIT Press, 2004.

Haraway, Donna. *Simians, Cyborgs, and Women*. New York: Routledge, 1991.

Harrison, Charles, and Paul Wood, eds. *Art in Theory*. Oxford: Blackwell, 1993.

Hasse, L., and F. Dobson. *Introductory Physics of the Atmosphere and Ocean*. Dordrecht: D. Reidel, 1986.

Hayles, N. Katherine. *How We Became Posthuman*. Chicago: University of Chicago Press, 1999.

Haynes, Cynthia, and Jan Rune Holmevik, eds. *High Wired: On the Design, Use, and Theory of Educational MOOs*. Ann Arbor: University of Michigan Press, 1998.

Heim, Michael. *Electric Language*. New Haven: Yale University Press, 1987.

Heisenberg, Werner. *Philosophical Problems of Quantum Physics*. Woodbridge, CT: Ox Bow Press, 1979.

Henke, H. A. "The Global Impact of eBooks on ePublishing." *Proceedings of the 19th Annual International Conference on Computer Documentation, 172–80*. New York: ACM, 2001. http://portal.acm.org/citation.cfm?id=501551

Hershman-Leeson, Lynn. *Clicking In: Hot Links to a Digital Culture*. Seattle: Bay Press, 1996.

Higgins, Dick. *FOEW&OMBWHNW*. New York: Something Else Press, 1969.

Hjelmslev, Louis. *Prolegomena to a Theory of Language*. Madison: University of Wisconsin Press, 1963.

Hobart, James. "Principles of Good GUI Design." http://www.iie.org.mx/Monitor/v01n03/ar_ihc2.htm

Hockey, Susan. *Electronic Texts in the Humanities*. Oxford: Oxford University Press, 2000.

Hofstadter, Douglas. *Metamagical Themas*. New York: Basic Books, 1985.

Hollis, Richard. *Graphic Design: A Concise History*. London: Thames and Hudson, 1994.

Horn, Robert E. *Visual Language*. Bainbridge Island, WA: Macrovu, 1991.

Howard, Philip N. *Society Online: The Internet in Context*. Thousand Oaks: Sage Publications, 2004.

Innis, Harold. *Empire and Communications*. Toronto: University of Toronto Press, 1972.

Ivins, William. *Art and Geometry*. New York: Dover, 1946.

Jarry, Alfred. *Exploits and Opinions of Dr. Faustroll, Pataphysician*. Boston: Exact Change, 1996.

Jensen, C. S., J. Clifford, S. K. Gadia, A. Segev, and R. T. Snodgrass. "A Glossary of Temporal Database Concepts." *Proceedings of ACM SIGMOD International Conference on Management of Data* 23, no. 1, March 1994.

Jones, Steve. *CyberSociety 2.0: Revisiting Computer-Mediated Communication and Community*. Thousand Oaks: Sage Publications, 1998.

Jordan, P. W. "Determining the Temporal Ordering of Events in Discourse." Masters thesis, Carnegie Mellon Computational Linguistics Program, 1994.

Joy, Bill. "Why the Future Doesn't Need Us." http://www.wired.com/wired/archive/8.04/joy.html

Jussim, Estelle. *Visual Communication and the Graphic Arts: Photographic Technologies in the Nineteenth Century*. New York: R. R. Bowker, 1974.

Kelly, Michael, ed. *Encyclopedia of Aesthetics*. Oxford: Oxford University Press, 1998.

Kemp, Martin. *Visualizations: The Nature Book of Art and Science*. Berkeley: University of California Press, 2000.

Kern, Stephen. *The Culture of Time and Space*. Cambridge: Harvard University Press, 1983.

Kirschenbaum, Matthew. Home page. http://www.otal.umd.edu/~mgk/blog/

———. "Lines for a Virtual T[y/o]pography," http://www.iath.virginia.edu/~mgk3k/dissertation/title.html

———. *Mechanisms: New Media and the Forensic Imagination*. Cambridge: MIT Press, 2008.

Knuth, Donald. *Tex and Metafont*. Bedford, MA: American Mathematical Society and Digital Press, 1979.

Kolko, Beth E., Lisa Nakamura, and Gilbert B. Rodman. *Race in Cyberspace*. New York: Routledge, 2000.

Kosslyn, Stephen. *Image and Mind*. Cambridge: Harvard University Press, 1980.

Kroker, Arthur. *Digital Delirium*. New York: St. Martin's Press, 1997.

Kurzweil, Ray. *The Age of Intelligent Machines*. Cambridge: MIT Press, 1990.

Landow, George. *Hypertext*. Baltimore: Johns Hopkins University Press, 1992.

Lewis, Peter. *Wittgenstein: Aesthetics and Philosophy*. Burlington, VT: Ashgate, 2004.

LeWitt, Sol. "Paragraphs on Conceptual Art." *Artforum,* June 1967.

Licklider, J. C. *Libraries of the Future*. Cambridge: MIT Press, 1965.

Lister, Martin, ed. *The Photographic Image in Digital Culture*. London: Routledge, 1995.

Liu, Alan. *The Laws of Cool: Knowledge Work and the Culture of Information*. Chicago: University of Chicago Press, 2004.

"Logical Frameworks and Metalanguages." Special issue of *Journal of Functional Programming*. 13 (2003): 257–60.

Loizeaux, Elizabeth Bergmann, and Neil Fraistat. *Reimagining Textuality*. Madison: University of Wisconsin Press, 2002.

Lovejoy, Margot. *Postmodern Currents: Art and Artists in the Age of Electronic Media*. Ann Arbor: UMI Research Press, 1989.

Lupton, Ellen, and J. Abbott Miller. *Design Writing Research*. New York: Kiosk, 1996.

Lycan, W. G. *Philosophy of Language: A Contemporary Introduction*. New York: Routledge, 2000.

Lynch, Clifford. "The Battle to Define the Future of the Book in the Digital World." *First Monday* 6, no. 6 (2001). http://www.firstmonday.org/issues/issue6_6/lynch

MacEachren, Alan. *How Maps Work*. New York: Guilford Press, 1995.

Machlup, Fritz. *Information: Interdisciplinary Messages*. New York: Wiley and Sons, 1983.

Mandel, Theo. *The Elements of User Interface Design*. New York: Wiley and Sons, 1997.

Manovich, Lev. *The Language of New Media*. Cambridge: MIT Press, 2001.

Marcus, Aaron, Nick Smilonich, and Lynne Thompson. *The Cross-GUI Handbook for Multiplatform User Interface Design*. Boston: Addison-Wesley Longman, 1994.

Marr, D. *Vision: A Computational Investigation into the Human Representation and Processing of Visual Information*. San Francisco: W. H. Freeman, 1982.

Mathes, Adam. "Folksonomies—Cooperative Classification and Communication through Shared Metadata." http://www.adammathes.com/academic/computer-mediated-communication/folksonomies.html

Mathews, Harry. *Oulipo Compendium*. London: Atlas Press, 1998.

Maturana, H. R., and F. J. Varela. *Autopoiesis and Cognition: The Realization of the Living*. Boston: D. Reidel, 1980.

McCaffery, Steve, and bp nichol. *Rational Geomancy*. Vancouver: Talonbooks, 1992.

McCarty, Willard. *Humanities Computing*. Hampshire: Palgrave, 2005.

McGann, Jerome. *Black Riders: The Visible Language of Modernism*. Princeton: Princeton University Press, 1993.

———. *The Critique of Modern Textual Criticism*. Chicago: University of Chicago Press, 1983.

———. *Dante Gabriel Rossetti and the Game That Must Be Lost*. New Haven: Yale University Press, 2000.

———. *Radiant Textuality*. New York: Palgrave, 2001.

———. "Texts in N-Dimensions and Interpretation in a New Key." http://texttechnology.mcmaster.ca/pdf/vol12_2_02.pdf

———. *The Textual Condition*. Princeton: Princeton University Press, 1991.

McLeod, Randall. Lectures on "Material Narratives." http://www.sas.upenn.edu/~traister/pennsem.html

McLuhan, Marshall. *The Medium Is the Massage*. New York: Bantam Books, 1967.

———. *Understanding Media*. New York: New American Library, 1964.

McMurtrie, Douglas. *The Book: The Story of Printing and Bookmaking*. New York: Dorset, 1943.

McShine, Kynaston. *Information*. New York: Museum of Modern Art, 1970.

Minsky, Marvin. *The Society of Mind*. New York: Simon and Schuster, 1986.

Minsky, Marvin, with Seymour Papert. *Artificial Intelligence*. Eugene: Oregon State System of Higher Education, 1973.

Mijksenaar, Paul. *Visual Function*. Princeton: Princeton Architectural Press, 1987.

Mitchell, William J. *City of Bits: Space, Place, and the Infobahn*. Cambridge: MIT Press, 1995.

———. *The Reconfigured Eye: Visual Truth in the Post-Photographic Era*. Cambridge: MIT Press, 1994.

Moreau, René. *The Computer Comes of Age*. Cambridge: MIT Press, 1984.

Moretti, Franco. "Graphs, Maps, and Trees." *New Left Review*, no. 24, November–December 2003.

Morison, Stanley. *Selected Essays on the History of Letter-Forms in Manuscript and Print*. Cambridge: Cambridge University Press, 1981.

Morse, Margaret. *Virtualities*. Bloomington: Indiana University Press, 1998.

Moser, Mary Anne, ed., with Douglas MacLeod. *Immersed in Technology*. Cambridge: MIT Press, 1996.

Mosely, James. *Romain du Roi*. Lyons: Musée de l'imprimerie, 2002.

Motte, Warren. *OuLiPo: A Primer of Potential Literature*. Normal, IL: Dalkey Archive Press, 1998.

Nelson, Ted. "Project Xanadu." http://www.xanadu.net

Nielson, Jakob. "Top Ten Web Design Mistakes." May 30, 1999. http://www.useit.com/alertbox/990530.html

Nyce, James M., and Paul Kahn, eds. *From Memex to Hypertext: Vannevar Bush and the Mind's Machine*. Boston: Academic Press, 1991.

Ong, Walter. *Ramus, Method, and the Decay of Dialogue*. Cambridge: Harvard University Press, 1958.

O'Toole, M. A. "The Theory of Serialism in *The Third Policeman*." *Irish University Review* 18, no. 2 (1988): 215–25. 1988.

Panofsky, Erwin. *Studies in Iconology*. New York: Harper and Row, 1972.

Parkes, Malcolm B. "The Influence of the Concepts of *Ordinatio* and *Compilatio* on the

Development of the Book." In *Medieval Learning and Literature*, ed. J. J. G. Alexander and M. T. Gibson, 115–41. Oxford: Clarendon Press, 1976.

Peirce, Charles. *The Philosophical Writings of Charles Peirce*. Ed. Justus Buchler. New York: Dover, 1955. (Republication of *The Philosophy of Peirce: Selected Writings*. London: Routledge and Kegan Paul, 1940.)

Penny, Simon. *Critical Issues in Electronic Media*. Albany: State University of New York Press, 1995.

Popper, Frank. *From Technological to Virtual Art*. Cambridge: MIT Press, 2007.

Powers, Richard. *Galatea 2.2*. New York: Farrar, Straus, and Giroux, 1995.

Price, H. "The View from Nowhen." In *Time's Arrow and Archimedes' Point*. New York: Oxford University Press, 1996.

Price, William Charles. *The Uncertainty Principle and Foundations of Quantum Mechanics: A Fifty Years' Survey*. New York: Wiley, 1977.

Prueitt, Melvin. *Art and the Computer*. New York: McGraw-Hill, 1984.

Raley, Rita. "Interferences: [Net.Writing] and the Practice of Codework." http://www.electronicbookreview.com/thread/electropoetics/net.writing

———. "Reveal Codes: Hypertext and Performance." http://www.iath.virginia.edu/pmc/text-only/issue.901/12.1raley.txt

Reichardt, Jasia. *The Computer in Art*. New York: Van Nostrand Reinhold; London: Studio Vista, 1971.

———. *Cybernetics, Art, and Ideas*. Greenwich, CT: New York Graphic Society, 1971.

———. *Cybernetic Serendipity*. New York: Praeger, 1968.

Renear, Allen. "Out of Praxis: Three (Meta) Theories of Textuality." In *Electronic Text*, ed. K. Sutherland, 107–26. Oxford: Clarendon Press, 1997.

Renear, Allen, with Steve De Rose, David G. Durand, and Elli Mylonas. "What Is Text, Really?" *Journal of Computing in Higher Education* 1, no.2 (Winter 1990): 3–26.

Reynolds, Robert, and Thomas Zummer, eds. *CRASH: Nostalgia for the Absence of Cyberspace*. New York: Thread Waxing Space, 1994.

Reynolds, Teri. "Spacetime and Imagetext." *Germanic Review* 73, no. 2 (Spring 1998): 161–74.

Ritchin, Fred. *In Our Own Image*. New York: Aperture, 1990.

Rucker, Rudy. *Software*. New York: Eos/HarperCollins, 1987.

Saint-Martin, Fernande. *Semiotics of Visual Language*. Bloomington: University of Indiana Press, 1990.

Saussure, Ferdinand de. *Course in General Linguistics*. Ed. Charles Bally and Albert Sechehaye. London: Duckworth, 1983.

Schmid, Calvin. *Handbook of Graphic Presentation*. New York: Ronald Press, 1954.

Scholem, Gershem. *Kabbalah*. New York: Meridian, 1978.

Schreiber, F. A. "Is Time a Real Time? An Overview of Time Ontology in Informatics." In *Real Time Computing*, ed. W. A. Halang and A. D. Stoyenko, 283–307 (Springer Verlag, 1992).

Schreibman, Susan, Ray Siemens, and John Unsworth, eds. *A Companion to Digital Humanities*. Malden, MA: Blackwell, 2004.

Schrödinger, Erwin. *My View of the World*. Cambridge: Cambridge Uniersity Press, 1964.

———. *Science and Humanism: Physics in Our Time*. Cambridge: Cambridge University Press, 1951.

Sebeok, Thomas. *Introduction to Semiotics*. London: Pinter, 1994.

Seuphor, Michel. *Abstract Painting.* New York: Abrams, 1962.

Shanken, E. "The House That Jack Built." http://www.duke.edu/~giftwrap/, http://mitpress.mit.edu/e-journals/LEA/ARTICLES/jack.html

Shannon, Claude. "A Mathematical Theory of Communication." Bell Labs, 1947. http://cm.bell-labs.com/cm/ms/what/shannonday/paper.html

Shneiderman, Ben, and Catherine Plaisant. *Designing the User Interface: Strategies for Effective Human-Computer Interaction.* Boston: Pearson/Addison Wesley, 2005.

Shulman, Holly, ed. Dolley Madison Digital Edition. University of Virginia Press. http://www.upress.virginia.edu/books/shulman.html

Simon, Herbert. *Representation and Meaning: Experiments with Information Processing Systems.* Englewood Cliffs, NJ: Prentice Hall, 1972.

Smith, M. M. "The Design Relationship between the MSS. and the Incunable." In *A Millennium of the Book,* ed. R. Meyers and M. Harris. Winchester, England: St. Paul's, 1994.

Smith, Paul. *Discerning the Subject.* Minneapolis: University of Minnesota Press, 1988.

Sondheim, Alan. *Disorders of the Real.* Barrytown, NY: Station Hill Press, 1988.

Spencer-Brown, George. *The Laws of Form.* New York: Julian Press, 1972.

Stafford, Barbara. *Good Looking.* Cambridge: MIT Press, 1996.

Stainton, Robert J. *Philosophical Perspectives on Language.* Peterborough, Ontario: Broadview Press, 1996.

Steedman, M. "The Productions of Time." Draft tutorial notes 2.0. University of Edinburgh. ftp://ftp.cis.upenn.edu/pub/steedman/temporality/

Stefans, Brian Kim. *Fashionable Noise.* Berkeley, CA: Atelos, 2003.

Stillman, Robert. *The New Philosophy and Universal Languages in Seventeenth-Century England: Bacon, Hobbes, and Wilkins.* Lewisburg: Bucknell University Press, 1995.

Sutherland, Kathryn, ed. *Electronic Text.* Oxford: Clarendon Press, 1997.

TEI Consortium. *Guidelines for Electronic Text Encoding and Interchange.* Humanities Computing Unit, University of Oxford, 2002. http://www.tei-c.org/Guidelines/index.xml

Todorov, Tveztan. *Theories of the Symbol.* Oxford: Blackwell, 1982.

Tufte, Edward. *The Visual Display of Quantiative Information.* Cheshire, CT: Graphic Press, 1983.

Turing, Alan. "On Computable Numbers, with an Application to the Entscheidungsproblem." *Proceedings of the London Mathematical Society,* series 2, vol. 42 (1936).

Twyman, Michael. *Printing 1770–1970: An Illustrated History of Its Development and Uses in England.* London: British Library, 1998.

Updike, Daniel B. *Printing Types.* Cambridge: Harvard University Press/Belknap, 1961.

Varela, Francisco J., Evan Thompson, and Eleanor Rosch. *The Embodied Mind: Cognitive Science and Human Experience.* Cambridge: MIT Press, 1991.

Vesna, Victoria, ed. *Database Aesthetics: Art in the Age of Information Overflow.* Minneapolis: University of Minnesota Press, 2008.

Virilio, Paul. *The Vision Machine.* Cambridge: MIT Press, 1995.

von Foerster, Heinz. *Observing Systems.* Salinas, CA: Intersystems Publications, 1981.

von Glasersfeld, Ernst. "An Introduction to Radical Constructivism." In *The Invented Reality: How Do We Know?,* ed. P. Watzlawick, 17–40. New York: W. W. Norton, 1984.

———. *Radical Constructivism: A Way of Knowing and Learning.* London: Falmer Press, 1995.

Weaver, Warren, and Claude Shannon. *The Mathematical Theory of Communication.* Urbana: University of Illinois Press, 1949.

Weigand, Wayne. "The 'Amherst Method': The Origins of the Dewey Decimal Classification Scheme." *Libraries & Culture* 33, no. 2, Spring 1998. http://www.gslis.utexas.edu/~landc/fulltext/LandC_33_2_Wiegand.pdf

Wells, H. G. *World Brain: The Idea of a Permanent World Encyclopedia.* 1937. https://sherlock.sims.berkeley.edu/wells/world_brain.html

Wiener, Norbert. *Cybernetics of Control and Communication in the Animal and the Machine.* New York: Wiley, 1948.

Wilkins, John. *An Essay towards a Real Character and Philosophical Language.* London: Printed for Sa. Gellibrand, and for John Martyn, 1668.

Wilson, Stephen. *Information Arts: Intersections of Art, Science, and Technology.* Cambridge: MIT Press, 2002.

Winograd, Terry. *Artificial Intelligence and Language Comprehension.* Washington, DC: U.S. Department of Health, Education, and Welfare, National Institute of Education, 1976.

Wurman, Richard Saul. *Information Architects.* New York: Watson-Guptill, 1997.

Würtz, Elizabeth. "A Cross-Cultural Analysis of Websites from High-Context Cultures and Low-Context Cultures." *Journal of Computer-Mediated Communication* 11, no. 1, article 13. http://jcmc.indiana.edu/vol11/issue1/wuertz.html

Yates, Frances. *The Art of Memory.* Chicago: University of Chicago Press, 1966.

———. *Lull and Bruno.* London: Routledge and Kegan Paul, 1982.